The Art of the Vatican ❧ ❧

Being a Brief History of the Palace, and an Account of the Principal Art Treasures within Its Walls ❧ ❧ ❧

By

Mary Knight Potter

Author of " Love in Art," etc.

Illustrated

Boston
L. C. Page & Company
MDCCCCIII

Published, October, 1902

Colonial Press
Electrotyped and Printed by C. H. Simonds & Co.
Boston, Mass., U. S. A.

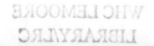

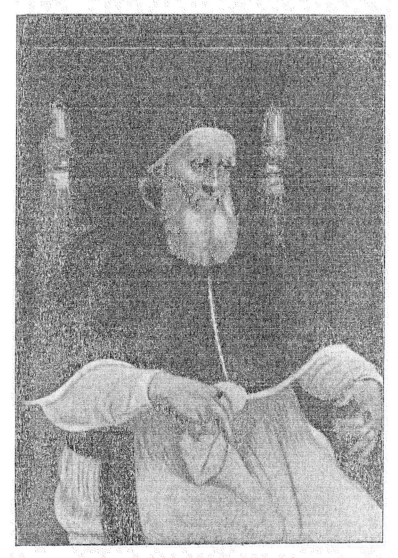

JULIUS II.
By Raphael; in the Pitti Palace, Florence

Preface

To describe even superficially all the art treasures of the Vatican would require many fat volumes. To consider fully the contents of only one of its many departments would take the entire space allowed for the present work. The question then has been, under the title of "The Art of the Vatican," what shall be chosen as representative of that art, and how much room shall be given to each subject. Into this choice, of course, the personal equation must largely enter. Probably all will agree that none of the galleries, museums, and chapels included here could be omitted. The only doubt would be concerning the exclusion of other divisions. The reason for ignoring the Library, the Egyptian and Etruscan Museums, and the Pauline Chapel, may seem to many difficult of comprehension. The pre-eminence of the sections selected being acknowledged, however, there remain but two ways to admit others within these covers. The first, of course, would be to devote less space to each subject. That, however, in the opinion of the writer, would

be to defeat the principal object of the book. If the descriptions were much shortened, the volume becomes little more than a bare catalogue. And there are already plenty of catalogues of the Vatican collections. The other method would be to cut out the chapter devoted to the palace as a whole, and give its place to the collections above mentioned. This has seemed an undesirable alternative. It was felt that the preliminary account of the building, and the brief mention of the part it has played in the history of the centuries, gave the work a homogeneity, a unity, not otherwise attainable.

The same reasoning applies to the actual paintings and sculptures described in each gallery or chapel. It has been thought better to devote as much consideration as possible to the most noted of the works rather than to speak more briefly of many. In this way it is hoped that the book may be valuable both for travellers, who wish to have something more than mere guide-book information of the great treasures of Rome, and for the amateur who has not sufficient time or desire to consult the many original works necessary for a thorough art training.

It is probably not necessary to remind the reader that a book of this kind can be little more than a compilation of a few of the opinions of the critics, archæologists, and historians who are recognised authorities, each in his own field. There is practi-

cally no room for original research or criticism. The most that can be claimed is an honest endeavour to cull the very best from a tremendous mass of often conflicting opinions, and to present the result as clearly and succinctly as possible. If a deep personal love for some particular works has sometimes led the writer to give undue prominence to them, at least she has been able to fortify her position by the equally strongly expressed likes of the greatest of the art critics.

One thing more. Even at the risk of being tiresome, much space has been given to very exact and literal descriptions of the composition of pictures and of the attitudes of statues. Nothing fastens a scene in one's mind so firmly as to know how it is actually depicted. To discuss, for instance, the grandeur of pose of a certain figure means comparatively little unless one knows where the figure is to be found and what it is doing in any given composition. In other words, the verbal descriptions, it is hoped, will help to recall more quickly the picture or statue to those who have already seen it, and will also bring it more distinctly before the mental vision of those who have not.

Guide-books and even art books are singularly silent regarding the amount of modern restoring that has often nearly remade many of the masterpieces of a bygone day. The young traveller in consequence,

when he first sees the fresh, vivid colours of frescoes and pictures and the unbroken arms and legs of statues, must be greatly perplexed to know what is of to-day and what of yesterday. For this reason efforts have been made to give at least a general impression as to how far this work of restoration has been carried on. The writer is particularly indebted to Wolfgang Helbig for his explicit statements concerning the additions made since their discovery to ancient statues.

Finally, it is certainly unnecessary to remark that, in such a volume as this, it is practically impossible wholly to keep mistakes from creeping in. The writer claims no infallibility in her judgment or selections, but she sincerely hopes that her earnest efforts have succeeded in keeping the book moderately free from errors.

Contents

List of Illustrations

List of Illustrations

PARTIAL PLAN
OF THE VATICAN PALACE
AND
GALLERIES

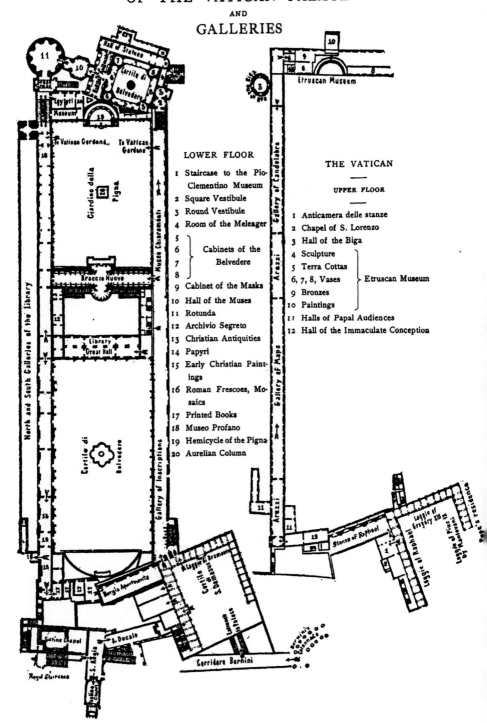

LOWER FLOOR

1 Staircase to the Pio-
 Clementino Museum
2 Square Vestibule
3 Round Vestibule
4 Room of the Meleager
5
6 } Cabinets of the
7 Belvedere
8
9 Cabinet of the Masks
10 Hall of the Muses
11 Rotunda
12 Archivio Segreto
13 Christian Antiquities
14 Papyri
15 Early Christian Paint-
 ings
16 Roman Frescoes, Mo-
 saics
17 Printed Books
18 Museo Profano
19 Hemicycle of the Pigna
20 Aurelian Column

THE VATICAN
—
UPPER FLOOR

1 Anticamera delle stanze
2 Chapel of S. Lorenzo
3 Hall of the Biga
4 Sculpture
5 Terra Cottas
6, 7, 8, Vases } Etruscan Museum
9 Bronzes
10 Paintings
11 Halls of Papal Audiences
12 Hall of the Immaculate Conception

The Art of the Vatican

CHAPTER I.

THE VATICAN PALACE

In mighty, irregular, unbeautiful masses, the
Palace of the Popes rears itself beside St. Peter's,
its huge, angular pile almost dwarfing the great
cathedral itself. The product of many centuries,
its construction the result of many differing minds
as well as times, its appearance from the outside
suggests a helter-skelter conglomeration of big
factories or towering tenements. It is as if giants,
standing on the seven hills of Rome, had played
a monstrous game in which walls, windows, por-
ticoes, loggie, courts, and roofs were hurled down
into the Borgo, striking where they would and
adhering where they struck. So little apparent
plan is there in this mountainous pile of buildings.
The dull, muddy yellow of the walls does not make
its architectural sins any less aggressive. In fact,

1

outwardly, as a composite achievement of the generations that have lavished untold gold upon its building, it must be accounted an egregious architectural failure.

There is little chance, however, for viewing the Vatican as a whole. Only from the balcony around the lantern of St. Peter's can the entire extent of the sprawling mass be seen. Practically, the palace must be studied as it was built, — piecemeal. Thus considered in detachments, it shows much of beauty and interest. Unfortunately, the very worst of it is that part seen first and last by the visitor in Rome. The ugly divisions that rise at the right of St. Peter's, over Bernini's colonnade, do not hint of the loggie about the Court of St. Damasus or the long lines of galleries leading to the graceful Belvedere. These fiercely windowed, jaundiced walls suggest the many real beauties of the Vatican as little as they proclaim the marvellous treasures of art collected within them. To get a true appreciation of these architectural triumphs, it is necessary to view them not only with the eye of present sight, but with the eye of retrospection as well. Even a short and necessarily incomplete account of the why and when they were built will tend to give a truer basis for opinion as to their worth and success.

The Vatican as it is to-day, with its outbuildings, gardens, and grounds, covers a space equal in area

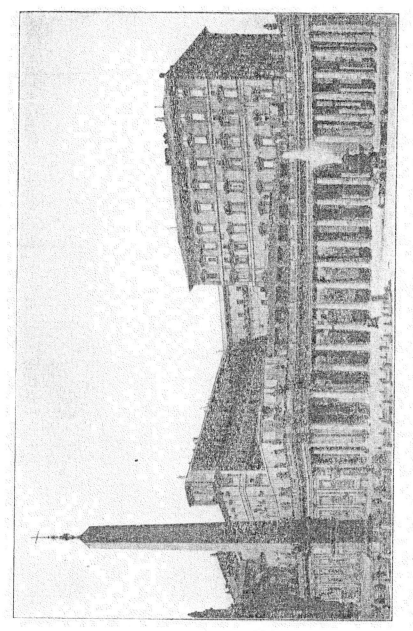

VATICAN PALACE, FROM THE PIAZZA DI SAN PIETRO

to a city with a population of a hundred and thirty thousand. Compared in size with the palace alone, even the Colosseum sinks into insignificance. For the Colosseum would not quite fill up the ground plan of St. Peter's. And it would take all of St. Peter's and more than half as much again to equal the extent of the Vatican.

Roughly speaking, the shape of the Vatican is that of two separate and wholly dissimilar groups of buildings on the slope of the hill at the foot of which is St. Peter's. These groups are connected by two narrow parallel galleries about a thousand feet long and two hundred and forty feet apart. These in turn are joined near the middle by two cross-galleries, dividing the enclosed space into two rectangular courts. The huge edifice at the southern end of these galleries is connected with St. Peter's, and is really the palace proper. Here, within its vast, irregular walls, are the Pope's private apartments, those of several cardinals, the Sistine Chapel, Pauline Chapel, Borgia Tower, the Stanze and Loggie of Raphael, and the Court of St. Damasus. The group at the other end, made more beautiful in line and mass, is smaller as well as more homogeneous. This still keeps its old appellation of the Belvedere, given it when it was the summer house of the Popes, and entirely unconnected with the palace. Named the Belvedere because of the lovely views from it,

the windows still look out over the walls of the
Eternal City. There have been fabulous stories
told of the number of rooms in the palace. Including
anterooms, closets, guard-rooms and the like, they
have been computed as high as twenty-two thousand.
The best authorities, however, give them as about
seven thousand, with over two hundred staircases
and twenty courts. By far the larger and more im-
portant of these are given up to the galleries,
libraries, and chapels. The Pope's own apartments
are, in comparison, most insignificant. They are in
the east wing of the part surrounding the Court of
St. Damasus, and the windows of his rooms can
be seen over the colonnade from the Piazza di San
Pietro. He thus, though to a certain extent the
prisoner he has been called, can overlook the whole
of the city that once was the capitol of the Church's
temporal kingdom.

Viewed from a certain standpoint, the Vatican
may be called a history in stone of the rise, the
decline, and the temporal fall of the Roman Catholic
Church. Originally built when days of martyrdom
for Christians were not far behind, it was three
hundred years after that it was the scene of the
greatest height of the Pope's power, — the crowning
of the emperor of the world by the Pontiff of the
Church. A thousand years after that the same office
was demanded of his successor by the man whose

ambitions seemed about to make him the veritable
ruler of all Europe. Since then, the museums and
galleries of this mighty pile have indeed grown in
extent. But the priceless paintings and tapestries
within have undergone the inevitable spoliation of
that time aided by zealous restorers. No longer at
the Vatican is held the dazzling court that rivalled
the splendours of fabulous Eastern monarchs. No
longer the sceptre of him whom policy must keep
close within its limits can claim unquestioned
obedience from the greatest of the kingdoms of the
world. It does not require abnormal imagination to
feel in the dead palace itself the infinite changes
the years have brought. In the extreme quiet that
pervades all its vastness, in the subdued, noiseless,
almost furtive air of its custodians, in the away-from-
the-world effect of the whole place, there are num-
berless hints of the different days that have descended
upon it. But most of all in the blackened, dulled, or
villainously rebrightened frescoes that make its
chief treasures, does the change appear in all its
glaringness. One can dream what were the glories
of the Sistine Chapel under Leo X.; one can guess
how the Pinturicchio golden stucco-studded ceilings
gleamed under Alexander VI.; one can imagine the
Stanze of Raphael in all their freshness and clarity;
but, like the temporal power of the most ancient
hierarchy of Christendom, these things can be actu-

ally seen no more. Perhaps it is an artistic heresy to suggest that to him of vivid poetic imagination these art works of the great Renaissance have after all in some ways gained by the ravages of the years. Surely, he who studies them with the sympathetic appreciation of their possibilities ever before him hardly needs to see them as they were fresh from their creator's brush. Perhaps, even, he builds from what he feels are wrecks of one time perfection, a glorious whole more wonderful than could ever come from the painter's palette. For though time destroys, it casts a glamour over the past that recreates in even lovelier forms the ruins it has made. So, in looking back at the history in which this palace of the Popes bore so large a share, the days of its splendour and omnipotence linger long after the wars and pestilence, the bloodshed, the crime, the immorality that made it the 'very centre of their rioting course, have been forgotten.

There are various opinions as to the actual founding of the original Vatican palace. The Emperor Constantine and St. Sylvester have both been credited with its inception. The probability seems to be that somewhere about 500 A. D. Pope Symmachus built near the ancient basilica of St. Peter's an episcopal residence. This was the Pope who appealed to Theodoric to confirm his election, there being on the field at the time a rival, Lawrence, who claimed

the papal chair. Not till Symmachus's successor
came to the pontifical throne did the wars and blood-
shed caused by his accession cease. Gregorovius
states that, having in spite of Lawrence and his
adherents kept the seat, in gratitude for being spared
to what was perhaps not a blameless life, Symmachus
built and adorned many churches, as well as founded
the Episcopia on the right and left of the stairway
of St. Peter's. Before long this had increased to a
number of different, if connected, buildings, for
various churchly purposes. There were cardinals'
apartments, presumably some sort of treasury or
counting-house, a dwelling for strangers and Church
dignitaries who were passing through Rome, and
perhaps even some kind of school or exercise rooms
for novices in the priestly ranks. The name, Vati-
can, belonged really to the whole region about.
" Mons Vaticanus " is said to be derived from Vati-
cinis, — oracles. `And it is stated that the ancients
used to receive prophecy from certain oracles there
living or officiating. This Mons Vaticanus was not
one of the seven hills of Rome, but was quite outside
the walls. It was here where Caligula had his
gardens, and it was here that Nero built the circus
where hundreds of Christians were put to frightful
deaths. According to Roman Catholic teaching also,
the crucifixion of St. Peter took place not far from
where is now his tomb in the cathedral. Thus hal-

lowed by the blood of saints and martyrs, it followed
almost as a matter of course that the greatest of the
Christian cathedrals should rise from the ground
so full of sacred memories. After that, though the
heads of the ever-widening church had their palace
as far away as the Lateran, the very needs of the
basilica demanded some sort of royal abode near
by. So the Vatican grew, till, by the time of Pope
Stephen II., there were already chapels, oratories,
mausoleums, a pontifical palace, the presbytery,
dwellings for canons and choristers, convents and
monasteries. Stephen II. made additions to the
palace, and less than fifty years later it had grown
to such proportions and magnificence that Charle-
magne spent the winter of 800 under its roof. It
was at the end of this, his third visit to the city,
that the Pope crowned him Emperor of the Holy
Roman Empire. In three hundred years the Popes'
power had mightily advanced. Symmachus had
appealed to Theodoric to confirm his own election.
Leo III. claimed and exercised the right to confer
the greatest temporal title of the world upon this
conquering Frankish king. Almost from this time
till the return of the Popes from Avignon, the Vati-
can, like the rest of Rome, was the scene of never-
ending bombardment, plague, pillage, fire, and
misery. In 846, the whole of the city was devastated
by Saracens, and St. Peter's and all the surrounding

buildings left in nearly total ruins. Up to now,
this quarter had been, as in the ancient days, out-
side the city walls. Consequently it was quite at
the mercy of any foes who chose to attack it. Leo IV.
put an end to such untrammelled invasions. Under
his orders a heavy protecting wall was raised, en-
circling the whole region. The name of the Leonine
city has ever since been associated with the en-
closure. In Raphael's Incendio del Borgo, he glori-
fies the miracle said to have been performed by this
pontiff. The wall of Leo IV. still exists in part, and
one of its towers serves for a summer-room for
Pope Leo XIII. This is a large, round chamber, with
a half-spherical ceiling painted with the symbolical
figures of the constellations. One of these, the lion,
has two stars for eyes, which, by some system of
lighting, shine and sparkle all through the night.
The walls are so thick and impenetrable that, while
the city is boiling under the pitiless August sun, here
is a coolness like a tomb.

After Leo IV., internal and external wars rav-
aged the city of Rome with little pause. One long
line of battle and siege after another raged, contest-
ing now the supremacy of the Popes, now the ancient
rights of the senate and people of Rome, now cham-
pioning the attempts of neighbouring towns, anon
establishing the absolute reign of the German sov-
ereigns. Whatever the cause, the Popes were in-

variably on one side or the other, till by the
beginning of the fourteenth century, for very fear
of life and possessions, they abandoned their ancient
throne and took their court to Avignon. Up to
this time the Lateran had always been the chief resi-
dence of the Popes. Occasionally, however, when
hard pressed by enemies, they had been forced to
take up their abode in the Vatican, that being better
fortified. Eugenius III. fled here for awhile, and to
him are ascribed some of the foundations of the pres-
ent palace. Celestine III., in spite of the troublous
days, made further additions and extended the forti-
fications. It was by now practically nothing but
a barricaded fortress, and as such was subject to
attacks and sieges. By the twelfth century it was
in an almost ruined condition. Innocent III., who
for awhile lived there, built more walls and towers
to protect it, and is said to have employed the Flor-
entine architects, Fra Sista and Ristori, to aid him
in his plans. To Innocent IV. are due the Gardens
of the Vatican. An inscription, says Pératé, that
was preserved up to the last century in the garden
of Pius IV. related in detail the laying out of these.
Nicholas III., in 1277, also lived at the Vatican, and
his additions are supposed to have occupied the site
of the Borgia Tower. Boniface VIII. died here at
the beginning of the fourteenth century. Kept a
prisoner there by the Orsini, who believed him in-

sane, it is more probable that it was grief and rage
over the triumph of his old enemies the Colonna,
which drove him to his unhappy end.

During the thousand years of papal residence in
Rome, invasion and bloodshed often enough had
scourged the city of the Cæsars. The seventy years
following the transfer of the head of the Roman
Church to Avignon witnessed such a devastation as
can hardly be conceived. Castles, palaces, churches,
houses, whole streets lay demolished in the dust.
Cattle were grazing in the Lateran and St. Peter's.
All kinds of government had practically ceased. In
1347 Cola di Rienzo declared that the Eternal City
was more like a den of thieves than the abode of
civilised man. All who could get away had fled
from the scene of desolation. It has been stated that
at the time of Urban V. there were scarcely five
hundred people left within the broken walls. Amid
the wreckage of two epochs — pagan and Christian
— Rome seemed no longer to exist.

For many hundreds of years the Lateran was the
official palace of the Popes. When Urban V. was
finally persuaded to come to Rome, this palace was
too ruinous for habitation. The Vatican, being bet-
ter fortified and protected by its nearness to Castle
St. Angelo, was in somewhat better condition. Be-
fore the Pope left Avignon, he sent orders ahead for
the Vatican to be made as livable as possible. In

spite of hurried restorations and renovations the
bare, half-ruined pile must have looked desolate
indeed to this prince of the Church used to the royal
magnificence of Avignon. The corps of artists he
brought with him, among whom were Giottino,
Giovanni, and Angelo Gaddi, could have made little
impression upon the hapless heaps. It is hardly
surprising that he did not stay long. Even St.
Bridget's woful prophecy could not keep him from
the waiting ease and joys of the Church's adopted
capital. History states that his chief desire to re-
turn to Avignon was to be near the protection of
the French king. He could there better wreak his
revenge upon Charles IV., Emperor of Germany,
who had manifested an independent spirit galling to
the pontiff. But there is little doubt that the lux-
uries and culture of the city near the Rhone had
something to do with his decision. Rome, the den
of thieves, as Rienzo styled it, could offer nothing
that was attractive or stimulating. The Vatican
palace itself, gaunt, gloomy, ill-supplied with even
fourteenth century comforts, must have been a daily
contrast to the kingly splendour in the halls at
Avignon.

But St. Bridget's prophecy came true. Urban was
taken sick the very day of his arrival at Avignon,
and died nineteen days after. Meanwhile Rome,
and indeed a large part of the Italian peninsula,

had grown more and more indignant that the head
of the Church should no longer be in the city of
its birth. The demands became so vigorous and
imperative that Gregory XI., Urban's successor, at
length decided to give in to the popular clamour,
and returned to the Holy City. Wars and inter-
nal disturbances prevented him from doing much
in the way of embellishment of church or palace.
At his death the magistrates locked the conclave
into the Vatican to select his successor. Outside the
walls the Roman populace thronged, yelling with
threatening cries that unless an Italian were chosen
the whole assembly of cardinals should be put to
instant death. And while the uneasy priests were
debating, a fearful storm arose that bellowed and
boomed through the shaking halls and extinguished
all the lights. The black darkness was only broken
by sharp lightning flashes, and in one of them the
cardinals saw drawn up under the rafters a deter-
mined body of soldiers. In consternation they de-
layed no longer. Bartholomew Prignano of Naples
was proclaimed Urban VI. But this was the begin-
ning of schism and worse disorders. There was no
peace or safety for the Popes in Rome. In spite
of one and sometimes two rival pontiffs in different
parts of the world, the Romans continued to elect
their own man. They were forced, however, to flee
from one city to another, pursued by enemies both

within and without the Church. While Innocent
VII. was Pope, Ladislas of Naples seized the Vati-
can, and the Pope escaped to Viterbo. Later, in
1413, the Neapolitans again triumphed, and then
there began such a sack as recalled the days of the
Vandals. Finally the end of the schism was the
election of the Roman, Otto Colonna, who took the
title of Martin V. Before him Alexander XXIII.
had built the covered way to the castle of St. Angelo,
thus giving an outlet to safety for many a future
Pope.

Once more the whole of the city was a fearful
ruin. There were soldiers in St. Peter's, and wolves
in the deserted gardens of the Vatican. Martin V.
set to work with enthusiasm, and, while he built
churches and monasteries and streets, he made only
enough repairs in the Vatican to keep the walls
standing. It was in too hopeless a condition for
residence, and he lived in a palace near the Church
of Saints and Apostles. From his day on the Vati-
can became the principal palace of the Popes. As
such it was the centre of that power that was ever
striving to grasp the world. No history has yet
told the secrets its walls have known. It might
almost be said that from Martin V. to the time of
the French Revolution no event in the history of
the time but was known and to a certain extent
influenced by the mighty court assembled there.

Fearful wrongs as well as unquestioned virtues have paraded unafraid beneath the shadow of its protection. Humanity in all its journeys from heights near the angels to depths below all devilhood has passed unhindered through its doors. With Martin V. the first signs of the Renaissance appeared in Rome. In art, Rome was far behind the other Italian cities. Not only did she produce none of the great artists that were already beginning to be known beyond her borders, but she woke up to their importance only after others were claiming their work. Eugenius IV. continued the efforts of Martin V. He succeeded in inducing Fra Angelico to come to decorate a chapel he had built in the Vatican. Before it was accomplished — or probably even begun — he died, and it was left to his successor, Nicholas V., to inaugurate with all its possibilities the Renaissance that was already making Italy the queen of the world.

Nicholas V. had vast schemes. Books and art were a passion with him, and he planned to decorate his capital till it should be the envy of Christendom. Almost immediately he began to carry out his designs for the rebuilding of the Vatican palace. To accomplish these designs it is practically certain that he tore down what parts of the old building were still left standing. Some of the foundations he doubtless retained, and Eugen-

ius's chapel became his own oratory. It was his
idea to keep a plain, almost severe outside, the better
to emphasise the richness, elaboration, and luxury
within. It was to be something of citadel shape,
recalling by its walls and towers the palace of Avi-
gnon. A triumphal door would lead into the courts
full of rare trees and fountains, about which were
grouped the buildings. There was a beautiful thea-
tre, whose round arch was supported by columns of
marble. At the right were the hall of the conclaves
and the coronation, with two smaller halls and the
apostolic treasury. Below this the immense Gallery
of the Benediction opened its windows toward the
Castle of St. Angelo. Upon the left a large chapel
with arched roof, which may be said to be the Sis-
tine, was entered by a vestibule. In mounting
toward the extremity of the palace, one entered a
large building of the library, lighted by windows on
two sides. A little beyond was another court, and
then the kitchens and stables. The apartments of
the Pope and the apostolic rooms looked upon the
first court. Pératé quotes Manetti as saying that
the ground floor was used in summer, that above in
winter, and the next for spring and autumn. The
plan for this is said to be that of Alberti. Before
these immense designs had begun to be realised in
wood and masonry, Nicholas died. The only parts
of the present palace unquestionably his are the

buildings immediately surrounding the Court of the Papagallo, including the Borgia wing. Behind the loggie of Bramante, the stanze, which Raphael afterward painted, served as the apartments of Nicholas. These were first decorated with works at least ordered during his life. Buonfigli da Perugia, one of the masters of Perugino, Bartolommeo da Foligno, Simone di Viterbe, Andrea del Castagno, and Piero della Francesca, were among the artists employed. Francesca's works were once where now one sees the Miracle of Bolsena. They were historical compositions full of contemporaneous portraits, among which were Charles VII. of France, Cardinal Bessarion, Prince of Palermo, and Nicholas Fortebraccio. Higher than all other artists in the favour of the Pope stood Fra Angelico. By some miracle of oversight or unexpected discrimination the exquisite paintings in the studio of Nicholas are still intact, a joy for all beholders even to the present day.

Besides with the work of architect and painter, Nicholas V. filled his palace with exquisite stained glass, with rare marbles, wonderful illuminations, embroidery, and sculptures. He sent to Venice and Florence and still farther afield for every kind of art product that would help to make his palace the most beautiful in the world. He practically founded the Vatican library, and his court became famous

for the historians, poets, engineers, architects, paint-
ers, sculptors, and writers that filled his audience
halls. Flemish tapestry had already excited much
admiration by its brilliant colouring, and Nicholas
established the first school of Roman tapestry
weavers in the palace itself, under the direction of
the Frenchman, Reginald de Maincourt.

After his death Calixtus III. began an entirely
different régime. Poets, and painters, architects,
and engineers, were no longer in demand. All work
toward the completion of the Vatican was stopped.
Calixtus did not hesitate to follow to the letter
his conviction that the regal appurtenances of his
predecessor were so many wiles of the Prince of
Darkness, entirely out of character for him who was
the successor of the fisherman apostle.

Pius II. had no such ascetic views as to the rights
and privileges of the See of Rome. He built a tower
which commanded a door of entrance to the Vatican,
and completed some of the unfinished rooms of
Nicholas V.

His successor, Paul II., was accused of being a
mere " commercial " by the literati of his day. His
principal desire was to conquer the Mussulmans. In
waging war against them he had little time left to
carry on the artistic schemes of Nicholas V. At
the Vatican, however, he built a façade of three
stories which, though it had disappeared by the time

of Paul V., served as model for Bramante for his noble Court of St. Damasus.

By 1470 the Renaissance could show such names as Brunelleschi, San Gallo, Ghiberti, Donatello, Verrocchio, Pollajuolo, Della Robbia, Rossellino, Mino da Fiesole, Masolino, Masaccio, Castagno, Melozzo da Forli, Gentile Fabriano, Benozzo Gozzoli, and Fra Lippo Lippi. It was not the capital of the Christian world, however, that knew them best, or most encouraged their works. Since Nicholas V. Rome had fallen far behind Florence or Siena or even minor towns in all advancement of art.

Sixtus IV. came to the papal throne in 1471, and with him begins a new era. If Rome could not produce native artists, at least she could adopt those of more fortunate regions. So intensely interested was Sixtus IV. in this art advancement that he has been said to occupy to the development of the Renaissance in Rome a position similar to that of Lorenzo de' Medici in Florence. At the Vatican he continued the work of rebuilding and restoring, following largely the plan of Nicholas V. The palace at this date was an irregular quadrilateral triangle, inclosing the Court of the Papagallo and joining by the Loggie of the Benediction with the vestibule of St. Peter's. This, the ground floor of the principal building, was below the rooms which make the Borgia apartments. They were under the Raphael

rooms, where Sixtus IV. had his library. Contemporary accounts state the architectural works of this pontiff to be of considerable extent and beauty, and they praise the magnificence of their decorations. Melozzo da Forli was the head of a school of painters whom Sixtus IV. had persuaded to come to Rome, and it was to him the Pope gave the decoration of his library. That part of the Vatican most intimately associated with Sixtus IV. is the Sistine Chapel. This was finished even to its side frescoes during his pontificate, and has ever since borne its founder's name.

It was during the pontificate of Innocent VIII. that Granada was finally wrested from the Moors, and it was near the end of his life that Columbus set out on his great journey. If he did not continue in quite the lavish way of his predecessor, at least he left substantial additions to the papal palace. His part of the building is more or less mixed up with the constructions of Paul II., and there have been many discussions what to ascribe to each. It seems probable, however, that the large division of the building where the door of the palace connects with the Loggie of the Benediction, belongs to the time of Paul II. This is where he put his arms. Innocent VIII. restored the door, and continued the large façade by an edifice which makes a right angle, overlooking on one side the Square of St. Peter's,

and on the other the court of entrance of the palace.
This façade, which was after the style of the Palace
of St. Mark, was of much inferior beauty to the
Loggie of the Benediction. It, as well as the great
hall which Innocent VIII. finished, was destroyed
to make place for the new St. Peter's in 1610.

What does remain as a monument to Inno-
cent VIII. is the Villa Belvedere. This is probably
almost wholly of his pontificate. At that time it
was built for a summer home, and was some distance
from the palace. Vasari and others have given Pol-
lajuolo as his architect. Müntz says, however, that
trustworthy documents ascribe it to Jacopo da Pietra-
santa. It is said to have cost sixty thousand ducats.
Mantegna did most of the interior decorations. A
story is told that the Pope, often being behindhand
with Mantegna's just pay, the artist determined to
teach him a lesson. So the Pope one day found him
at work upon a figure whose meaning he could not
guess.

"Who is she?" he asked, curiously.

"That," replied Mantegna, with covert emphasis,
"is Economy, your Holiness."

"Ah!" answered Innocent, "then paint next to
her Patience, Mantegna." But it is said that after
this the artist's money was promptly ready.

His works here, as well as his frescoes in a chapel
of the Vatican, have all perished. Gone, too, are

the floors in the Belvedere that were made of tiles from the workshop of the Della Robbia.

It was in this Belvedere that Alexander VI. kept prisoner Catherine Sforza, ex-sovereign of Forli, and it was in one of the rooms of the Borgia apartments that he himself died a terrible death, a death generally believed to have been caused by the poison he had meant for another.

Apologists for Alexander VI. lay great stress upon his patronage of the arts, many of them, like Müntz, claiming that posterity actually owes him a debt of gratitude for the encouragement he gave to the genius of Bramante, San Gallo, Perugino, Pinturicchio, Caradosso, Michelangelo. There is no doubt that he seized with avidity upon any artist who was capable of adding to the external glory of a reign almost unparalleled for its outward magnificence. But indeed all Italy was fairly throbbing with the joy of her awakening from the long sleep of art. Princes, potentates, and even merchants vied with one another in their efforts to secure the services of new stars in the firmament of sculptors, painters, and architects. In those eager days any real talent was most unlikely to die neglected. It would have been extraordinary if the luxury-loving Pope, he whose very vices required the richest of accessories, had not followed in the lead of the nobles of Florence, Venice, Milan, and Verona. And after

all is said, Alexander VI. completed and added to
the works of his predecessors rather than created
new. At the Vatican the only part wholly of his
era is the Borgia Tower. The so-called Apparta-
menta Borgia belongs to Nicholas V. Under Alex-
ander it was merely finished and decorated. And
though the Pinturicchio frescoes are among the
priceless treasures of the palace, yet, as has been
truly said, too much of such style of decoration
would have ended in the death of painting. The
Oriental voluptuousness of the Pope showed itself
in the excesses he demanded in gold, ornament, and
scintillating colour. A little of such bravura of
embroidery is permissible even in highest art. Be-
yond this, it becomes merely cloying and degenerate.

Under Julius II., nephew of Sixtus IV., began
the greatest period in the history of the Vatican. To
him and to his follower, Leo X., are due the larger
part of the marvellous works of art that to-day
still make the Vatican palace the most wonderful
museum in the world. It was Julius II. who com-
manded Bramante to join the palace to the Belve-
dere, who ordered Michelangelo to paint the ceiling
of the Sistine Chapel, and who set Raphael at work
on the Stanze.

Bramante's plan for making the Belvedere a part
of the Vatican proper was simple, dignified, and
rational. If it had been allowed to remain as he

designed it, the mass of buildings under the one name would be so much the gainer in coherency and charm. He threw out two long, parallel galleries joining the Villa at one end, the Vatican at the other. These two powerful lines were three stories high, each story an arcade whose columns and pillars circled the immense court that to-day is cut by the Library and Museum.

Julius II. at first lived in the Borgia Apartment. Tiring, likely enough, of for ever seeing the image of his predecessor, he decided to move into the story above, which had been the part used by Nicholas V. These rooms, decorated by artists of the earlier Renaissance, he ruthlessly ordered entirely refrescoed. Of all the works he saved only the little Chapel of Fra Angelico, where, each morning, he celebrated his mass. By 1508 a whole colony of painters was installed in the venerable apartment. Signorelli, Perugino, Sodoma, Bramantino, Peruzzi, Lorenzo Lotto, and the Flemish Jean Ruysch were hard at work covering walls and ceiling. Then, suddenly, Raphael, who was working by Perugino's side, stepped into fame at one bound. All the others were dismissed, and to him alone was confided the whole work.

Not till the very end of the fifteenth century did a passion for the antique begin to be felt in Rome. In Florence the Medicean collection of ancient sculp-

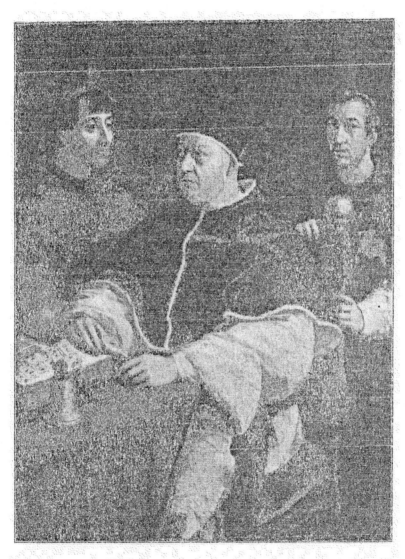

LEO X., CARDINAL GIULIO DE' MEDICI, AND DE' ROSSI
By Raphael; in the Pitti Palace, Florence

tures were in existence long before any such effort was made in the city of the Church. Sixtus IV. did open a museum of antique bronzes, and Innocent VIII. added some newly found works in brass and a colossal head of Commodus. From then till Julius II. no attempt was made to increase these relics of the past. While Julius was still cardinal he came into possession of a recently discovered Apollo, and when he became Pope he had it put into the Cortile di Belvedere. This court, about one hundred feet square, was laid out as a garden with orange-trees and running streams. Bramante designed semicircular niches for the statues that from then on were placed there. It was the beginning of the famous sculpture gallery that so excited Napoleon's admiration and greed.

Leo X. added to the sculptures in the Vatican Garden, and went on with the great plans of Julius II. for the beautifying of the palace. Among other constant demands upon Raphael he ordered him to make cartoons for tapestry which was to be hung around the walls of the Sistine Chapel below the paintings. Raphael also built on to the Bramante loggie a third story above the two already completed, and made the façade to the old pontifical palace.

Into the midst of all these wonder-works of art, despoiling the hard-won triumphs of generations, overturning, breaking, ruining precious gems no

after efforts could replace, came the destroyer from
the north. Under Fründesberg and De Bourbon,
the Germans and the Spaniards descended upon
Rome with the fury of the Vandals of old. The
Pope, Clement VII., was forced to flee to St. Angelo
with his cardinals, prelates, and household, and there
for seven long months he watched the destruction of
his city. Houses were razed, churches and convents
stripped of vases and vestments; relics, tiaras,
chasubles, tabernacles, chalices ornamented by the
great artists of the fifteenth century, tapestries, pic-
tures, sculptures, manuscripts, — all were broken,
torn, dispersed. Nobles, civilians, artists, poets, and
scholars fled from the burning, rioting town, and
Rome knew once more the desolation she had escaped
since the days of the return of Gregory XI. The
Vatican suffered equally with the other palaces. In
the Borgia apartments open camp-fires of the bar-
barians smoked and blackened beyond recognition
the golden dreams of Pinturicchio. Every treasure
that could be melted or smashed or by any means
converted into a commercial value was like kindling-
wood to the flames of their greed. After that they
wantonly ruined all that could be made of no mone-
tary value. Spears, javelins, sabres were thrown
at the frescoed walls, till many of them had scarcely
a foot unscarred. The costly stained glass windows,
the pride of Sixtus IV., were shattered to millions

of glistening splinters. Statues were overthrown
and broken, the gardens despoiled, — the whole
place turned into a wreck that might be rebuilt but
could never be the same. Everything considered,
it is only remarkable that the very stones of the
foundation were preserved. Conquering, invading
armies even of twentieth century civilisation do not
pretend to preserve for their victims' future use the
treasures that come within their triumphal march.
In the invasion of 1527 there was a spirit beneath
that would have regarded any clemency as sacri-
legious. The Protestant Germans under Fründes-
berg considered the smashing of images, the ransack-
ing of churches, the tearing of priestly vestments,
and the razing of convent and monastery as part
of their religious duty. They felt to the elaborate
paraphernalia of the Roman Church much as the
early Christians did to the stone and marble gods
and temples of the heathens. In each case the loss
to art has been the same.

When finally Clement VII. was released and the
Imperial army withdrawn, like a true Medici he at
once set about the renovating and reornamenting
of his palace. Giulio Romano, a pupil of Raphael,
was ordered to finish the stanze Raphael had begun,
and Del Vaga and Da Udine were set at work in the
Borgia Tower. Finally, Michelangelo was com-
missioned to paint the Last Judgment in the Sistine

Chapel. In the Pauline Chapel, the Conversion of St. Paul and Crucifixion of St. Peter were also finished during the latter's pontificate. Though the Pope was sixty-five and Michelangelo sixty, so great was the ardour of both that all Rome began to feel as if she were back in the days of Julius II. Antonio San Gallo restored the Court of the Belvedere, commenced by Bramante, and of which one whole gallery had tumbled down. He also constructed the entrance of the Sistine Chapel, and Sala Regia, an enormous vestibule with dome in the centre whose two stained glass windows were by Pastorino da Siena. This vestibule, where he wrote the names of the Farnese and Paul III., took the place of very ancient chambers of the palace, part of it being the oratory of the Holy Sacrament, decorated by Angelico for Nicholas V. As Pératé emphatically says, there can be no excuse for the self-aggrandisement that effaced these souvenirs of bygone times. The same Pope who destroyed this chapel of Nicholas V. blazoned his name upon the door of the Pauline Chapel, a chapel whose richness was only equalled by its banality.

For Julius III. Michelangelo designed a beautiful flight of steps for the Belvedere, in the shape of a quadrangular staircase with a balustrade of peperino marble. By this time the master was getting old, and although his advice was consulted for what-

ever alteration or addition was made to the Vatican, fresco painting had got beyond his failing physical powers. One can imagine his disgust when, unable himself to paint, his great fresco of the Last Judgment was ruthlessly altered to suit the prudery of the time. Paul IV. either felt or was persuaded that much that had been sanctioned under the name of art was mere blatant indecency. Accordingly he started in on his crusade against immorality by commanding that the nude figures in the great fresco should be properly clothed. Red and green and blue and brown robes and capes and scarfs were therefore carefully painted over the undraped angels and saints and martyrs and fiends. The fact that this conscientious veiling of the " human form divine " was bound to alter the lines of the composition, and greatly to change the distribution of the colour-mass, influenced this encourager of reforms not at all.

While Pius IV. was Pope, the great Court of the Belvedere was finished after the plans of Bramante under the superintendence of Michelangelo. Alongside of the Sala Regia were added two other rooms with a vault feebly arched over an arcade. It was decorated with a fresco of landscape alternating with figures of the virtues, the vaulting ornamented with fine arabesques.

Since the death of Leo V. the third story of the loggie had remained untouched. This was now dec-

orated with stucco and fresco by Da Udine and Pomarancio. But the most charming achievement of Pius IV. was the erection of a summer-house in the gardens about the palace. This, built by Piero Ligorio, was called the Villa Pia. It was a wonderfully happy architectural invention, abounding in all the grace of the antique. In form it was an ingenious joining of two small houses by a circular court of marble. Placed in the groves of pines and aloes, with flower beds tier upon tier, fountains and marble basins and covered galleries, with the walls ornamented with bas-reliefs and paintings by Baroccio, Santo de Tito, and others, nothing was lacking to make this exquisite creation a veritable artist's dream. Built at the very end of the Renaissance, it breathes a delicate fragrance like a last tender bloom upon a dying branch.

Gregory XIII., in whose time came the reform of the calendar, added the Torre dei Venti to the Vatican, and founded its gallery of geographical charts. He also finished the second arm of the loggie on the north of the Court of St. Damasus. In the palace a whole army of painters was at labour. Federigo Zucchero worked on the vaulting of the Pauline Chapel, and with Vasari finished the frescoes of the Sala Regia. These represent the great pontifical deeds from the Carolingian donations to the Battle of Lepanto, the triumph of which Rome had cele-

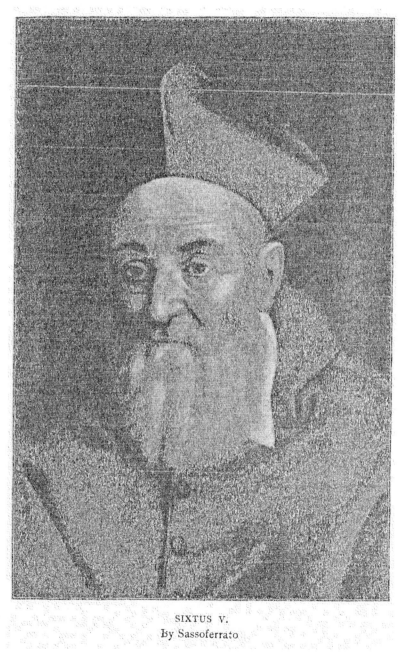

SIXTUS V.
By Sassoferrato

brated with the pomp of ancient days. Pomarancio
the younger imitated on the first floor of the new
loggie the decoration of Giovanni da Udine. On the
second floor Sabatini and Tempesta attempted and
failed to reproduce the style of Raphael in the series
of little frescoes illustrating the life of Christ. The
rooms opening into this gallery are the apartments
given to foreign potentates, and they as well as a
chapel dedicated to St. Paul and Anthony are all
overdecorated. Landscapes, Biblical scenes, life of
St. Gregory the Great, figures of Virtues, crowd and
jostle one another almost, it would seem, without
plan. Truly the Renaissance is dead. The third
floor continues the ornamentation begun under Pius
IV. on the first floor. These are scenes of the
life of Pius IV. and Gregory XIII., and all along the
ceiling is the solemn procession transporting the
body of St. Gregory from the St. Mary of the Campo
Marzo to St. Peter's. These loggie lead into an
immense gallery of one hundred and twenty metres,
constructed in 1581 by Muziano, and enriched by
stucco and paintings under the direction of Tem-
pesta.

Romans felt, when Sixtus V. became Pope, as if
the Renaissance were beginning to live again. Fon-
tana, who was his chief architect, had worked with
pupils of Michelangelo, and the Pope kept him busy
altering and making additions to his palace. He

closed the Court of St. Damasus toward the east by
a third body of building where the continuation of
the Loggie of Bramante made a new palace.

Henceforth this was the habitation of the Popes.
It is extraordinarily large, more open and more
healthy than the old rooms of Nicholas V. and of
Julius II. Fontana made it of bricks, the window-
cases and the cornices of travertin. He gave it the
form of a rectangle, a little elongated, bounding an
interior court and growing about the base of the
massive tower of Nicholas V.

Not less important but more questionable in taste
was the creation of the Vatican library, which vast
edifice, cutting across the Court of the Belvedere,
interrupted the gracious lines of Bramante's designs.
Commenced during the winter of 1587, it was almost
entirely finished by the autumn of the following year,
and it cost a thousand crowns of gold. In 1590 the
windows were provided with glass, and the superb
central gallery, divided into nine naves by the pilas-
ters of stucco, received a most elaborate decoration.
These frescoes, more precious for their history than
for their art, are accompanied by Latin inscriptions
which tell most ingeniously of all the works of
Sixtus V.

Clement VIII., he who condemned Beatrice Cenci
to death, completed the palace of Sixtus V. by a
third story, where to-day are the apartments of the

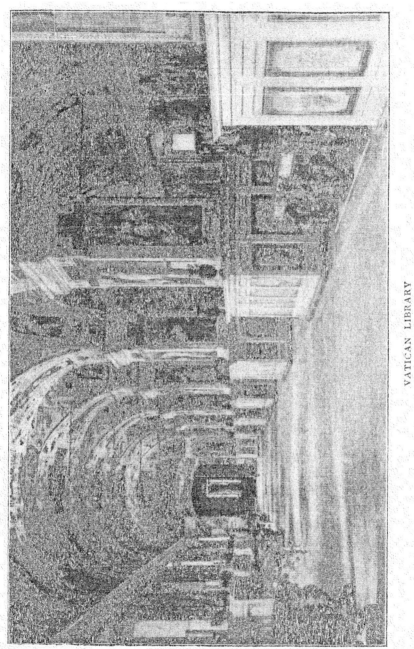

VATICAN LIBRARY

Cardinal Secretary of State. A mediocre painter, Giovanni Alberti, covered the walls with gigantic frescoes which represented the baptism of Constantine, the death and glorification of St. Clement. Clement VIII. also ordered the completion of the library of Sixtus V.

Urban VIII. added to this library a new division, expressly to receive the Palatine collection which had been bequeathed to it. In an effort also to reëstablish the pontifical army, which since the sixteenth century had amounted to little, he formed an arsenal in the Vatican, placing it over the library.

In 1660 Bernini, in constructing his imposing colonnade to the cathedral, changed the entrance to the Vatican, making it as one sees it to-day. Of the old door there remain the " portoni di bronzo," which Innocent VIII. had put in place and which Paul V. had restored. Passing the ever-present Swiss Guards, one comes to the Royal Staircase. This majestic entrance-way has a beautiful roof of caissons, supporting the Ionic columns, and mounts slowly and harmoniously to the Sala Regia. Bernini, as has been often said, in his inexhaustible fertility of invention, has perhaps never achieved a more expressive decoration.

During the seventeenth and eighteenth centuries, the Popes assiduously collected all the antique sculptures they could find to enrich the Vatican, and to

ornament the public squares of Rome. The Gardens
of the Belvedere had been changed into the Museo
Pio-Clementino, which was fast being filled with
innumerable bas-reliefs and inscriptions. The actual
founder of the Vatican Museum in its present form
is Clement XIV., and his work was finished by his
successor, Pius VI., under the guidance of the archi-
tect Simonetti. It meant the entire remodelling of
the old villa of Innocent VIII.

Hardly had Pius got his treasures safely and beau-
tifully housed when, after the invasion of the Italian
states by the French, the treaty of Tolentino gave
the gems of the collection to Napoleon. When
Pius VI. died in exile at Valence, the marbles of his
palace were in the Louvre in Paris. Despoiled of all
the more wonderful of the art treasures of his cap-
ital, Pius VII. started bravely to replace them, if
not in value, at least in extent and number. It was
during his years that Canova produced his once
extravagantly admired figures, poorly enough, in
reality, taking the place of the antique fragments.

The lapidary of Pius VII. extended from the first
floor of the Loggie of Bramante to the sill of the
library of Sixtus V. Its walls were ornamented with
antique inscriptions, and bordered by sarcophagi and
all sorts of broken bits. After that began the Museo
Chiaramonti, where the statues, farther than eye can
see, line the walls. Almost all are too much restored,

and the majority of them are only of inferior artistic
value. But meanwhile explorations in Rome and the
Campagna were constantly bringing new works to
sight. To give them a fitting place, Pius VII. had
Raphael Stern construct, in 1821, a long, rectangular
room, called the Braccio Nuovo. This was parallel
to the library of Sixtus V., and over the same prin-
cipal court of the Belvedere. The Pope bought every-
thing he could lay his hands upon, and in 1818 had
already brought to the Vatican the celebrated antique
fresco of the Marriage of the Aldobrandines, dis-
covered during the pontificate of Clement VIII., near
the Arch of Gallier. In 1819 he formed the Egyp-
tian Museum, with the collection of a Roman ama-
teur, Andrea Guidi.

And then, finally, after Waterloo, in 1815, the
Louvre in its turn had to disgorge, and back came
the treasures Napoleon a score of years before had
sent in triumph to the city on the Seine. The Vati-
can gained by the transfer more than she had lost,
in spite of the fact that France managed to retain
a few minor sculptures. For Pius VII. took from
the returned spoils of war enough canvases that once
had hung in Italian churches to start a picture-gal-
lery in his palace. They were placed in the building
of Gregory XIII., in the third story of the loggie.

This brings us almost to the Vatican as it exists
to-day. In 1836, Gregory XVI. created the Etrus-

can Museum in twelve small rooms, and in 1858
Pius IX. added to the chambers of Raphael the room
of the Immaculate Conception, decorated in fresco
by Francesco Podesti. Pius IX., as well, opened the
old balustrade giving access to the Court of St.
Damasus by a large covered stairway of travertin
and white marble and stucco. His orders repaired
with marble and glass the magnificent staircase
leading with its three hundred steps to the palace of
Sixtus V., and under his direction Alessandro
Mantovani repaired the paintings of Da Udine and
Pomarancio on the first floor of the loggie. They
also decorated the wing of Sixtus V. with landscapes
and Christian allegories.

In 1870 the temporal power of the Popes no longer
existed. Only in the Vatican was that power still
omnipotent. If now Italy had the great painters
and sculptors of the Renaissance, one can imagine
that every means would be employed to secure their
ablest efforts for this last remnant of the might that
once claimed the world's obeisance. Even with the
inadequate talent at his command, Leo XIII. has
done much to prove his artistic right to be the
successor of the Popes of days for them more for-
tunate. He has opened new rooms in the library
and archives. He has ornamented the Gallery of
the Candelabra with a rich pavement of marble, and
a ceiling where are painted in allegories the acts of

his pontificate. His greatest claim to the gratitude of all art-lovers is his restoration and opening to the public the apartments of the Borgia.

Perhaps, when the to-be-hoped-far-away future has crumbled to ruins the Stanze and the Sistine Chapel, perhaps the soil of Italy will have ready a new race of giant creators, who can worthily replace the masterpieces of the vanished past. Meanwhile, for us, the embers of that golden era still glow with a brilliancy that dims all present achievement. Only one of many museums where are garnered the art treasures of the world, it is the Vatican which holds more completely than any other worthy examples of the greatest art-epochs of all times.

CHAPTER II.

CHAPEL OF NICHOLAS V.

THERE is little of the atmosphere of the outside
world anywhere in the Vatican Palace. Yet the
quiet that pervades the galleries, museums, and
chapels in this home of the Popes, seems noise com-
pared with the still solemnity of the small room
once the studio and now called the Chapel of Nich-
olas V. So thoroughly do the paintings of that
monk who worked only for the glory of God domi-
nate both the room and those who enter it.

After more than a decade spent in the Convent
of San Marco, Angelico da Fiesole, called lovingly
Fra Angelico, was summoned to Rome by Eugenius
IV. In the spring of 1447, when Eugenius had been
dead some months, the fráte began his labours in
the Vatican. The painting of the study of Nicholas
was preceded by his decoration of the Chapel of
St. Peter, a building between the basilica and the
palace, and which was destroyed less than a century
afterward to give place to the great staircase of
the palace. The frescoes thus destroyed contained

46

portraits of Nicholas V., St. Antonio, and Biondo of Forli.

Upon three walls of the vaulted study of the Pope he painted the histories of St. Stephen and St. Lawrence. The St. Stephen series fill the upper lunette-shaped portions of each wall. They picture his Ordination, his Distribution of Alms, his Preaching, his Defence before the Council, his Expulsion from the City, his Death by Stoning. The lower part of each wall has a scene or scenes from the life of St. Lawrence, corresponding in subject to those above: his Ordination, the Pope Bestowing upon him the Treasures of the Church, his Distribution of these Treasures, his Appearance before Decius, Conversion of his Jailer, and his Martyrdom.

These frescoes, painted when Fra Angelico was already an old man, show nothing of the weakness of age. Instead they are a grand culmination of a life that, using art only to express the joys and solace of religion, nevertheless advanced steadily and triumphantly to complete artistic expression. The most splendid are the St. Stephen Preaching, Martyrdom of St. Stephen, Ordination of St. Lawrence, St. Lawrence Giving Alms, and St. Lawrence before the Emperor Decius.

St. Stephen Preaching shows the saint on a low step that apparently leads to some building near

the city wall. Before him, a company of women sit
listening to his words, while behind them stand a
number of men, as deeply interested. The Gothic
architecture of the background may possibly be
attributed to Benozzo Gozzoli, a pupil of Fra
Angelico. There are, in this composition, twenty-
two or twenty-three figures. And each and every
one, it is not too much to say, has a life, an indi-
viduality, an expressiveness scarcely ever before to
be found in paintings of the early *quattrocento*. The
saint himself, as he stands before his listeners, has
a solidity, a roundness, a reality that might be
credited to that great creator of solid, firmly built
human forms, Masaccio. But he has as well the
grace and charm and spirit that Masaccio never
acquired. These were Fra Angelico's birthright.
This, too, like the rest of the frescoes, abounds in
realistic touches. St. Stephen, gazing intently and
with great persuasion at his audience, has grasped
his left thumb between the forefinger and thumb of
his right hand; a gesture as natural as it is telling,
in marking off the points of his discourse. In the
women seated on the ground there are innumerable
indications of the study Fra Angelico was constantly
making from living models. Though they are all
dressed very much alike, the position of their hands,
the expression of their faces, are as different as
if a modern painter were representing them. There

is, perhaps, a slight sameness in their features. Yet
this does not make them less individual. While all
are deeply engrossed, they show their attention in
varying ways and degrees. One woman has her
hands crossed on her breast, while she gazes at the
saint with her head thrown back, as if she were
drinking from the very fount of the Most High.
Beside her another has her hands clasped, while with
even eyes she follows the words, her whole manner
evidence that each sentence is fraught with deep
personal application. Farther front, nearly in full
face, is one, her hands on her lap, her eyes level,
looking out of the picture instead of at the preacher.
She listens with veneration but with the calmly
quiescent spirit of one who already knows and appre-
ciates the Scriptural pleadings she hears. One of
the most remarkable faces is that of an older, more
closely draped woman, somewhat behind the last
mentioned. Only her head and shoulders can be
seen. But the dark-eyed face hints of trouble and
suffering, and she listens to the words as if her soul
was longing for the help she is sure must come.
The men in the rear are no less striking in delinea-
tion. There is more difference in facial expression,
and their attitudes are full of change and action.
The two men on the left who stand talking together
are especially noteworthy. One is evidently ex-
pounding some precept of the saint, while the other,

wrapped closely in his robe, turns his bearded face in eager attention.

The Martyrdom of St. Stephen fills the other half of the lunette that shows him thrust out from the city. The two scenes are separated by the curving wall of the city with its towers and battlements that recede into the distance against the hills of the background. The figures of the latter division are not up to the best work in the chapel. The characterisation of the faces is still penetrating and distinctive, but there is less happy placing, and the forms are thicker and clumsier, and show less intimate knowledge of construction. On the other side, however, the painter-priest returns to his higher level. At the extreme right St. Stephen kneels in prayer, apparently unconscious of the stones hurled against him, or of the streams of blood that are trickling down his face and neck. As always with Fra Angelico's saints, his halo is well defined, like a round disc, against which his face comes sharply in profile. Behind him are two of his slayers, one, an old man who, holding his garment away from his feet with his left hand, is about to hurl a rock with his other. His hairy face expresses implacable revenge and fanatic rage, and his figure is tense with the concentrated passion of the moment. In front of him a younger, equally vigorous figure, has just discharged one of the stones that is crashing against the

martyr's head. Back of these two stand the Phari-
sees, sternly relentless, conscientiously vindictive.
Prominent is St. Paul, who holds some of the
garments of the slayers. No figure by Masaccio
ever stood more firmly upon the ground or showed
keener sense of what Berenson names " the tactile
values." In almost all the frescoes of the chapel,
it appears quite possible to walk around these well-
constructed figures. They are no mere shells
pasted against a background. They stand upon
firm foundations, and behind them is a real distance,
with ample room between. The figure of St. Paul
has these attributes in a marked degree. The
painter, too, has portrayed him so well that it is
easy to see how that sturdy, uncompromising per-
sonality became afterward the fervid, compelling
apostle.

Next to the St. Stephen Preaching comes the
scene before the Council of Jerusalem. The judge
in white on the throne-like bench is splendidly con-
ceived; the folds of his ample mantle have the
dignity of the antique.

In the Ordination of St. Stephen, Peter is bending
over the kneeling saint before six disciples. The
nave and transept of the church in the distance
are excellent in proportion, and of a good style.
Until very late in his artistic career, Fra Angelico
had paid little attention to perspective, — painting

with a flatness like the Japanese or early Byzantines. Here he turns away from all this and gets effects of distance and proportion as accurately as if he had always been striving for them. Time and restoring have greatly injured both St. Stephen's Expulsion and his Martyrdom.

St. Stephen Giving Alms is pathetic and lovely in the extreme. Standing on the steps of his church, he slips a piece of money into the hands of a young mother. She is draped in flowing robes that accentuate her graceful femininity. A clerk is behind the saint and near the mother is an older woman entranced in prayer. Others press forward for their share of the charity, and at the right two women depart and commune with each other. Fra Angelico here, as in the companion to this, St. Lawrence Distributing Alms, succeeded in showing poverty and frailty without arousing dislike or shrinking in the spectator's mind. He emphasises instead the joy of giving and the thankfulness of the receiver, and fills the picture with a tender feeling for helplessness that does not obscure the excellent pictorial effects of the composition.

In the Ordination of St. Lawrence by Sixtus II., which is much damaged, the Pope, with the tiara, is seated in a basilica of a late classic style. Before him kneels the young deacon, to whom he is handing the patten and chalice. Seven or eight ecclesiastics

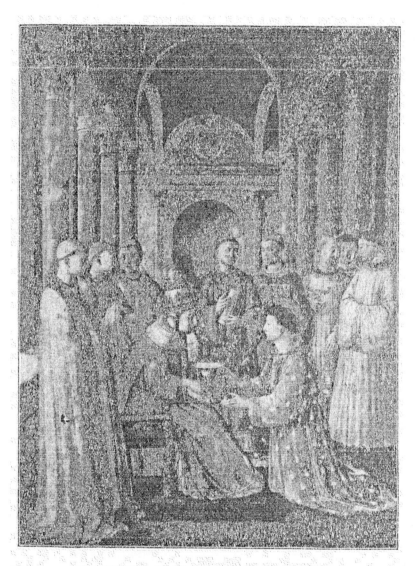

ORDINATION OF ST. LAWRENCE BY SIXTUS II.
By Fra Angelico; in the Chapel of Nicholas V.

surround them. One bears a book, another a censer, another an incense boat. But they are of slight character and generally uninteresting. It is upon the Pope and the kneeling saint that the painter has spent his chief efforts. The grave old man and the eager young priest are worthy of closest study. Here, too, as in the St. Stephen, the Pope is a portrait of Nicholas V.

The panel of St. Lawrence Receiving the Treasures of the Church has a complicated but correct architectural background. The two soldiers at the door are realistically portrayed and full of action, if slightly twisted in construction.

It is in the mate to this, however, St. Lawrence Giving Alms, that Fra Angelico's power is at its height. Standing in front of the nave of a basilica, the saint is surrounded by a pleading, importunate, but cheerful crowd of beggars. In spite of infirmities and needs of all description, they express in every line their confident belief in the generosity of the giver. The mother holding the child close in her arms might almost be the model for one of Fra Angelico's Madonnas. Like one of his saints, too, is the old man with the long beard, who is bending forward and leaning on his cane, while he claims his share. Two little children, one of whom already has his gift, are clasping arms in great content, the childlike naïveté of their expressions being no less

true to childhood than to Fra Angelico's art. The architectural background is exact in its lines of perspective, and the delicate ornaments of the pilasters and capitals are exquisitely indicated. On the whole, this may be called the most remarkable of all of Fra Angelico's works. He shows in it his enthusiastic study of the antique, his no less earnest consideration of the human form, and at the same time his own deep spiritual power, and that delight he took in making his religious ecstasies intelligible to his day. It is indeed the culmination of much of the best art of the early *quattrocento*.

In the St. Lawrence before Decius, he has the most florid of all his architectural accessories. The emperor is seated upon a throne in an apse-like recess, on either side of which are two pilasters with Corinthian capitals. The entablature over the arch runs along on the same level over a wall flanking the canopy on each side, this wall also divided by Corinthian pilasters placed at even distances. In front of it a rich brocade hangs loosely, and above, on each side of the attic of the canopy is a large flat bowl full of flowers. In Decius, who sits upon his throne " for all the world a king," is a certain sense of aloofness. His eyes are downcast and do not look at St. Lawrence, who faces his accusers squarely. All about are the populace, drawn with much variety of detail and attitude. The head

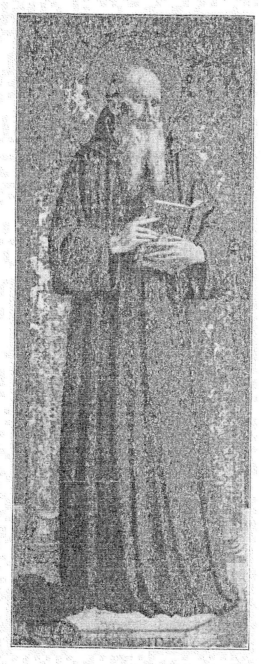

ST. BUONAVENTURA

By Fra Angelico; in the Chapel of Nicholas V.

of Decius was undoubtedly copied from a Roman
bust.

The Martyrdom of St. Lawrence is greatly in-
jured, but the figures are clearly differentiated and
strongly expressive.

Throughout the series the colour has of course
undergone the usual vicissitudes. Many portions
have been repainted, more have suffered from damp-
ness and corrosion. In spite of everything, however,
there is still much of the simple brilliant tones Fra
Angelico loved so well, and that gave to his heavenly
scenes a lightness and freshness unexcelled by any
other master of his time.

Between the lower series of frescoes, on the pilas-
ters, are painted saints, standing in niches. These
are SS. Anastatius, Leo, Thomas Aquinas, Ambrose,
Buonaventura, Augustine, John, Chrysostom, and
Pope Gregory the Great. Of them the Buonaventura
is the most celebrated. The slender, ascetic hands,
clasping the open book, are as full of character as
is the benignant head, with its kindly introspective
eyes, its firm, generous mouth, its flowing, forked
beard. It is probable that the painter-monk was
making a portrait of some dear friend, so sympa-
thetic and intimate is the treatment.

In the vaulting are the four Evangelists with their
symbols, against an azure golden-starred sky. St.

Matthew has his book and pen, and an exquisite little angel with clasped hands is standing beside him.

St. Luke, whose wide forehead is widened by his lack of hair, also has a book and pen, and near him kneels the ox. The face is wonderfully expressive of the physician side of the apostle.

St. John is shown with the eagle, his face not strongly unlike Buonaventura.

St. Mark appears with his lion watching by his side, while the apostle with bent head and eyes busily writes in the volume on his knee.

To quote the American editors of Vasari's " Lives," " The scenes in the lives of Stephen and Lawrence in this chapel . . . do not suffer greatly even in their close juxtaposition with the Stanze of Raphael." In this nearness they " are like the *plein chant* of the mediæval Church beside the chorded melodies of Palestrina." " . . . Consider the very early epoch of Fra Angelico, and that he was well known even before Masaccio began the frescoes of the Carmine, and it must be admitted that here, in spite of his self-imposed limitations, was one of the greatest masters of the Renaissance."

CHAPTER III.

THE BORGIA APARTMENTS

THE Appartamenti Borgia of the Vatican are directly under the Stanze of Raphael. These rooms, so elaborately decorated by Pinturicchio for the Borgian pontiff, were deserted by Julius II., and for four hundred years were allowed to fall into neglect. In 1816, after the return of the papal treasures by France, they were taken for the picture-gallery. The light was so bad, however, that the paintings had to be removed, and the suite was then made into a miscellaneous museum and library. In 1891 Leo XIII. began their restoration. By that time the plaster in many places had been cracked and destroyed, and during the time of Pius VII. a varnish was applied to parts of the ceiling, which made a kind of crust. The restoration, carried out under the direction of Signor Lodovico Seitz, was confined to repairing the plaster and stucco, and to cleaning the frescoes from dust and damp. In some parts of the fifth and sixth halls, stucco has been taken from the walls, and the walls then re-

constructed and the surface "refixed." But it has
been done so exquisitely that no mark is observable,
and fortunately retouching, with some trifling excep-
tions, has not been allowed. What repairing there
is dates from the time of Pius VII. This, of course,
so far as the actual panel paintings are concerned.
The purely decorative part, especially of the lower
walls, was in such bad condition that it had to be
completely renovated. When possible the fragmen-
tary remains were closely followed, and if they were
wholly lacking appropriate hangings have taken their
place. These minor decorations form a tremendous
study in themselves, and are particularly interesting
because it is so apparent that the artist superintended
every bit of the work, ordering the marble mantels
and cornices, the wainscoting, and even the porce-
lain flooring to suit his colour plan. The rooms
were reopened to the public in March, 1897.

Ehrle and Stevenson in their splendid volume
show very clearly that it is only with the second
of the Borgia apartments that Pinturicchio's work
commenced. The rooms occupied by Alexander VI.
for living purposes were the Hall of Mysteries, the
Hall of Saints, that of Arts and Sciences, and the
two "withdrawing" rooms. There were thus five
rooms which probably took Pinturicchio about three
years to finish. His superintendence is evident in
every one. Undoubtedly he had assistants, and

many of them, but his vigilance must have made
him nearly omnipresent. His oversight was so
careful that nowhere is there any break. They are
his own, not only in design and placing, but largely
in actual execution. Probably the marble work
is by Andrea Bregno, who was with Pinturicchio in
the Sistine Chapel.

The glowing yet subdued beauty of the rooms is
like a brilliant flower bed seen through a filmy haze,
the colours swimming and melting and absorbing one
another till there is a bloom that, rich, resplendent,
is far removed from even a suggestion of garishness.
The chambers are square, not very high, and slightly
vaulted. It was in the Hall of Arts that the first
husband of Lucrezia was murdered. In the next
the Pope died in terrible anguish.

The first room, the Hall of the Pontiffs, which
Ehrle and Stevenson claim was never painted by
Pinturicchio, was at any rate entirely redecorated in
the time of Leo X. by Perino del Vaga and Giovanni
da Udine. Though the scheme of the ornamenta-
tion leads easily into the following rooms, it is
much inferior to them. In the vaulting are frescoes
of the constellations, with a heavy stucco work there
as well as on the walls. The tapestries below repre-
sent the myth of Cephalus and Procris.

In the Hall of the Mysteries, the first of the Pin-
turicchio series, are seven principal paintings in the

lunettes made by the lines of the vaulting: the
Annunciation, the Nativity, the Adoration, the
Resurrection, the Ascension, the Descent of the
Holy Spirit, and the Assumption of the Virgin. All
these are simple in the extreme, of a peaceful, poetic
character, with the figures drawn on the quiet, con-
ventional lines suited to the demands of the Church
of that early date.

The Annunciation is considered to be wholly by
Pinturicchio. In a stately hall of rich ornamenta-
tion, Mary is kneeling on a tesselated floor, a vase
of roses between her and the angel carrying the lily
branch. Through the central, imposing, triple arch-
way, an attractive Umbrian landscape is seen.
Above, in the sky, the Eternal, surrounded by
cherubs, sends the dove of his Spirit to the kneel-
ing maiden below. The colour is as charming and
restful as the drawing is simple and graceful, the
sentiment reverently religious. The angel's robes
are a rose-pink, Mary's an exquisite combination of
peacock blues and greens. There is over the whole
a delicate suffusion of colour as fascinating as it is
softly luminous. Here as everywhere, parts of the
composition are picked out in gilded stucco, that,
after the toning of hundreds of years no longer
obtrudes or overaccentuates.

In the Nativity, the Virgin and Child are cer-
tainly by Pinturicchio himself, though there is evi-

dence of pupils' work elsewhere in the picture. The baby Christ lies in the centre foreground on a cloth thrown over a bunch of hay or straw. At some distance kneel Mary and Joseph, in adoration. Projecting from one side are the pillars and thatched roof of the stable, over the wicker manger of which an ass and a cow look out with wise, questioning eyes. Slightly back of Joseph two charming angels are also kneeling, and above in the golden starred sky are other angelic messengers, three of them grouped together holding a scroll. The landscape is similar to the one of the Annunciation, with trees and roadways, hills and distant castles.

Schmarson attributes the Adoration of the Magi to a Lombard, with the exception of the boy standing on the extreme right at his horse's head. He is thought to show the hand of a pupil of Botticelli. Mary, tender and sweet-faced, sits on the porch of a building that, though tumbling into ruins, still retains elaborately carved pillars and arches and cornices. At her side stands Joseph, leaning on his staff, and in front are the Eastern kings, with their numerous followers. There is some careful study of the faces of these old and young men, but both in the drapery and in the build of the figures beneath there is much less knowledge displayed than in the best of Pinturicchio's work. The landscape is again Umbrian, sharp hills in the distance and a

mass of ruins in the foreground. In the sky two
angels fill the upper part of the lunette, rather too
fully perhaps. The child, standing on Mary's knee,
is unusually poorly constructed and modelled.

The magnificent figure of the Pope kneeling at
the left of the open tomb in the Resurrection is what
saves that fresco from intense archaism. Though
the guards in armour opposite him are full of spirit,
they are angular in construction and of laboured
foreshortening. Christ, in mid-air over the tomb,
stands on a cloud, an elliptical golden glory com-
pletely encircling him. This glory is of golden
stucco of innumerable round spots, over which raised
golden flames are splayed. His right breast, shoul-
der, and arm are uncovered by the voluminous
drapery that leaves his left leg from the knee down
fully exposed. He is imperfectly conceived and
weakly drawn. Far and away from the knowledge
and authority of the hand that painted the Pope.
This pontiff is so entirely draped by his magnificent
brocaded jewel-bordered robe that only his head
and hands are free. Even his short neck is nearly
swallowed from sight by the heavy collar. Yet the
figure beneath this swathing is almost as clearly felt
as if Michelangelo himself had painted it. Not an
unnecessary fold is there, either, in the gorgeous
papal costume as it hangs straight from the thick
shoulders. It is in the face and hands, however,

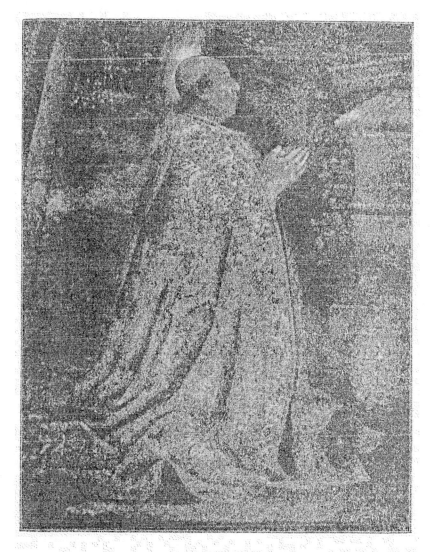

ALEXANDER VI.

Detail from Resurrection, by Pinturicchio; in the Hall of Mysteries

that the artist reveals himself as a portrait painter
of high rank. The face is in direct profile, — a posi-
tion that shows as little as may be the fat cheeks
and extra layers of flesh running from cheeks and
chin to neck. But a square full face would not
more truly have given the character of this Borgian
pontiff. An insufficient, sloping forehead, full eyes,
too close to the nose, which is large and with a high
Roman arch to it, long upper lip over a heavy lower
one, a chin that leads by one diagonal line without
a curve into the wide, short neck, a most abnormal
development of the lower back part of head and neck,
— these are the salient points of this portrayal which
can be no caricature. For it must have pleased the
Pope, or it would not have remained on the walls,
and perforce it must have done him full credit.
The hands with their smooth taper fingers would be
nearly ideally perfect, if the flesh had not made
them puffy. Not the kind of hands likely to be
found on a strong, noble man, but of charming line
and colour for a — soulless dilettante perhaps.

In the arch above the window is the Ascension.
Here once more is the Christ with the flame-raised
glory behind him in very similar position to that of
the Resurrection. It is also an equally weak, ill-
drawn figure, and indeed the whole scene lacks the
fresh spontaneity of many of the others. Around
Christ in the sky is a border of cherubs, with still

more beyond. Of the two angels who are kneeling beside the Redeemer, the one on the right with slashed sleeves and robe is especially lovely, showing a charming feeling in the praising hands and the fair, downcast face. Below this heavenly division is an expanse of sea bordered with fields, pompon-foliaged trees, and hills, and castles. Here are Mary and the apostles. Some of the younger heads remind one of Botticelli, especially the one in the background on the right. There is considerable attempt at characterisation, but they do not make at all homogeneous groups. The colouring in this, as in all, is restful in its blues and greens, enlivened without being sharpened too strongly with the gold.

The Descent of the Holy Spirit has suffered much from the damp and restoration. The scene is in an open field, with background similar to the land-scapes of the other spaces. In the clouds above, surrounded with golden rays and a dozen or more cherub heads, is the dove with outspread wings. Below, with Mary kneeling in the centre facing the spectator, are the disciples again. If possible, they are even less successful than in the Ascension.

The last one of the large frescoes of the room is the Assumption, and it is a rarely beautiful work. There are certain parts which recall Perugino, but it is probably by Pinturicchio's own hand. Above the open, rose-filled tomb, Mary is being borne

heavenwards. She is sitting with prayer-laid hands in the centre of the usual elliptical, golden glory, bordered with cherubs. Over her head two graceful angels hold a crown and the pendant jewelled ribbons. Below these, with their feet resting on clouds, are four angel musicians. One plays a guitar or mandolin, one a violin, one the triangle, and the fourth the tambourine. Their positions and draperies are as effective as some of Raphael's own conceptions. On the left of the tomb is a saint with aureole, the face turned up till it is strongly foreshortened. The excellent drawing of the hands, the full, heavily folded drapery with its narrow golden edges, the intent, earnest expression, and the feeling for bone and muscle in the whole figure make this a very remarkable accomplishment. Even stronger and more vigorous is the black-robed man facing him. In its sharp delineation and unflattering truth it is evidently a portrait. It is splendidly modelled, firmly and knowingly constructed. This with the Pope is enough to mark Pinturicchio as a really great portrait painter.

In the vaulting of the room are eight medallions with figures of prophets. These are surrounded with lines and squares of ornament made of arabesques, curves, and scrolls, with everywhere the conventionalised bull and the arms of Alexander VI. It is a wonderfully beautiful and harmonious

effect of exquisite tone, the blues and greens and chocolate shades almost dissolving into the gold. The bull, so frequently appearing, was a device belonging to the Borgia family from the thirteenth century.

A marble doorway with a lunette above, in which two delightful *putti* bear a shield, leads to the Hall of Saints. There the decoration is much more ornate, inventive, and imaginative than in the preceding chamber, and in the paintings there is far more action, better grouping, more poetic feeling, and lovelier colour. The principal frescoes, besides the legends of the saints, are scenes from the Old and New Testament.

Over the door is Susannah and the Elders. In the centre of the lunette a boy holding a dolphin is perched on the top of a fanciful fountain enclosed in a little rose-bordered garden. Within the plot are various animals, — a stag, hares, a monkey on a gold chain, a doe. In front, a little to the left, stand Susannah and the two elders. Her position is that of the Venus of Milo, reversed. With her white clinging garments that fall in unbroken, simple folds, she is as lovely a creation as can be imagined. Quiet, reposeful, though an elder grabs her furiously by each arm, she is entirely unafraid and unexcited. The modelling of her face and arms and hands is fine, soft, and delicate, her figure is

beautifully drawn, her face winsome. The two
elders are executed with energy, and are full of
character. Beyond, on the left, the maiden is again
seen, hurried to execution by guards in fifteenth
century costume, while slightly behind her Daniel
prances up on a white steed to intervene in her be-
half. On the other side the elders, bound to a tree,
are being stoned to death. Even a small child is
throwing with all his might as big rocks as he can
handle. The landscape is painted with a fascinating
minuteness, that, though making each part in itself
enchanting, has spoiled the coherence of it as a
whole.

The next panel to this represents St. Barbara's
escape from the tower where her father has con-
fined her. The tower itself, not altogether a happy
piece architecturally, occupies the centre of the pic-
ture, and displays on its side the big break that
furnished the way of escape for the young saint.
At the left, with her fair hair and draperies flying,
St. Barbara, calling upon Heaven for help, has just
fled through the opening. Her father, with scimiter
in hand, is hunting for her in the wrong direction
on the other side, while of the two guards behind
him, one apparently sees the fugitive, and is glad
of her release. In the distance, her hand clasped in
her protector's, Santa Giulia, the young saint has
got beyond her pursuers. Opposite again, the

father is interrogating a shepherd, and this unfortu-
nate, evidently confessing to having seen her, is
turned in consequence into marble. To convey the
idea he is painted all white. The landscape back-
ground adds to the naïve gaiety of the picture.
The bright colours and charmingly flowered fore-
ground, the delicate, dainty saint, give an unreal,
fairy-like effect to the whole scene.

Facing this is the lunette holding the visit of St.
Anthony to Paul the hermit. It is one of the most
successful of this highly successful set. In front of
a tall, rocky, natural archway, the two saints are
breaking the loaf which the raven has brought.
Behind the hermit are two disciples in white robes,
and behind St. Anthony three demon women. They
are extravagantly dressed, but, except for their bat-
like wings, horns sprouting from their towering
head-dresses, and claws instead of feet, they might
be merely fashionable women of the world. The
last of the three, with head thrown back and hands
pressed against her waist, is really a lovely figure,
with a piquant, childlike face. St. Anthony is
scrupulously drawn, his robes splendidly handled.
The hermit and disciples seem to show the brush
of a pupil.

The Visitation has a delicate, pervasive charm
that is hard, perhaps, to localise or fully explain, yet
which is the very heart of the picture. Florid, light

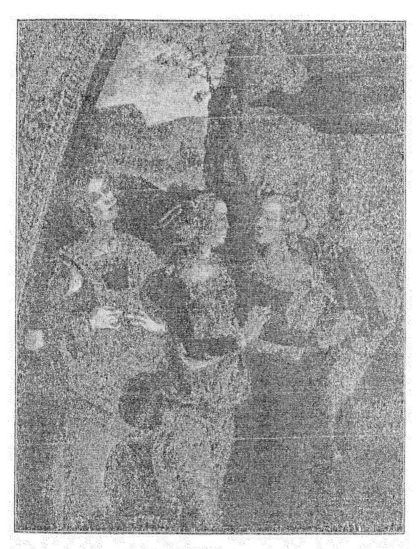

DEMON WOMEN

Detail from Visit of St. Anthony to Paul, by Pinturicchio; in the
Hall of Saints

architectural forms, open arches and loggie above,
fill up a large part of the space. In front, clasping
hands, stand Mary and Elizabeth, the younger's
head and eyes down, Elizabeth gazing at her with
the intent, piercing look that all the old painters
give her. They are dressed in the conventional
blue and green robes, and each is capitally drawn
and modelled. The calm, peaceful dignity of Mary
is especially well indicated. At her side Joseph
leans upon a staff, and behind him appears a train
of children and pages. The other half of the com-
position carries the most charming group of all.
Zacharias, backing up against one of the pillars, is
reading, oblivious to all that is taking place before
him. Under the arches a number of maidens and
elderly women sit spinning and embroidering, while
behind, a girl holds a distaff, and a child plays with
a dog in the foreground. The figures are well
drawn and grouped, and they all have that soft,
restful beauty that seems particularly " Pinturic-
chiesque." The gradations in the landscape, the
softened colours of the distance, combine to make
this one of the most satisfactory of the sequence.
Here, as in every room, the light is so bad that it
is very difficult to get any good view of the frescoes.

It is particularly hard to see the Martyrdom of St.
Sebastian, which in some ways is the most vigorous
and displays the most knowledge of all. Strapped

with his hands behind him to a pillar in the centre
of the big lunette over the window, is Sebastian.
His head and eyes are lifted upward, and he seems
to see the angel who, in the sky, brings him hope and
comfort. The solidity and excellent modelling of
forms of this nearly nude figure are almost unex-
pected from the hand of such a *quattrocentist* as
Pinturicchio. On either side the archers are shoot-
ing or stringing their bows, all in leisurely unemo-
tional attitudes, suggesting, as has been said, a
jovial shooting-match rather than an execution.
One archer on the right stands with his bow resting
on the ground, his eyes turned to the sky, perhaps
to indicate regret for his part in the tortures. All
the figures are spirited, one of the best being the
archer back to on the left who is just about to let an
arrow fly. The landscape proves that Pinturicchio
studied the Roman surroundings. In the distance
is the Colosseum, to the right a church, and in front
a broken marble column. It was the first time that
any artist attempted to render the sad beauty of
the Roman landscape.

The principal wall of this room has the finest
of all Pinturicchio's works. It is called the
Dispute of St. Catherine, and shows her in an out-
door court before the Emperor Maximian and
fifty philosophers, to whom she declares her beliefs
with a serenity and poise unequalled. The centre

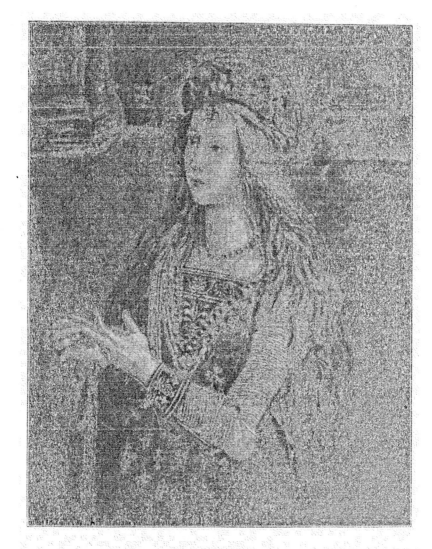

ST. CATHERINE

Detail from Dispute of St. Catherine, by Pinturicchio; in the Hall of
Saints

of the lunette is taken by the Arch of Constantine,
crowned by a golden bull. In front of this are the
doctors and philosophers and princes and their reti-
nues, pages, and children, and the emperor on his
richly ornamented throne. Here Pinturicchio's
fancy has revelled with a joyous abandon, a riotous
floridity that yet never becomes meretricious.
Robes are heavily embossed and embroidered, and
edged with gold, trappings of horse are jewel-
studded, the ground is covered with delicate, starry
flowers, the very trees are blossom-laden. The
emperor sits in untroubled judicial attitude on his
throne at the left, with a crowd of courtiers behind
him. Directly in front is the slender, youthful,
beautiful Catherine, the rest of the great assemblage
filling nearly the whole of the remaining space of
the lunette. Some are searching their books, some
are instructing their pages to look for certain notes,
some are merely listening to the young saint's dis-
course, while others are discussing among them-
selves. Of all the young and old, children, horses,
and dogs, St. Catherine is the only woman in the
whole congregation. Straight, willowy, undismayed,
robed in a magnificent brocaded gown, her long,
fair hair hanging to her waist, she is marking
the points on her fingers. There are many portraits
among the crowd; in fact, it is probable that a large
part of the heads are representations of what were

well-known personages. At the extreme right is one
of the most noticeable figures of all, a Turk on a
white charger. He is so much in the foreground that
he and his steed almost dominate the scene by their
size and brilliancy. The horse, splendidly modelled,
the gorgeous saddle-cloth, golden-studded harness,
and the extraordinarily heavy, gold-stuccoed dress
of the rider, all combine to make the two of startling
prominence. He is supposed to represent Prince
Djem, son of Sultan Mohammed II. Catherine is
thought to be a portrait of Lucrezia Borgia, the
famous daughter of Alexander VI., whose beauty
has been extolled as noisily as her crimes. If this
looks at all as she did then, when she was about
fifteen, there certainly was nothing to indicate in
face or figure the wickedness with which she was
afterward charged.

The ceiling of this room is as worthy of careful
study as the more prominent wall frescoes. Unfor-
tunately, besides the necessity for either standing
on one's head or constantly using a mirror to see
these vaulting decorations, the light is so bad that
to obtain any adequate idea of them is extremely
difficult. Divided by the framing bars are eight
large, triangular spaces, in which are scenes illustrat-
ing the myth of Isis and Osiris, which, because of
the history it contains of the deification of the bull,
was undoubtedly chosen to symbolise the exaltation

of the house of Borgia. The whole ceiling is a
maze of golden stucco work intermingled with the
paintings, even the separating bars being marvels of
intricate decoration. The first of the divisions
devoted to King Osiris shows him ploughing with
bulls, and teaching the Egyptians to plant orchards .
and vineyards; then comes his marriage to Isis; in
the following the warriors throw their unused
armour into a corner, while a fat *putto* is astride a
swan, — this last undoubtedly copied from a recently
discovered antique; the wicked brother persuades
the Egyptians to mutiny; farther on poor Isis finds
the scattered legs and arms and body of her mur-
dered husband; next comes his burial; after that
a pyramid is erected to him; finally his apparition is
deified in the form of the bull Apis; and the history
ends in a procession, with the bull borne in triumph.

The whole room is an entrancing vision. It
appears that certain parts of the execution, espe-
cially in the smaller designs, were left to Pinturic-
chio's assistants. But he undoubtedly was the origi-
nator of the designs, and his presence as supervisor
is more strongly marked all through this room than
in the Hall of the Mysteries. It is of all the suite
his masterpiece.

A round medallion of the Mother and Child is
over the doorway leading into the Hall of Arts and
Sciences. The Madonna, with her clear eyes, deli-

cate mouth, and rather long nose, was evidently studied from life. She is apparently the one whom Vasari calls a portrait of Giulia Farnese, the Pope's mistress. But his claim that Alexander VI. was kneeling in adoration before her seems to be without foundation, for no third person was ever painted within the circle. The child is daintily constructed, dressed in a tunic to his knees, intent upon his book. Altogether it is a lovely group, and adds to the long list of triumphs for Pinturicchio. The background is gold, and the borders of the robes and even the high lights are of the shining colour.

The ceiling of the Hall of the Arts and Sciences is more conventionally mechanical in design, but is extremely soft and harmonious in its spacing and colouring. A great central octagon fills a large part of the vaulting, most of the remaining portions being taken by two triangular divisions on each side. What is left is given over to borders and panels of ornament, in which grotesques are sparingly used. Every part is treated minutely, and is full of rich, conventional designs, yet each keeps its place in the general scheme. In the centre of the octagon are the arms of the Borgia bordered by radiating sun rays. Everywhere the sign of the family, the bull, appears. The wide architrave has octagonal medallions joined by oblong ones representing the virtue of justice and other sacred and legendary scenes.

They have been so badly hurt by damp and restoration that there is little left of their original state. In fact, the whole of this room has suffered more from time than any of the others. Some of the scenes have been almost wholly and very badly repainted.

Each of the seven principal panels on the walls contains a woman on a high architectural-backed throne. About the base are the disciples of the art or science which the throned woman personifies. Beyond is a softly tinted landscape, with a blue and gold embossed sky. These calm, thoughtful, contemplative beings are far removed from the world. They are the very spirit of the art or science they typify.

Rhetoric is a graceful, youthful figure, holding a sword in one hand and a globe in the other. These same emblems are in the hands of two stocky little *putti* on each side of the platform on which her feet rest. Above, two other *putti* hold the drapery over the top of the throne. Three men stand on the left and right, one of whom on the left may be meant for Cicero. There are traces of Perugino's style in this painting, and it is very possible that Pinturicchio took some of the figures from drawings he had received from Perugino. Rhetoric is unusually lovely, with soft hair falling away from her face, and with a bright look in her questioning eyes. The drapery, too, is well massed.

Geometry sits more nearly full face, holding her
square and compass. There are no *putti* in this
lunette, and their place is taken at the foot of the
throne by the bald-headed Euclid, dressed in red,
drawing a diagram. In the extreme left corner is
a figure, which is probably a portrait of Pinturicchio.
Several of the disciples about Geometry's throne
show pupils' rather than Pinturicchio's hand.

The loveliest of all these personified arts and
sciences, perhaps, is Arithmetic. She has a certain
weary air, and a pensive wistfulness about her long,
delicate face that somehow add to its attractiveness.
In the turn of her neck and head she is reminiscent
of Botticelli's figures, but there is much less strain
of muscle and much less of that painter's anæmic
look. The transparent veil half covers the hair that
falls over a beautiful gold-embroidered robe, hang-
ing in softly indicated folds. The figures standing
near the throne are vividly drawn, and their robes
are as carefully painted as their faces. Here are
the colours Pinturicchio so delighted in, the rich
pinks, dull blues, and soft greens. Here also is a
real attempt at massing the light and shade.

Another delightful creation is Music, though
with not quite the delicate bloom of Arithmetic.
She is playing upon a violin, her lids drooped, a soft,
introspective smile upon her lips. Her head-dress,
with the knots of thin drapery over her ears, recall

Botticelli again, and perhaps even more strongly, Perugino. There are four charming *putti* in this group, two standing on the steps at her feet playing flutes, while two above hold up the rich green drapery. Tubal-cain, forging musical instruments, and two other old men are on the right, while on the left are seen three joyous boys, one playing a harp, one a lute, and one singing. Through all these groups are a charming spontaneity and unity, and one feels a gaiety and pleasure in them, as in few other paintings of the *quattrocento*.

Astrology is badly damaged. The restorations make it practically impossible to tell what was Pinturicchio's part in it, but it seems doubtful if any of it was worthy of him. The four *putti* who hold wands with the signs of heavenly bodies on their tips are too heavy and clumsy for the charming babies he could paint so well. Equally unhappy are the groups on each side who, separated from the principal figure by the rocky landscape, have no connection with the scene in which they were placed.

Grammar and Dialectics are also both badly modernised. The period of this flagrant retouching, judging from the dragon by the side of the central octagon, and which is probably the crest of the Buoncompagni, was therefore in the pontificate of Gregory XIII.

Between Rhetoric and Geometry the Borgia

scutcheon, surmounted by the keys and tiara, is set in a stucco frame, supported by three full-length angels. The grace and freedom of their figures, the rhythmic lines of their flying draperies, and the excellent drawing make this as beautifully perfect and decorative a group as there is in the whole set of rooms.

The next two chambers, which are alike in architecture, are those called the " withdrawing rooms." They are far more simple in decoration than the others.

The first has a ceiling of geometrical designs and grotesques, below which is a frieze of twelve half-length figures, two by two, of apostles and prophets. Each prophet holds a scroll with a prophetic saying, and the apostles carry one with a sentence of the creed upon it. A mediæval legend credited to each apostle one sentence of the creed, and each is here supposed to hold the one originated by him.

In the second room sibyls are paired with prophets, each pair surrounded with ribbons upon which are written the early prophecies of the Church, concerning the birth of the Redeemer. These ribbons are treated in a decorative way to fill up the spaces, and were traditional with painters of the fourteenth and fifteenth centuries.

The figures in these two rooms are much restored, and, compared with the earlier ones, stiff and archaic.

A few of them, however, have the Pinturicchian
head-dress and gestures, as well as certain lines and
folds of the drapery characteristic of him. Zach-
arias has a noble face with heavy tumbled hair, and
is not an unworthy predecessor of the mighty ones
of the Sistine Chapel. Though these halls are not
up to the grand scale of the others, they show a
coherency and a harmony that make them an inte-
gral part of the whole. In the window recesses of
the Hall of the Creed are marvellous decorative
schemes, where fishes, masks, fauns, cupids, flowers,
and musical instruments are mixed and mingled and
twisted, with astonishing ingenuity. It was in the
Borgia apartments where were first used the gro-
tesques and fanciful borders afterward so exten-
sively and masterfully employed by Raphael in the
loggie.

In these rooms, the triumph of Pinturicchio, in
spite of all the limitations and defects of his art,
he shows " a self-restraint and a feeling for effect
which are unerring, he hits upon the exact size, and
keeps the composition exactly within the picture, and
at the right distance from the eye." They " are a
rich yet unobtrusive setting, they do not compel
your attention, but only give the impression of a
refined splendour of surrounding, of a marvellous
insight into beautiful harmony of colour. The effect
of the light has been so nicely calculated that even

when freshly executed, the walls would not have been overbrilliant for the brilliant scenes to which they formed the background." " Everywhere we are aware of the vigilant and sensitive grasp of the master's hand upon his tools, and allowing for all shortcomings of detail, we cannot but feel that here we have an enviable monument for a painter to leave behind him."

In the Stanze one is in the presence of an art that is clear, sane, and gloriously happy, full of the spirit of life itself. The Sistine breathes a very different atmosphere. Grand, majestic, awe-inspiring, telling of the life of the soul in the travails of a weary world, are the messages that come to us here. Neither of the world of flesh, of mind, nor yet of soul, the frescoes of the Borgia rooms exhale a delicate, evanescent perfume that comes straight from the realms of phantasy, full of the glimmer of will-o'-the-wisps and dancing fireflies, from the over- or under-world of elves and sprites and fairies, of genii and dancing loves.

CHAPTER IV.

THE SISTINE CHAPEL

JACOPO PONTELLI, a Florentine, has generally
been credited with being the architect of the Sistine
Chapel, built about 1473. Müntz, however, brings
forward some late discovered documents from the
archives of the Vatican that seem to show that not
Pontelli but Giovanni de Dolci was responsible for
the edifice. Whoever the builder, the constructional
lines of this world-renowned chapel are not in them-
selves beautiful or scientifically exact. The vault-
ing is irregular, the lighting insufficient, and the
general proportions insignificant. The decorations
alone are what have made this small sanctuary one
of the greatest of the world's treasure-boxes. De-
scribed literally, it is a barn-like, slightly vaulted
room less than one hundred and fifty feet long, and
not quite fifty feet wide. On each side are six
round-arched windows, directly beneath the spring
of the vaulting. Below these, separated by painted
pilasters, are the side frescoes executed during the
pontificate of Sixtus IV. From a cornice running

along the walls below are painted imitations of heavy hangings, the space once covered by Raphael's tapestries.

The twelve side frescoes are of unequal merit, differing schemes of composition, and once must have been of strongly varying colour. Time, ungracious to them individually, has treated them well considered as a decorative whole. The general effect of these twelve works of the *quattrocento* is lofty and surprisingly harmonious. The colours have so faded and blended that now, in their dull blues and grays and greens, they make a wonderfully appropriate and sufficiently unobtrusive setting to the majestic ceiling above.

Besides these twelve panels there are two on the entrance wall, and originally there were as well three by Perugino at the altar end. For the two opposite the altar slight consideration is required. One by Cecchino Salviati represents Michael victorious over Satan, bearing away the body of Moses. The other is the Resurrection by Domenico Ghirlandajo. They were badly disfigured by the sinking of the architrave, and were afterward wretchedly repainted. Above the line of frescoes between the windows and along the southern end at the same height, Botticelli and his assistants painted the figures of twenty-eight Popes. These, though doubtless more or less restored, are practically as they

bunch of trees, rising from behind the well and be-
yond, springs up to the top of the fresco and assists
in drawing the multitude of scenes into something
approaching unity. Regarded from the standpoint
of true composition, this is not one, but many pic-
tures. Yet it is worth remembering that any attempt
for centralisation of composition was not natural to
artists of this day. Botticelli made no effort to pro-
duce what Raphael instinctively accomplished, a well
massed and balanced picture. His desire, as well,
probably, as the command from the Pope, was to
represent as many incidents in one panel as possible,
in order that the story of Moses might the more per-
fectly be told. Considering his aim, he has really
brought together the various moments depicted with
a good deal of skill. The worst thing about it is
the lack of perspective between the figures of the
foreground and those of the background. These
latter are of course inordinately large. When the
separate groups are studied, many of Botticelli's
most delightful, characteristic attributes are dis-
covered. In the scene about the well he shows a
grace, an idyllic spirit, that is remarkably quiet and
serene for a man so often expressing in his works
the intensity of subjective emotion. The procession
of Israelites is no less full of dignity and simple
movement, with individualistic treatment of the
various members. Moses, with his calm gravity,

Aaron intent and serious, the loving mother with her unhappy child, the pathetic little boy carrying his pet dog in his arms, — all are expressive to an intense degree. The colour of the picture is mostly in gray and white, emphasised by the white sheep, the white robes of the maidens, and the gray-white shades of the buildings, the walls, and the roadways. Moses, in the background, is dressed in yellow; in other places his robe is an olive green over a dull yellow. There are many more blues than reds in the fresco, and the sky is a deep indigo, growing white near the edge of the distant blue hills. The foliage of the oak-trees (the device of Sixtus IV.) and most of the landscape are a dark green.

Farther on along the same side comes the Punishment of the False Priests. In the foreground, at the right, Moses, with upraised hand, denounces the one who blasphemed. By his side the offender tries to protect himself from the indignant group of men who are armed with stones. A fire is burning on the centre altar, and gathered round it are the deceiving priests, Korah, Dathan, and Abiram. Before them, Moses with lifted rod calls upon God for their punishment. Already they have fallen back, dropping their censers, one grovelling on the ground. Just behind them, and at the left, Aaron is swinging his censer. Again, Moses bends with condemnatory hand over the defilers of the temple,

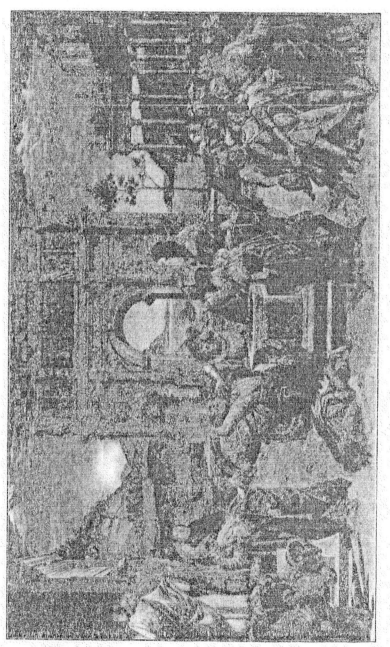

MOSES CALLING HEAVEN'S VENGEANCE UPON THE FALSE PRIESTS
By Botticelli; in Sistine Chapel

while the earth is opening and swallowing the sinners. The centre middle distance has a fine Roman arch going to the top of the picture, at the right is a ruined building with many Corinthian pillars, and beyond a line of sea-broken coast. Here the three episodes are even less connected than in the other fresco. The separate groups, however, are fine, — extreme violent action contrasting with dignified calm. The architectural background is splendidly done, so well that it has sometimes been credited to Filippino Lippi.

Though on the other side of the chapel and called the Temptation of Our Lord, this fresco really deals principally with the Old Testament. In front of the altar erected in the foreground, a young man is presenting a basin to the High Priest. On each side of these two are men, women, and children, bringing in bundles on their heads, or talking to each other, or simply looking on. Somewhat back and at the side of the altar is the leper with open shirt, while a young man carefully examines him to see if the healing has begun. A white-haired man kneels in front of them, guessed to be the leper's father. At the left a woman comes hurrying in, bearing on her head a bowl, within which are two birds covered with a cloth. It is back of all this that the scenes of the Temptation begin. On a high cliff, Satan, dressed in cloak and cowl, points down-

ward, saying to Christ beside him, " If thou be the
Son of God, command that these stones be made
bread." In the next scene Satan has brought Jesus
to the pinnacle of the Temple, supposed to be San
Spirito, and signs to him to cast himself down.
Then, at the right, upon a mountain, Christ stands
with lifted arm, bidding the Devil begone, and the
fiend, revealed in his own true character, throws him-
self down the cliff. After this, angels come to
minister to the Lord. The landscape is used remark-
ably well, and the architectural features are finely
rendered. The fresco as a whole is crowded with
figures, and at the first it seems as if no one and no
group was particularly distinctive. Yet before long
one sees that here and there a figure by its inherent
dignity or grace of line and pose does stand out and
becomes at once so accentuated to the vision that
involuntarily it absorbs one's mind ever after. Such
is the girl bearing the scarlet-bound bundle of cedar
and hyssop on the right. Such, too, is the child at
her feet, who has dropped one of his load of grape
bunches in his fright at finding a snake just curling
about his leg. The group also of the Master with
the angels, on the left, where he points out the leper,
is full of a tender grace and dignity. It is sug-
gested that this theme, the Cure of the Leper, was
chosen in compliment to Sixtus IV., who had built
San Spirito as a hospital for lepers.

It is now believed that of the frescoes once supposed to be by Perugino, only the Delivery of the Keys is really his work. The others, once credited to him, as well as the two formerly supposed to be by Signorelli, the majority of critics assign to Pinturicchio, the painter of the Borgia Apartments.

Of these, the Journey of Moses has as many separate divisions in subject as have the Botticelli frescoes. Nevertheless, it has a certain cohesiveness which these lack, and as a decorative piece it is charming. An angel is in the very centre of the foreground, planted firmly upon wide-stretched legs, his head in profile, his figure nearly back to. Rising up almost to the top of his head, his wings sweep nearly to his knees. Standing there with commanding arm, he forms an effectual break and yet a connection between the group starting on their journey, headed by Moses, and the ceremony of circumcision carried on at the right. Behind, Jethro and his daughters are taking leave of Moses, and farther back still the shepherds are dancing on the green. At this time Pinturicchio painted such landscape as no other man had succeeded in equalling in charm of sentiment or delicate colour. In this panel are the purple-shadowed hills sloping with golden gleams to the winding stream, the soft stretches of field, and the decorative trees, all so characteristic of the prince of landscape painters of the *quattrocento*.

The Baptism of Christ is more crowded with figures, and there is less connection between them. There are again the charming landscape background and the carefully studied groups of portrait-like figures. Indeed, the solidity and firmness of drawing and the enchanting expression of many of the heads are among the best work Pinturicchio ever did. The central foreground group shows John pouring the water upon the head of Christ, a carefully and painfully modelled nude figure. Over the Saviour's head is a dove, and above in the sky the Almighty, completely framed into a round filled with cherubs' heads. The sky is sprinkled with more of these, and on each side is an adoring angel with flying draperies. In the middle distance, Christ is twice shown, both times preaching from a height to enormous crowds surging below. Many people also are watching the baptism, and numbers of these are evidently portraits. They have been repainted so many times, and are now so dark and grimy, that little remains to show what they once were. The charm of the landscape, however, is still felt, as well as the decorative parts of the whole.

The one that has so long been attributed to Signorelli, is Moses Giving the Laws to the People. On the right, raised on a stone platform, Moses, now an old man, reads to a big concourse of the Israelites. Here are interesting, characteristic faces and

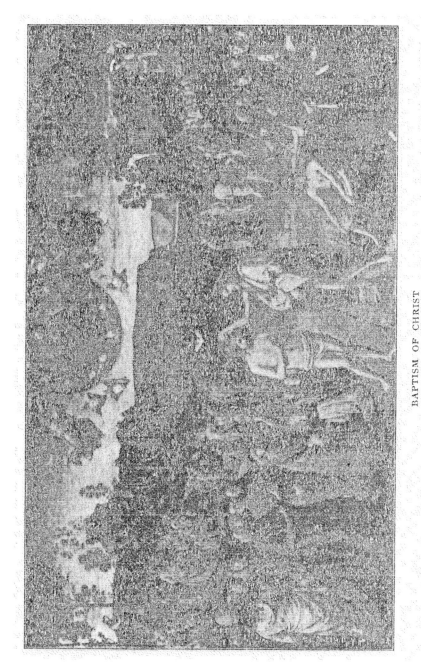

BAPTISM OF CHRIST
By Pinturicchio; in Sistine Chapel

carefully studied forms, all executed with the technical knowledge that Signorelli alone of that age was supposed to possess. ·Almost merging into this crowd at the left, Moses, surrounded by the elders and leaders, gives over his command to Aaron, who kneels in heavy-hearted reverence before him. Behind the central assemblage, Moses has been shown the distant promised land, and, leaning heavily upon his staff, is just turning from the directing angel. There are great pathos and originality in his fine old figure, as with bent head he goes down the hill. Rarely lovely, too, is the angel above showing the tottering old man the land he is never to reach. Finally, at the left, with only the sky and a few scattered trees for background, they are laying the faithful servant to his rest. Throughout the whole of this composition the individual groups are full of a feeling that never lacks inherent strength.

As a composition, Christ Giving the Keys to Peter is considered to be Perugino's greatest work. It is as coherently arranged, is within as definite lines, and carries the eye of the spectator straight to what is intended for the central, and is the all-pervading idea of the picture, as any of Raphael's own works. In front of Christ kneels Peter, receiving the key. The deep fervour of the disciple, the splendid fall of his drapery, the careful study and rendering of his figure, are all wonderfully ex-

pressed. Even more remarkable an achievement is
the Christ. The lines of his drapery are incredibly
beautiful. The big, simple, wide spaces that lead
into the deep shadow-making folds are emphasised
by the lighter half-tones of the less marked plaits.
The poise and swing of the figure are grandly noble,
the head pathetic and full of the soft beauty of the
Christ-ideal of the fifteenth century. On each side
of him are the apostles, and beyond them others.
Behind, the pavement of the Piazza of San Pietro
extends far in the rear to the great Basilica of Bra-
mante. A mighty arch finishes the architectural
background on each side, and between these and the
foreground groups are other figures, running, walk-
ing, talking, getting smaller and smaller as they near
the distant buildings. Back of all stretches the
Umbrian landscape with softly sloping hills and
single stiff trees. It is what we may justly call
modern painting, — strongly in contrast even to the
best of the other frescoes. Here is space, vast, illim-
itable, only bounded by the sky itself. Here is
atmosphere, here is the strong, balanced composi-
tion, one part treated in relation to its bearing upon
another, here are figures in true perspective, and all
making more telling the central idea of the whole.

Next to this must rank Ghirlandajo's Calling of
Peter and Andrew. Better, stronger, more perfect
in every way than any of the rest, it is doubtful

if even one of Perugino's figures can compare with
the dignity and inherent grandeur of Jesus, recalling
as it does that by Masaccio in the Tribute Money.
Behind Jesus stand James and John, and before
him kneel Peter and Andrew, to whom the Master
is speaking. The crowd of spectators on each side
and beyond is admirably massed, and the chiaroscuro
is far in advance of the other frescoes on the walls.
On the shores of the lake behind, Christ is shown
again, with the fishing-boats beyond. There is a
distant view of promontories and hills settling down
to the water's edge. As is usually true of Ghir-
landajo, his colour is too bricky, and he has worked
over his shadows till they are leaden. But in chiaros-
curo, balance of parts, nobility of figure, strength
of mass and line, he has done splendid work.

It is said that of all the paintings in his chapel
Sixtus IV. admired those of Cosimo Rosselli most.
Rosselli won this admiration easily. Far below
his companions in talent, he at least realised two
important things. First, that unless his short-
comings could be somewhat covered up, his medi-
ocrity would be patent to all, and next, that the Pope
particularly loved all kinds of grandeur and display.
Consequently, and for both reasons, his panels were
a mass of richest gilding. Robes, crowns, archi-
tecture, even the high lights on flesh, were all made
of gleaming gold. The Pope saw the prodigal,

kingly lavishness of the precious metal, and loved it.
Others must have had little chance amid the dazzling
display to see the weaknesses and faults beneath.

Of the four the Last Supper is the worst. The
curving table, the three windows above with the
landscape seen through, the figures automatically
placed about the board, without dignity and with
no grace, the bad colour, make it what it unques-
tionably was from the beginning, in spite of papal
encomium, — a failure.

The Sermon on the Mount is the least unsuccess-
ful. It is believed that his pupil, Piero di Cosimo,
is responsible for the landscape of rolling hills, de-
tached trees and roofs and spires. The scene shows
many separate groups listening to Jesus' discourse,
as he stands upon a hillock a little back from the
centre foreground. His drapery, as well as that
of most of the others, is too voluminous and
meaningless, but there are individual figures that
have both charm and interest.

The Passage of the Red Sea is hopelessly dull
except for certain single figures, where are some
vigour of action and energy, slightly recalling
Benozzo Gozzoli.

As has been mentioned, there were besides these
the three frescoes by Perugino at the altar end of
the chapel. No drawings of them are known, nor
is there left any definite description of them. If

they were at all equal to the Delivery of the Keys, the world has lost much in their total disappearance. Only their subjects are left to us, Moses in the Bulrushes, Christ in the Manger, and between the two the Assumption of the Virgin, in which Pope Sixtus IV. was introduced.

If we know only the names of these once famous frescoes, we know equally little of the designer of the beautiful marble screen that separates that part of the chapel reserved for ecclesiastics from the rest of the church. Exquisitely wrought, of most lovely design, who did it or when is not told. It may have been the work of the architect, it may have been the loving labour of some artist long forgotten in name, yet for ever remembered in this marble creation, — a truer expression of himself than any accidental nomenclature.

Such was the chapel when in 1508 Julius II. commanded Michelangelo to decorate the ceiling. It was Bramante, we are told, who suggested this undertaking to the Pope, Bramante, who for the sake of his young protégé, Raphael of Urbino, was jealous of the unquestioned preëminence Michelangelo had won as sculptor. The architect thought, so Vasari gravely states, that if the great Florentine could be diverted from the path in which he had so far outstripped all others, that then there would be no one to compete with Raphael for the Pope's favour.

Whether this is literally true or not, at least it
is certain that Michelangelo was with difficulty per-
suaded to the task. He had already purchased the
marble, and was about to begin the wonderful mau-
soleum Julius had before ordered; he was no painter,
he vowed, and he at once suggested that the young
Raphael could much better do the work. But the
Pope, possibly still backed by Bramante, would ac-
cept no excuses. He would have no mausoleum while
he was still alive; he had engaged the sculptor's time,
and that time should be spent on nothing but the ceil-
ing of the chapel. Thus, grumbling, and with much
distaste, the great sculptor was forced into becoming
a painter. And to-day, the fame of Michelangelo
rests not so much on the works of sculpture he left
behind, wonderful as they are. It is the marvel
that his brush wrought above the line of those of the
quattrocento that has placed him beyond all com-
petitors, as far away from the striving and imita-
tion of those who came after as it is from all who had
gone before.

This so-called ceiling is not only the actual roof-
ing. It extends down the walls to the line where
the windows begin to spring into their arched tops.
The central part of the ceiling is flat. From there
it is slightly vaulted, the pendentives ending between
each two of the twelve windows. This entire smooth,
easily curved surface is covered with painting that

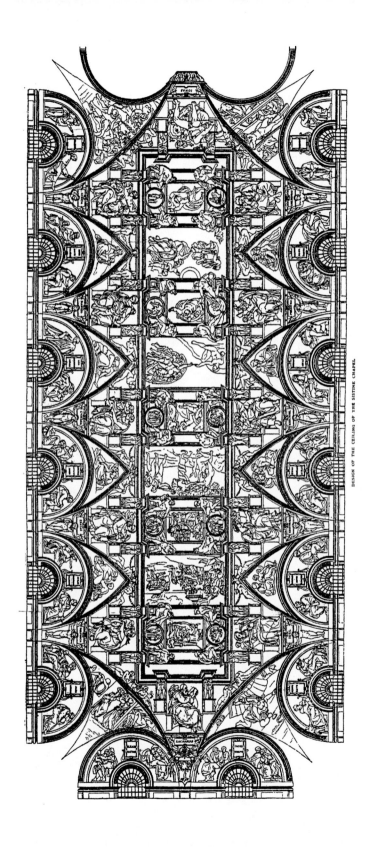

DESIGN OF THE CEILING OF THE SISTINE CHAPEL

leaves not one square inch undecorated. Unlike the earlier wall paintings of the Renaissance, there are no large spaces or even intertwining lines given over to arabesques, wreaths of flowers, fruits, grotesques, and conventional ornament. Figures — figures everywhere. For background or separation, architectural forms alone are used. No ornament *per se*. With his brush Michelangelo built a structure that, springing from the window, rises in grandly conceived lines, a " temple without a foundation," yet so artfully, so skilfully designed, that one never thinks of the unreality of its formation. Pilasters, cornices, platforms, arches, and niches, — it is scarcely possible, as one looks upward, to suspect that this marble edifice is but a simulation, — nothing but brush work. It is no wonder that the mere mechanical dexterity, almost the mere trick of the performance, should be so overpowering that even before the mighty design and undermeaning of the whole have been perceived, one exclaims, " Truly here was the greatest genius of the sixteenth or of any century."

It is almost impossible in words to give a comprehensive idea of the general plan. Very roughly speaking, it may be said to consist of the nine panels illustrating the Genesis story, which fill the central flat part of the vaulting. From this curve the twelve pendentives that spring from between the windows.

They hold the five sibyls and seven prophets seated upon their thrones. Between these pendentives are the arched spaces on the walls over the windows, and the triangular lunettes forming the under sides of the pendentives, and capping the windows visorwise. In these are painted the ancestors of the Virgin. But such a bare outline contains slight idea of the effect of the whole composition, where every inch is filled with figures or architectural forms, yet so combined and separated, joined and detached, that there is no overcrowding or overelaboration. The nine central panels are separated from each other by a painted framework simulating cornices and pilasters. Five of these, including one at each end, are much smaller than the other four. This is accomplished by a different division of the space allotted to them. The four large ones are simply framed with the painted cornice that takes nothing from the picture room. The five smaller ones are over the prophets and sibyls seated in the pendentives, between the windows. On each side of these massive throned beings are two boy caryatids standing upon a double-based plinth, holding a cornice on their heads. These cornices project, in painting, it is always to be remembered, into and out from the four smaller central panels. Upon each of these cornices is seated the god-like figure of a nude youth, making, since there is one at each corner of

the panels, twenty in all. Each two hold the ribbons that are joined to a round medallion, upon which are figures in relief. In some cases the heads or arms, or even shoulders of these seated youths project into the field of the central panel, framed otherwise by a simple ribbing. The four large panels are over the triangular lunettes above the arch of the windows, and completely fill the space between the two sides, save for the narrow spandrels made by the point of the lunette, the rib framework, and the caryatids on each side. Every spandrel holds a bronze-toned nude figure, no two alike, in all conceivable positions, filling the three-cornered space. Below the base of the thrones of the prophets and sibyls are tablets inscribed with their names, these held up by youthful figures, in some cases partially draped. At the four sloping corners of the ceiling, coming between the side and end windows at the entrance end, and joining the altar end to the sides, are four scenes supposed to be the four promises to mankind before the advent of Christ. Symonds says: " An awful sense of coming doom and merited damnation hangs in the thunderous canopy of the Sistine vault, tempered by a solemn and sober expectation of the Saviour." There is, however, in this chapel nowhere a realisation of this expectation. Despair, doom, destruction, from the first temptation to the final judgment, Michelangelo deals not with hope,

but with the deserved retribution for misspent
years. As has been said, the very elect of Paradise
show little of hope or joy. It is the power, might,
and resistless force of God, not his love or condona-
tion, that the painter has blazoned forth. The sin,
the pride, the weakness of man, rather than his
aspiration or his spiritual achievements. And, as
has been often remarked, nowhere on the ceiling
is the charm, the soothing spirit, or the tenderness
of woman displayed. No matter how much those
anxious to see every perfection in the works of
Michelangelo have praised the face and figure of
Eve, it is nevertheless true that at the farthest
stretch of imagination she is neither beautiful, nor
does she have any of that soft feminine enchantment
that, for instance, might answer to the " ewig weib-
liche," present even in the most doughty of Wagner's
heroines. The sibyls are majestic, mighty, inscrut-
able, an incarnation of insight, knowledge, and
power, — woman not sublimated so much as rein-
carnated in an entirely sexless, if highly vitalised
form. And in spite of their majestic calm and force-
ful, puissant grandeur, one finds not hope so much
as a stern integrity, a lofty purpose far and away re-
moved from joy or gladness. No — in the whole
immense series bearing the name of the most solitary
genius that ever lived, it is only in the figures of his
youthful men that we find any of the gladness, the

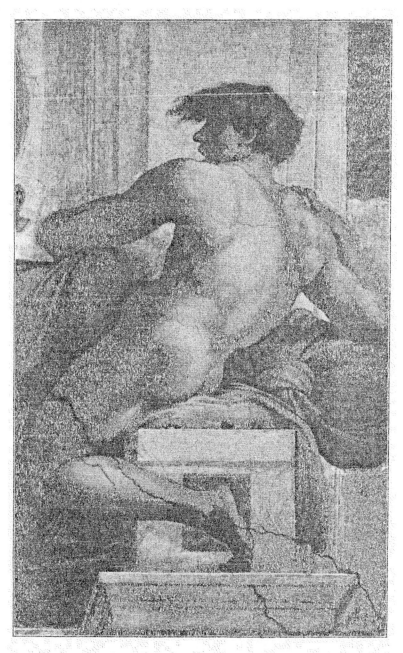

ONE OF THE "YOUNG ATHLETES"
By Michelangelo; from Sistine Ceiling

spring, and the elixir of life. And the Sistine, in spite of its overwhelming tragic significance, has innumerable figures of these youths. In the twenty young " athletes," holding the ribbons of the medallions in the central vaulting, the twenty-four bronze figures filling the spandrels, or the forty-eight " twinned caryatids," — the youthful male is shown in every variety of movement, position, and expression. Above all, they express some of the mere physical joy of living, as well as mental exuberance. The faces of the twenty central youths are very wonders for their sensitive, entrancing beauty, with eyes through which the soul shines seekingly. But most of all it is the rhythmic poetry that controls their limbs, the grand lines of their thorax, the very electricity that seems to throb through every inch of the pulsating flesh — it is the physical manifestation of the ecstasy of merely being that is the most compelling thing about them.

The story of the nine central panels begins at the altar end of the chapel. At the opposite end, Michelangelo commenced his work, and the first three divisions are filled with much smaller figures than the rest. It is supposed that when so far along, he realised that the effect from below would be much more impressive with fewer and larger figures. The first of the series, in the story, is directly over Jonah, the prophet on the pendentive that gives the double

arch to the altar end of the chapel. This is one of
the smaller panels, and at its corners are four of the
beautiful seated youths, each one, it seems, more
beautiful than his neighbour. The Creation of Light
gives Jehovah in a whirling cloud of drapery, his
figure thrown diagonally across the panel, and nearly
completely filling it. As in all the paintings of the
Renaissance, He, the Creator, is represented very
nearly as one would represent a patriarch of Israel,
with flowing beard and heavy white mane of hair.
Ineffectual, and often weak and undignified as most
of these portrayals are, they are very different under
the compelling genius of Michelangelo. Considering
the feeling and custom of the time, it is not too
much to say that in these pictures of the beginning
of all things, he has created a Jehovah such as never
before nor since has been done by the brush of man.
There is something very Godlike and awe-inspiring
in the powerful frame that yet floats as easily in
the firmament as if it were merely part of the ether
about it.

The second panel is the Creation of the Sun and
Moon. Here God is presented in two positions. In
the right hand division, attended with angels, he is
sweeping forward through the sky, both arms ex-
tended, the forefinger of his right hand resting
momently upon the great globe that half rises above
the ribbed framework. At the other side he is

rushing through space away from the spectator, with one hand lifted over a mass of vegetation that appears near the left-hand corner of the fresco.

In the third, "He is hovering over the waters," as Grimm expresses it, this time again with the accompanying angels. And "hovering" exactly describes the soft floating movement with which he rides the air, both hands flung out, his head with its heavy masses of hair and beard bent downward with a brooding tenderness that mingles with the infinite power of the face. The sweep of his mantle behind him, the whirling clouds about, all are full of the very spirit of the Almighty himself.

The fourth panel is probably the most celebrated of all. The Creation of Man gave Michelangelo an unsurpassed chance to represent what he loved best of all, the perfect figure of a young man. Nothing more perfect, it may well be imagined, could be conceived than this first man half reclining on the mountain top, not yet awakened sufficiently to stand upon his feet. The attitude of Adam is no less beautiful than his beautiful figure. He has just raised himself upon his right elbow, the action twisting the upper part of his body round into full face, with his left leg drawn sharply up. It is the preliminary poise before arising. Not for more than a moment, one would think, could he hold the attitude. Yet so full of ease, grace, and unexpended strength

is it that any sense of strain or weariness is entirely
lacking. And indeed weariness is the last thing to
be thought of in connection with that superb young
body. If the muscles have been so far unused, they
have nothing of flabby softness about them. Firm,
gloriously, evenly developed, Michelangelo here
shows none of the exaggeration of flesh and form
of which sometimes even at his greatest he is guilty.
Poised above Adam is the Almighty. His far out-
reaching hand has almost touched the answering
hand of Adam. One can fairly feel the pulsing,
throbbing life that will respond to that magnetic
touch. Behind Jehovah is a tremendous, swirling
cloud of drapery, and sheltered within it and pro-
tected by his encircling arm, are some exquisite child
angels, gazing with eager, loving eyes at the man
figure below. God is draped in a robe that covers
but does not hide his form. Every curving line is
felt through the clinging robe. The colour of it is
a lucent violet gray, as if woven of clouds. His face
expresses infinite benignity, without joy, almost,
perhaps, without hope.

The next, the Creation of Eve, is one of the small
divisions with the four splendid youths on the ped-
estals at the corners. These graceful, lovely-faced
figures have much more charm than the certainly
heavy and decidedly matronly form of Eve. She,
apparently just sprung from Adam's side, is half-

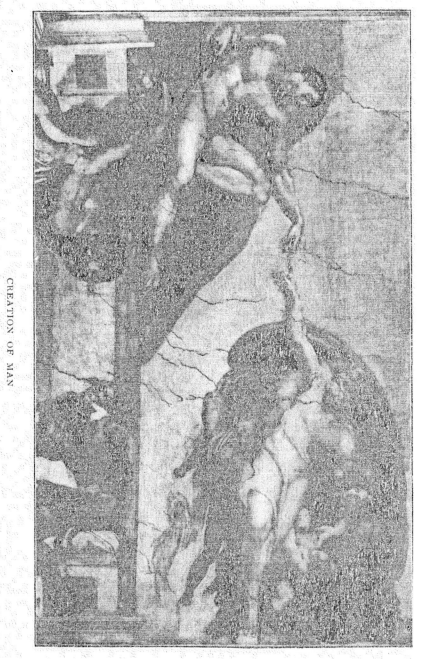

CREATION OF MAN
By Michelangelo; from Sistine Ceiling

kneeling with clasped hands before the Eternal. This time the Lord is walking upon the earth he has created, and here he is more than ever like a patriarch of the tribe of Israel. Wrapped in a voluminous garment, which he draws with one hand close about him, with the other he admonishes or instructs this, his last creation. Adam lies in a slightly raised position on the side of the hill, still sunken in slumber. Not to be profane, one can not help wondering how he, in his magnificent young beauty and elasticity, will regard this somewhat stocky, rather coarse-lined femininity bestowed upon him.

A double story is in the sixth compartment, that of the Temptation and the Expulsion from Paradise. The fatal tree of knowledge fills the centre of the composition. Around its trunk are wound the fat, yellow folds of an enormous serpent, that up in the branches end in the figure of a woman. She is reaching down an apple to Eve, who, seated facing in the opposite direction, has twisted herself round and is eagerly stretching up her hand for the fruit. Standing beside her, pulling down a branch with one hand, with the other Adam is feeling among the leaves. It is quite — begging Herr Grimm's pardon — as if, whether Eve had taken the apple or no, it would have been but a few minutes before her mate had secured a taste of the coveted fruit.

Here Eve is slighter than in the former panel, and
by so much loss of flesh so much more attractive.
On the other side of the tree, the angel with aveng-
ing sword pushes the guilty pair from paradise.
The wonderful realism of the two cowering figures
is beyond words. Nothing more real to the sense
of touch as well as to sight can be imagined. The
two sinners exist here with a corporeal certainty
that almost makes them more living than the living
themselves. They are equally impressive in their
attitudes and expressions. Adam strides forward
with arms thrown protestingly backward as if im-
ploring the angel. Despair and terror are on his
face as he hurries on. Eve on the other side is more
cowering than Adam, but perhaps less despairing.
Head and back bent, hair flying about her, she
has drawn up her arms in a very terror of shame,
clutching her golden tresses with her hands. But,
in spite of shame and terror, she has ventured to
look back curiously at the angel. One is tempted
to think she has still a sense of the possibilities that
may lie before her.

The seventh, eighth, and ninth frescoes, in con-
sequence of the smaller figures that fill them, are
that much less effective. First of the master's work,
it is only after the last of the three that he seems to
have entered into the labour with both surety and en-
thusiasm. The one next to the Expulsion from Para-

dise is the Sacrifice of Noah. Here, behind the altar
stand Noah and his wife, while his sons and ser-
vants are preparing the animals for slaughter, and
brightening the fire.

The following, being the last of the four larger
ones, is a scene of the Deluge. The lack of concen-
tration and point of focus that are often felt in
Michelangelo's designs are here extremely apparent.
Up to a wind-swept barren cliff, with one naked
tree at the far left, the doomed people are strug-
gling, clinging to their chattels, their children, or
each other. One wretch has climbed the tree and is
hanging there with desperate hands. Beyond, the
flood rages, threatening destruction to a small, over-
loaded boat in the centre of the torrent, and steadily
rising higher over a rocky embankment where are
more despairing mortals. One man, who is walking
through the shallows to the higher ground, carries
another flung over his shoulder, the limpness of the
body wonderfully expressed. Farther beyond, rides
the ark, triumphant. The lack of centrality in the
composition is counterbalanced by the remarkable
construction, modelling, and attitudes of the individ-
ual figures.

The last of the series, the first of Michelangelo's
labours, is the Drunkenness of Noah. Stretched out
asleep, half-lifted on his elbow, the old man lies, the
aspirations and the virtues of his earlier days for-

gotten. One of his sons stands deriding, while the other two cover him with a mantle. At the corners of this picture are left only three of the four young "athletes." The other, except for head and foot and part of a leg, has been entirely wiped away. The fascinating beauty of the head that is left, makes its destruction doubly mournful.

On the pendentive over the altar sits Jonah, with his head and upper part of his torso thrown far back and twisted to his right. The left arm, brought sharply across the body over to the right hand, emphasises the double action of the figure. There is some of the exaggeration of form here that Michelangelo is so often accused of, but it does not spoil what is a very beautiful as well as a powerful figure. At the prophet's right is a conventionalised whale, — scarcely larger than Jonah's thigh, and above the animal's head are two children.

At the extreme other end, on the pendentive between the simulated windows of the entrance-wall, is the Prophet Zacharias. He is an old man, bearded and sitting in profile, with heavy draperies, lifting the book he is reading in both hands close to his eyes, while behind him stand the two children genii, their hands clasped as they read over his shoulder.

Between these two, on each side of the wall, are placed the other five prophets and five sibyls. On the right of the entrance are Joel, Erythræa, Eze-

kiel, the Persian Sibyl, and Jeremiah. On the left
are the Delphic Sibyl, Isaiah, the Cumæan Sibyl,
Daniel and the Libyan Sibyl. The most beautiful
of the prophets, perhaps, are Jeremiah, Isaiah, and
Daniel, and of the sibyls the Delphic, Erythræan
and Libyan.

No two of any of these are alike in pose or
drapery. When one considers the twenty seated
youths of the ceiling and these twelve seated figures
here, it is not one of the least astonishing of Michel-
angelo's feats that he could vary pose and movement
so remarkably.

Jeremiah, the first on the left of the altar, as one
faces the entrance, is sitting squarely in full face,
his feet crossed beneath his robe, his chin buried in
his right hand, with the elbow on his knee, the other
hand falling loosely into his lap. The eyes are cast
down, too, and the simple, dignified attitude ex-
presses a thoughtfulness as deep as it is far from
pleasant anticipation. The whole position is that
of careworn weariness. From the virile, sinewy
hands to the broad, strong shoulders, and the grand,
aging head, the characterisation is as clear, marked,
and decisive as the drawing is faultless, masterly.
The two genii are behind him, and their heads, too,
are drooped as if in sympathetic appreciation.

Farther along on the same side is the Ery-
thræan Sibyl, sitting nearly in full profile, with her

knees crossed, her left hand turning the leaves
of a big book on a stand beside her. Her right
hand is dropped at her side. She is a youthful but
matronly figure, of full form yet not heavy, with an
earnest, questioning face. Her noble head, large
eyes, and curving lips, are full of a meditative calm
that adds to the abstraction of the figure. Behind
her a boy stands blowing at a firebrand, with which
he is to light her lamp.

On the other wall, exactly opposite this, is the
prophet Isaiah. He is in what would be full face
if it were not that he had turned his head toward
his right shoulder, listening to one of the two
small boys behind him. This boy is charmingly
piquant, and his face has a roguish charm as
he gazes at the prophet and motions far away
with his right arm. Leaning with his left elbow
upon a book which he partly holds open with the
fingers of his right hand, Isaiah is a splendid speci-
men of manhood scarcely beyond youth. Grace and
life, vigour and thought, are in every line of the
proud head and form. There is a certain feeling of
loftiness about him, a sort of aristocratic calm, that
would well become " the noblest Roman of them all."

Next to him, toward the entrance, sits the Delphic
Sibyl, perhaps more universally considered a beauti-
ful woman than any other feminine figure Michel-
angelo ever drew. And beautiful beyond doubt she

is, with besides a sort of weird, supernatural attraction. It is difficult to think of her as mere woman. Her youth and the soft curves of cheek and lip, the wide, deep eyes, are all full of a significance and comprehension beyond the ken of normal womanhood. She is placed with her body slightly in profile, but her head is turned full to the spectator. With her left arm she holds up a scroll, the lower part of which touches the right knee. This throws the arm straight across her body, bringing the elbow out beyond the plane of her face. Her right hand has fallen on to her knee, partly closed and holding a bit of drapery. At her side are the two accompanying boys, one reading to the other whose head alone is visible over the sibyl's shoulders. There is a sweep to her drapery that answers to the spirit in her glorious eyes. Some unearthly zephyr has surely stirred the scarf on her shoulders, and set in gentle waves the loose hair that curls down her shoulder.

At the far other end of the line is the Libyan Sibyl, of almost equal though more mature beauty. She, as Vasari says of this extraordinarily conceived figure, "having completed the writing of a large book taken from other volumes, is on the point of rising with a movement of feminine grace, and at the same time shows the intention of lifting and putting aside the book, a thing so difficult that it

would certainly have proved impossible to any other
than the master of this work." This double move-
ment is wonderfully indicated, and is, perhaps, the
greatest marvel of the creation. Though one foot
is bent under her, and the other is lifted on the
toes, yet the motion to rise has not so far actually
brought her from her seat. It is this amazing choice
of the moment of the action that prevents any strain
in the position, or any sympathetic ache in the spec-
tator. There can be felt neither the weariness of
a too long continued movement or a sense of anxi-
ety as to when the strain will be over.

Younger than Isaiah, imposing as Jeremiah, with
a grace almost equal to the Delphic Sibyl, Daniel
sits upon the next throne. The big book, which
partly rests upon his lap, is mostly supported by
the arms and shoulders of a charming naked boy
standing between Daniel's knees. Sitting full face,
but bending to the right, Daniel is inscribing some-
thing upon the tablet on the block beside him. He
is scanning his lines with great earnestness, and he
has flung his left arm over the book in his lap, so
that the wrist helps to keep it in position. The ease,
freedom, grace, and splendid swing of the figure
are a triumphant achievement even for Michelangelo.
Nothing more real, more perfect in line and mass,
could be dreamed of. The head of the prophet is
somewhat round, with a wide, full forehead, from

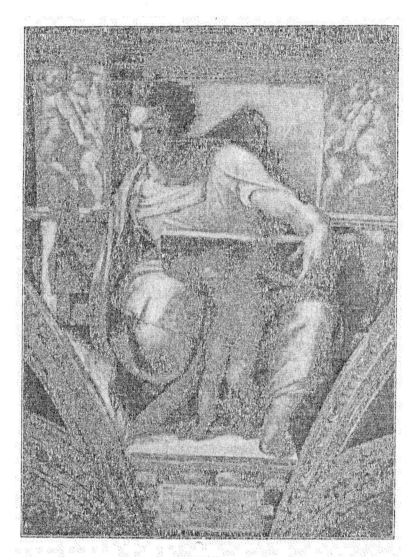

DANIEL

By Michelangelo; from Sistine Ceiling

which his hair is tumbled backward as if but a moment before he had run impatient fingers through it. His face is in nearly three-quarters, the eyes are down, a slight pressure about the lips expressing the intentness with which he works. But the most beautiful thing about him, perhaps, is the left hand hanging over the edge of the book. Those fine, firm sinews and muscles, the curve of the wrist bone, the hang of the fingers, the swelling muscle of the forearm, — surely nothing could be a better example of the gifts and attainments of this master of the human form.

In the arches over the windows is what Vasari calls the genealogy of the patriots, giving the ancestors of Christ, beginning with the sons of Noah. These are all in various positions in many kinds of draperies, but mostly of full, abundant lines. In every arch, directly in the centre over the window, is a tablet with the names of the persons represented. This disposition of the space leaves only the curve of the sides for the figures. The positions necessary for this are, therefore, generally seated ones, though often children are introduced standing singly or in pairs at the feet of the adult forms. The hand of time, the restorer, and the bad light make these very difficult to decipher.

Somewhat better preserved, but still more difficult to see, are the figures in the tympana or spandrels

between the points of the lunettes and the sibyls.
These are the bronze nudes exactly filling those nar-
row spaces. Attitudes again so free, so full of
subtile distinction and change, that any account of
them sufficient for full description would require
pages.

The four scenes in the four corners of the vaulting
are painted in very unequal divisions of peculiar
angles, and although with many individual figures
of great beauty, do not come up to the ceiling as a
whole. They represent the deliverances of the Jewish
nation.

Judith, with the head of Holofernes, has much
grace and simplicity. The victim is on a couch at
the right, with feet toward the observer. The result
is that in the shadow about the upper part of his body
the absence of the head is not noticed. At the left,
hurrying from the open door, is Judith, turning to
look back at the body. Or perhaps she is shrinking
from the laden salver borne by the maid in front of
her. Her figure is fine.

The Elevation of the Brazen Serpent gives a
whirling mass of legs and torsos and arms that,
while well filling the angular interspace, leaves one
confused and with no clear idea of the subject.

The Crucifixion of Haman has some wonderful
foreshortening, and a masterly drawing of the nude
figure squarely in the centre.

David Killing Goliath is almost archaic in its simplicity.

Kugler says the " so-called Genealogy of the Virgin, occupying not alone the arches, but the spandrels above the windows as well, is a succession of groups of a simple and domestic kind, showing no distinct event, but rather that form of family life so familiar in pictures of the time, but not otherwise treated by the great master, and offering interesting points of comparison with Raphael."

The colours of the whole chapel have faded, the plaster is cracked from end to end, there is scarcely a two-inch space free. The cleanser has washed with ignorant hands the very life away from some of the choicest parts. Yet the cool grays, the dull browns and golds and reds and greens are not so ruined as to be displeasing. This general submerging of the colours gives it perhaps a more architectural and so a more monumental character. The might of the whole conception, the power of the presentation, the marvellous majesty of the entire roofing, this it is that makes mere words of description utterly weak, inadequate, futile. One can describe it no more nearly than one can write descriptions of the greatest of Beethoven's symphonies. One can explain it as little as one can explain Hamlet. Power, majesty, might — neither before nor since has the brush thus triumphed. It is the crown-

ing work of the greatest mind that was ever in artist's body.

Thirty years after the completion of this ceiling, Michelangelo was once more at work in the Sistine. The three altar frescoes of Perugino were washed from the wall, and the Last Judgment begun. The pendentive of the vaulting upon which Jonah is throned divides the top of the fresco into two arches. Within them are crowds of angels holding the instruments of the Passion. Together they form two immense wreaths of figures, repeating in reverse the curves of the arches. In the upper part of the centre of the composition is Christ, seated within an ellipse-shaped glory. Beside him is Mary. About them is a circle of prophets, patriarchs, apostles, and saints, and beyond space and light. The curving outlines of the spheres of the blessed sweep down into a vast arch, above which is Heaven, below, Earth and Hell. Originally all the figures were nude, but while Michelangelo was still living, the Pope had Daniele da Volterra, a follower of Michelangelo, put draperies on many of them. He was called in consequence " Il Bragghettone," the breeches-maker. Afterward, in the time of Pius V., Girolamo da Fano continued the process started by Da Volterra.

The plane in the picture below that where the martyrs surround Christ, is made of three masses.

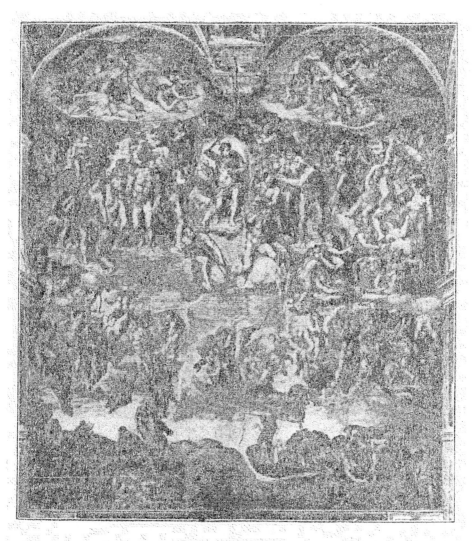

LAST JUDGMENT
By Michelangelo; in Sistine Chapel

The central section is held by a band of gigantic cherubs, who, blowing furiously upon long trumpets, are waking the dead. The forceful gusto of these announcers of the Day of Doom is so awe-compelling that the very walls seem to echo with their reverberating call. To the left, above the open graves, come the souls for judgment, some in air so misty as half to hide their grave-clothes, some assisted by angels and saints. On the right are the condemned, falling down to their abysmal torments, beaten back from the heights by vindictive angels, hauled by arm or hair or legs by grinning demons, — crowds of them, shoals of them, shrieking, screaming, a seething, torrid mass. Here is where Michelangelo's talent for expression shines with no uncertain power. Such anguish, such terror, such despair, are the proper accompaniment of the huge figures, with heavy ribbed muscles, small, pugilistic heads. It must be admitted, also, that the shapes he chose for the blessed are not the happiest to express eternal joy. Indeed, there is slight hint of happiness even among the saved. Stolid resignation or a vacuous inanity are the prevailing types of the ascending souls, while the saints and martyrs near Christ appear to be demanding retribution and heavy-handed justice rather than clemency or forgiveness. Mary alone, in her shrinking attitude, seems to recoil from the fearful judgment that the

terrible Son is pronouncing. He bears no resemblance to the meek Jesus, to the intermediary, to the Son who gave his own life to save the world. Rather, in all the awful anger of an avenger is he shown. In his colossal, muscular might, he suggests one of the victors of the gladiatorial ring. Below, on the lowest plane of all, on the right, is the opening of Hell. Michelangelo here follows the description of Dante. Charon forces a crowd of unhappy spirits into his boat to the other side of the dark river, where is Minos, Judge of the Infernal. The opening graves fill the left lowest half of the fresco. Here the unjudged are struggling upward, some in their shrouds, some mere skeletons, rising toward the Throne of Justice, some helped by the spirits above, some helping others.

Any real consideration of this fresco is out of the question. Blackened by the smoke of altar candles, still more by the burning of the conclave ballots, washed by the restorer, repainted and redraped by the commands of a prudish age, there is little left to tell how this enormous composition once impressed the beholder. Here and there from its turmoil one picks a figure, and finds it a marvel of anatomical knowledge, proof that even in his old age Michelangelo's brush had not lost its cunning. But if at times he could still thus accomplish, as surely he did and could exaggerate even more flamingly.

The overpreponderance of muscle, the overdevelopment of arms or legs or thorax, the undersized heads, here is the beginning of the decadence that in the Pauline Chapel proclaims Michelangelo what even here his years had made him, — an old man, with only the ragged mantle of mannerism left him. One thing may be said. The accusation against the lack of centrality, against the unskilful massing of the divisions of the Last Judgment seem rather far-fetched. To Michelangelo's mind and to his time, the Judgment Day meant such a confusion, perturbation, convulsion, that any sort of focus would have been impossible. He gives the Judge the central space, and so entirely that even in its present blackened, discoloured condition, one's eyes seek him first. After that there *is* no plan. The dead arise and are hurled down to deeper abyss, or they arise and join the saints. But amid the thousands thus called by the trump of Doom, what form, what order, what shape is possible? Or, if possible, it is questionable if regular or mathematical or even artistic massing would give the effect here conveyed, of a state that is a worse frenzy than chaos.

CHAPTER V.

Two rooms full of very mediocre modern pictures lead directly into the Sala dell' Immacolata. This was decorated by Podesti, under Pius IX., with frescoes celebrating the Immaculate Conception of the Virgin, a doctrine promulgated on December 8, 1854. These frescoes are chiefly interesting because they contain portraits of many of the ecclesiastics contemporary to that time. Among the subjects are the Proclamation of the Dogma, the Adoration of the Image of the Virgin, and the Reception of the News by the Virgin in Heaven. Though some of these are interesting and even spirited, by their very location they fail to rouse much enthusiasm. For from this room one steps directly into the Stanze of Raphael.

Of the four rooms of the series, the first in order, the Camera dell' Incendio ranks first only in position. It was in the fifth, the Camera della Segnatura, where was the scene of Raphael's earliest labours in the Vatican, and it is in the fifth that

one still sees the most perfect expression of that
genius that, at twenty-one, dominated Rome, as it
has since dominated the larger part of the art of
the Christian world.

As has been remarked in the first chapter, Raphael
came to Rome in 1509 merely as one of the corps
of artists ordered by Julius II. to make beautiful
the papal home. Of the works of all these others,
Sodoma's decorations of the ceiling of the Segna-
tura and the Perugino frescoes in that of the In-
cendio are all that the Pope permitted to remain
once he realised the capabilities of this youngster
from Urbino.

The four rooms are oblong in shape, with a vault-
ing whose pendentives come low down in the cor-
ners. The wall space on each side, therefore, is
semicircular, broken in the two narrower ends by a
deep-set window. Raphael's problem consequently
was to surmount the difficulties caused by a cross-
light, as well as to conform to the badly divided
space of the windowed wall. Seen to-day in all
the finished perfection of a compositional harmony
that seems equally easily accomplished and inevita-
ble, it is interesting and, to the student, most in-
structive to learn that all this apparently facile result
did not come at once even to Raphael. The studies
for the first of his great frescoes, the Disputa,
show that at first he was overwhelmed by the very

immensity of the space he must cover. Even the sketches nearest the painting are lacking in some of the finest points of the finished result. Raphael's power of assimilation was part of his capacity for learning rapidly. Yet, though after this first fresco he never again was so embarrassed by the limits or extent of his canvas, no veriest plodder in the artistic ranks ever trusted less to the inspiration of the moment. Or perhaps it would be more correct to say to the inspiration of any one moment. The museums of Europe abound with innumerable drawings of separate and grouped figures, in all sorts of attitudes, one after another of which he rejected before he found what he finally chose for picture or fresco.

On the two long, unbroken walls of the Camera della Segnatura are the Disputa and the School of Athens. Parnassus and Jurisprudence fill the windowed sides. Above each one is an allegorical figure in a large, ornamented circle. Connecting these, and dropping somewhat below them into the triangular spaces of the corners, are heavily bordered squares representing the Temptation, Judgment of Solomon, Creation of Planets, Marsyas and Apollo. Above these again, between the upper curves of the allegories, are smaller designs, which, as well as the allegories, are separated from the centre by ornamented bands in gold and blue and colours. In the

very centre is the large octagon, within which, against a blue sky, children support the Pope's escutcheon. Sodoma is the author of at least a considerable portion of this ceiling decoration. Originally the window had richly coloured stained glass panes, from the hand of William of Marseilles. These, as well as the ornate wainscoting, with seats of fine inlaid work, once covering the walls all around to a man's height, have long since vanished. But there is still preserved the sumptuous mosaic flooring, after the antique, where are seen the emblems of the Rovere.

The small square panel of the Creation of the Heavenly Bodies is supposed to be Raphael's first finished picture in the Vatican. After this came the Judgment of Solomon, the Temptation, and then Apollo and Marsyas.

The Creation of Worlds is represented by a woman, stooping over a transparent orb on which one of her hands is lying. No Christian saint or angel, she is more allied to one of the goddesses of the pagan heavens. Her look and gesture, as she watches the earth revolve in the centre of the crystal-like ball, through which her tunic and feet are visible, are full of surprise. Two boys by her side carrying books wing their way from little clouds, and smile at each other across the sky. The grace and arrangement of light and shade hint of

the Raphael of later days. But the pose and movement of the children still show the Perugian influence. His colour scheme is an adaptation of the mosaics in the early basilicas.

In the Judgment of Solomon, the king is shown as an aged man sitting on his throne, with his eyes fixed upon the executioner. This individual, grasping the child by the heels, stands with his back to the spectator. The real mother throws herself forward to stop him; the false one, on her knees at the foot of the throne, holds out her hands to the corpse which lies on the ground. Nothing is lacking here in the lines of the composition, in balance of light· and shade and contrast of movement.

Adam, in the Temptation, rests on a bank near the fatal tree. The coils of the woman-headed serpent are wound about the tree-trunk, while from the branches the head watches Adam as he takes the fig from his other half. Eve herself has the beauty of form and grace of pose of a Greek Venus. But in the foreshortened features of her face, as she looks down at her companion, are distinct traces of Raphael's Umbrian and Florentine training.

The Apollo and Marsyas augured well for the Parnassus to follow. Here Raphael demonstrated that he could treat subjects inviting comparison with the antique with perfect success. In the middle of the scene a shepherd holds a crown of laurel above

the god's head, who is sitting to the left, clasping
his lyre. With his raised right hand he is signing
to the other shepherd holding the knife ready for
the flaying. Marsyas is bound to the tree with his
arms in such a way that his toes barely reach the
ground. His shape at once recalls the ancient
statues of Marsyas. The composition is well if
somewhat arbitrarily filled.

As said, above each of the four great wall paint-
ings is an allegorical figure, a personification of the
subject in the fresco below. In Theology, which is
therefore above the Disputa, the colours have faded
and changed, — only the clouds have kept their
transparency and light. The girl sitting between
the two tablet-bearing boys, who are dancing on
the clouds, is looking downward with a gentle, intent
expression. Her auburn hair, garlands of leaves,
and a veil floating in the breeze are reminders that
Raphael still clung to a Florentine type, recalling
almost equally Perugino and Fra Bartolommeo.

Poetry, above the Parnassus, is conceived of as
a sibyl, and at her sides are winged genii, carrying
tablets that in Virgil's words claim she is inspired
by the Deity. Here Raphael has left behind him
the affectations of the school of Perugino. The mas-
culine vigour that in spite of his inherent sweetness
and light was a part of him, becomes more manifest.
Seated with her wings opened, Poetry turns her face

in the opposite direction from the pose of her body. The modeling of the forms is exquisite, her eye full of a creative fire. Her right hand holds a book on one of her knees, her left supports a lyre, her feet are gracefully crossed in front. Beautifully draped about the waist and arms, her tunic leaves her right forearm bare.

Like the other three, Justice, over Jurisprudence, is seated on clouds that float over a gold mosaic background. She holds a sword above her head in her right hand, and lower, in her left, the scales. Her eyes are downcast, but not blinded, and altogether she is a sweet-faced, not too heavy maiden, whose attributes rather than expression indicate her vocation. On each side of her are two charming genii in most delightful variety of action, holding the tablets bearing the motto for the picture. In the distribution of line and mass the composition is irreproachable, but the execution is less satisfactory.

Full of memories of the antique is Philosophy, placed above the School of Athens. She is sitting on a golden chair whose arms are shaped in imitation of the many-headed Diana of Ephesus, symbol, as Grimm says, of all-sustaining nature. In her star-embroidered tunic and flowered mantle, with her two hands holding upright the books of moral and natural philosophy, and in the two boys carrying

tablets inscribed with the words, "*Causarum Cog-nito,*" are reminders of the statues of the ancients. Her position, turn of head, and noble face are dignified and simple.

All of the four rounds have suffered from time and the restorers' hands. The backgrounds of all are of gold mosaic. In Theology retouching has spoiled the flesh shadows, and the green mantle is sadly damaged. Philosophy is full of patches and additions. Poetry is apparently entirely the work of Raphael. In Justice the draperies are poor, and these and some other parts may be assigned to assistants.

When Julius II. ordered the Disputa, he was especially desirous that this picture, which was to be an epitome of religion according to the Roman doctrines, should be at the same time a memento of what was to be the greatest act of his pontificate, — the rebuilding of St. Peter's. Therefore Raphael laid the scene in the court of an unfinished building where the marble piers are hardly raised above the heads of the people. Of the altar itself, on which is placed the sacrament, one writer remarks that it seems to indicate the marble stone which the Pope had sealed in the depths of the old basilica a few years before.

The Disputa shows clearly the effect upon Raphael of Leonardo and Fra Bartolommeo, as well as his

studies of the remains of the art of Greece. In consequence, there is less uniformity of style than in some others of his creations. Yet, perhaps of all his frescoes no other interests the beholder more. Though some of the parts may be unequal, the effect of the whole is that of " a splendid vision." It may be said to be composed of three divisions, two of these in heaven, the third on the earth. Above all is the Lord Almighty; the middle celestial region holds Christ, Mary, John the Baptist, and the prophets, saints, and apostles. In the lowest division is the assemblage about the sacrament. In spite of this arbitrary placing, the three sections do not exist independently. They are connected, not only in the intellectual scheme of the composition, but in the actual technical presentation of it. If there are certain mannerisms and what might almost be called archaisms in the upper portions, nevertheless there is that homogeneity of the whole that is never lacking in Raphael's creations.

God, in the highest curve of the arch of the fresco, is clad in tunic and mantle, clouds covering him below the waist. He bears the crystal orb and gives the benediction. His bearded head within its lozenge-shaped halo is characteristic of the old mid-Italian church type; and the hems and borders of his garments, ornamented with gold microscopically treated, are of the same order. But there is

more of the noble simplicity of the classic in his
impressive attitude and gesture and in the dignity
of his frame. From his sky, reflecting old tradition
again, are the rays that spread out through an atmos-
phere full of delicately toned boy angels, against a
star-spattered ground, below which other angels sup-
port a fringe of cloud. Quite different are the six
lovely winged seraphs that float in the air before
this cloud at the Eternal's side. They are con-
ceived in the very spirit of the old Greek Victories.
Slightly below, seated on the clouds, is Christ, his
white shroud slipped back to show the wound in
his side. His two hands are upraised, displaying
the stigmata, and they, with the depth of earnest-
ness of his face, tell the story of his redemption,
as much as the bending figure of the Madonna on
one side or John the Baptist on the other. Around
the group is a halo of rays, bordered by a semi-
circle of light in which cherub heads are flying. It
is all after the Umbrian traditions, and, lovely as it
is in its own way, shows that Raphael was here still
bound by his early schooling. This central group
is finished by the dove at Christ's feet, and four
winged boys carrying the volumes of the Gospels.
It rests, as it were, on a semicircle of clouds where
are seated, at the extreme ends, St. Peter and St.
Paul, and between, Adam and Abraham, John the
Apostle and James, Moses and Daniel, Lawrence

and Stephen, Jeremiah and Judas Maccabæus. Below these thick white clouds is the sky seen by earth eyes, and then comes the terrestrial portion of the painting. In the centre is the altar, slightly raised and approached by broad steps. On each side are the fathers and doctors of the Church. At one end are blocks of half-cut marble, at the other a landscape of low hills, sloping to the lake. The assemblage is grouped with the wonderful freedom, and has the natural and splendid massing of which Raphael was past master. Almost all of them are historical portraits. In front on the left, leaning on the stone balustrade, a middle-aged man draws the attention of a youth walking to the altar to a book into which a group of others are looking. He is Bramante, the genius of the new St. Peter's. At the altar itself are Jerome, Gregory, Ambrose, and Augustine. Connecting them with the noted figures far at each end, are bishops and youths, saints and martyrs. Among others are plainly seen the face of Dante, standing just in front of Savonarola, and before them is Innocent III. The names of these are told by inscriptions written in the nimbus encircling their heads, or else they are so well known by innumerable portraits that names are unnecessary.

Above, in the sky, are many beautiful figures. Mary, as she kneels before Christ, has a tender loveliness that is not less charming because of its pre-

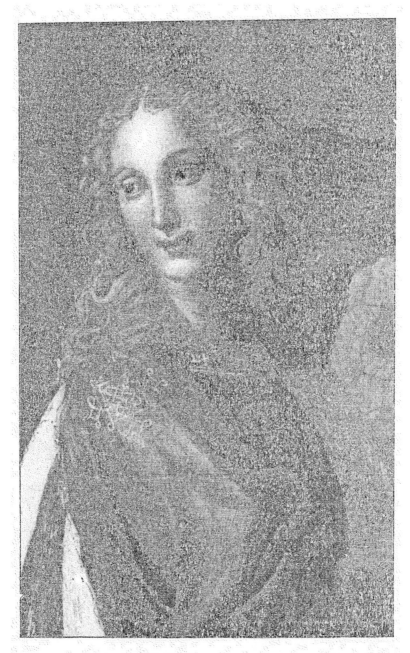

DETAIL FROM THE "DISPUTA"
By Raphael; in the Stanze

Raphaelic traits. One of the most interesting is
Adam, who, sitting calmly with one leg thrown over
the other, is, as Grimm observes, full of an " aristo-
cratic ease." And everywhere are the most exquisite
angels and angels' heads. The clouds seem fairly
permeated with them; as far as eye can pierce the
blue vapour, shine with faint but heavenly light these
angelic hosts.

But it is in the lower plane that we begin to see
the Raphael who could paint the School of Athens,
the Jurisprudence, and the Mass of Bolsena. The
grouping shows the balance, the unerring sense of
coherent composition, so marked an attribute of
Raphael from this time on. The vigour, too, in
the individual figures, the long free lines full of
verve and character, the spirited positions and
splendid counterbalance in the groupings, all make
such a vivid, life-like assemblage, that it is no
wonder the fresco as a whole is the most famous
or best known of all his works.

Of the School of Athens on the opposite wall,
Crowe and Cavalcaselle say it " is simply the finest,
best balanced, and most perfect arrangement of
figures that was ever put together by the genius
of the Italian Revival, and the scene in which it is
set is the most splendid display of monumental archi-
tecture that was ever made in the sixteenth century."

The scene takes place on the steps at the entrance

to an open air palace and temple, of proportions so
idealised that the choicest remains of the greatest
Greek temples pale before its perfection. In the
immediate foreground the tiled pavement of the
court ends at the wide, low marble steps that stretch
nearly across the whole picture. At the front and
on the sides of these steps are groups of philoso-
phers and students so arranged that each individual
is a connecting link in a chain leading to the two
philosophers who form the centre of the picture.
These two stand side by side, slightly back from the
edge of the platform, the one on the right, Aris-
totle, pointing to the earth, Plato by his side lifting
his hand to heaven. There is no hint of dispute
between them, though each looks attentively at the
other, as if wishing to impress him with his doc-
trines. The architecture that rises in majestic lines
about and over them is an arched aisle, supported
on huge pilasters and broken by a cupola and a
transept. Through the dome of the cupola, and over
the last arch beyond the transept, the clouds float
across the shining sky. No setting could be more
appropriate, more grandly impressive for this
"school" of philosophy. Vasari states that Bra-
mante designed the edifice and indeed the proportions
are such as he alone could have conceived, — Bra-
mante, who was filled with the secrets of the ancients
and who revitalised them with the spirit of the

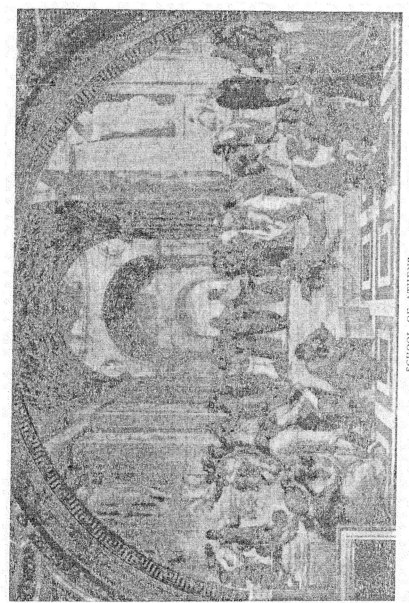

SCHOOL OF ATHENS

By Raphael; in the Stanze

Renaissance. The decorations of the building are
no less remarkable. The vaultings are cut into a
beautiful hexagonal pattern, the cornices and capi-
tals are exquisite in a grave simplicity, and the
whole is heightened by reliefs and statues so
designed by Raphael that they partake of the essence
of Greek art without being in any sense mere copies.

It is in the grouping and massing of his philoso-
phers that Raphael's power shines at its brightest.
Almost any individual picked at random shows a
mastery of form, of drapery, of characterisation
unsurpassed by any other painter. But not only
is each individual perfectly studied and completely
expressed; he is even more carefully considered in
his relation to those about him. Yet so easily is
it all done that the picture seems to compose of
itself. One could scarcely imagine as possible a
single change in the slightest detail. It is as if it
all happened spontaneously but with the rarest per-
fection. There have been many names given to these
figures, and indeed there has been much debate as
to the real subject of the whole fresco. Grimm
and others have claimed that it represents the
entrance of Paul into the midst of the Athenian
philosophers. The balance of opinion, however, is as
stated above, that the two central figures are Plato
and Aristotle. Below these steps on the left, bending
over his book and writing from the table of har-

monies held before him by a pupil, is the noble figure of Pythagoras. On the other side Bramante, posing as Archimedes, is leaning far down over a geometrical figure which he is spanning with a pair of compasses, while about him are a number of students earnestly watching him. Near by are Ptolemy, or perhaps Zoroaster, and behind are Raphael, and possibly Perugino. The figure stretched out on the steps to the right of the centre, with such astonishing compositional effect, is Diogenes. Above, on the platform, to the left of Plato is clearly recognised the pugnacious face of Socrates.

But whatever or whoever they may be, it is the way one part is connected with another; the gradations by which the sight is carried along to the central point of focus; the individual grandeur of the figures and the splendid lines of drapery; the swinging poses; the difficult foreshortening; the infinite variety of movement and position that make an overwhelming impression. "The spirit which pervades the School of Athens is that of Giotto, Ghirlandajo, Leonardo, and Michelangelo. Tempering these are Raphael's own innate nobleness and grace, and his constant appeal from the ideal and classic to nature. Combining all these qualities into his picture, he exhibits as additional elements of charm, a broader style of execution, a most striking balance of light and shade and a greater richness of harmonious

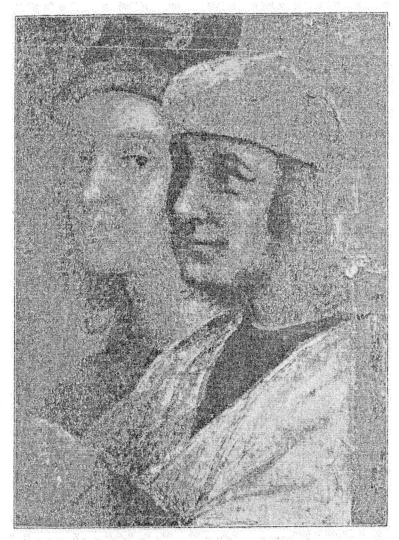

PORTRAIT OF RAPHAEL AND PERUGINO
Detail from School of Athens, by Raphael; in the Stanze

colour than he had hitherto attained in his practice
of fresco." The surface of the School of Athens
has been badly hurt by abrasion and discolouration;
the architecture has faded to such a degree that some
of the reliefs are almost indistinguishable. A long
fissure cuts right through the head of Diogenes. A
still longer one strikes through the whole picture
and divides the figure of the two philosophers
ascending and descending the steps.

Filling one of the window ends of the Camera
is the Parnassus. It thus forms a semicircular
design with a square hole cut from its centre by the
window. Apollo is directly over this opening,
seated on a rocky rise, from which a spring gushes
out, ending in a pool at his feet. The golden-haired,
laurel-crowned youth is nearly full face to the spec-
tator, his left leg slightly drawn under, his right
advanced. Partly covering his beautiful body is a
lavender robe which slips from his right shoulder
and half drapes both thighs. He is playing on a viol,
while his upraised head and eyes seem seeking in-
spiration directly from heaven. Behind him are
some laurel-trees, through whose slender trunks and
not too heavy foliage the sky, with its soft streaks
of cloud, shows clearly. At his right and left are
grouped the Muses and poets, a wonderfully simple
but most effective arrangement, apparently so
naturally accomplished that the necessity for filling

up the fan-like space hardly occurs to one. On
Apollo's right is Calliope, resting on her left elbow,
the upper part of her body turned slightly toward
the god, her head in profile away from him. She
is in white, entirely robed, except for the right arm
and breast. Seated on the other side is Erato, in
a light blue gown. She is gazing at Apollo with
intense interest expressed in every line. In her
left hand she holds the seven-stringed lyre. Behind
her are Melpomene and Terpsichore and Poly-
hymnia, in soft grays and lavenders and greens, in
the main fully draped, only an arm or shoulder
occasionally escaping from the graceful folds. Be-
tween them and the group beside Erato grows the
bunch of laurel-trees. Clio, Thalia, and Euterpe
are close together, Euterpe turning a little from the
other two to speak to Urania, who is standing back
to at Erato's feet. She is thus somewhat more fully
in the foreground than these others, and her golden-
toned gown is caught and held in beautiful big
masses, showing off to advantage her stately figure.
Below her, in the curving space by the side of the
window is a group of laurel-crowned poets. The
principal figure here is the splendid Pindar, seated
with his right arm outstretched and wonderfully
foreshortened. His fine gray-bearded head, with
its beautiful large dark eyes, is turned up to the
two poets standing beside and above him. Behind

these two, finishing the assembly Urania overlooks, are a number of men, some supposed to be contemporaries of Raphael. Vasari speaks of Tebaldeo, Boccaccio, Ariosto, and Sannazaro. But only Ariosto and Boccaccio, whom we have learned to know by traditional types, can be certainly placed now. This cluster is broken again by two of the laurel-trees, and rhythm and movement are given by the varying turns of the heads and shoulders of the poets. On Apollo's right, next to Melpomene, is the figure that, as a compositional unit, balances Urania. Yet, without overthrowing his delicate, unforced balance, Raphael has succeeded in imparting an interest to the noble, blue-robed figure second only to that of Apollo. There is no doubt as to the identity of the majestic being with his grand, Jove-like head. It does not need the sightless eyes to tell us this is the Homer, whom only the god of poetry himself could have inspired. Holding an end of drapery in his left hand, his right is outstretched with the fingers extended, as if he were trying to follow with them the strains of music from the god's violin. He is a remarkably impressive figure. Dante and Virgil are behind him, listening to his ecstatic incantation, while an attractive youth sits below, preparing to write the words the poet sings. Below him, around one tall laurel that breaks the sky behind, is another collection of poets, among

whom is Petrarch. Balancing Pindar and also
overlapping the window on her side is the seated
figure of Sappho. Here once more the painter has
given a double twist to the figure that finishes the
lines of the composition with fine curves. She sits
with feet extended away from the window, while
her left arm, leaning on the top of the frame, brings
her torso round in an opposite direction. Her head
again is turned to look at the poets beside her. The
central group of the picture is in a higher, lighter
key than the sides, apparently with the intention of
differentiating the celestial dwellers from mere earth-
born poets. Altogether the fresco shows less feel-
ing than the Disputa and less grandeur than the
School of Athens. Yet it is perhaps more pleasing
than either. Certain of the figures are, for com-
position purposes, out of proportion, and the Muses
have too small heads for their heavy bodies. As a
whole, nevertheless, it has a breadth and freedom
that characterise Raphael's greatest period. With
the exception of the modern retouching, it is un-
doubtedly wholly from his hands.

Opposite, over the other window, is the allegory
of Prudence, or, as it is usually called, Jurisprudence.
This is the least " full " of the four great frescoes
of the Camera. Prudence rests upon a pure marble
plinth, while on each side of her, sitting on the
platform on which are her feet, are Force and

Moderation. It covers merely the arched section
above the window. In spite of the gloom of the
place, Raphael succeeded in getting a wonderful
purity and clarity of colour. It is bright and light
and gay and spontaneous, with power of line and
grace of movement. Prudence, supporting herself
on her left hand, is sitting sidewise, her head inclined
to the left. A winged boy of lovely shape holds
before her a mirror, which she steadies with her
hand. Her position is majestic, and her whole out-
line grand and noble. A mantle hangs from one
shoulder and falls about the legs, displaying only
the sandalled feet. At the front of the plinth is a
graceful boy, holding aloft a flaming torch. Close
beside him is Moderation, who is lifting a bridle,
and at the same time is turning to gaze at an exquis-
ite naked child facing the spectator. With his hand
and finger pointing heavenward, he is emphasising
what is everywhere emphasised in this Camera, that
it is only from above that all virtue comes. Modera-
tion's full mantle covers her limbs and one of her
arms, the sweep of the folds partly hiding the affec-
tation of her pose. On the other side of Prudence is
Fortitude, a woman of fuller and richer curves than
Moderation. She sits in profile, helmeted, with the
ægis on her breast, an ample drapery covering her,
one leg encased in armour alone escaping from the
folds. Playing with a lion's head with her left

hand, she holds in her right an oak branch, recalling
the motto of the Rovere. A merry child climbs her
lap to pluck the acorns among the leaves. The
whole figure is massive, powerful, with stately, deter-
mined lines. As if calling attention to this embodi-
ment of government and rule, a boy on the plat-
form at the left, back to, signs to some one out of
sight. Raphael here has combined the grace and
rhythm of the Greek ideal with the unbounded
vigour and energy of Michelangelo. Yet there is
no copying of any one. In feeling, this nearly fault-
less composition is purely Raphaelesque. The col-
ours have the tender gaiety that perhaps he alone
knew how to obtain, the foreshortening and lines
of the groups are always his, and they are not less
masterly than that attained by the worker in the
Sistine.

At the sides of the window, below the Jurispru-
dence, are Emperor Justinian Promulgating the
Pandects and Pope Gregory IX. Promulgating the
Decretals. The idea of the latter panel Raphael is
said to have taken from Melozzo da Forli's famous
fresco, Sixtus IV. Appointing Platina to the Post
of Librarian, and which was originally in the Vat-
ican library. In this Julius II. poses as Gregory
IX., and with him are the Cardinal Giovanni de'
Medici, the future Leo X., Alessandro Farnese, the

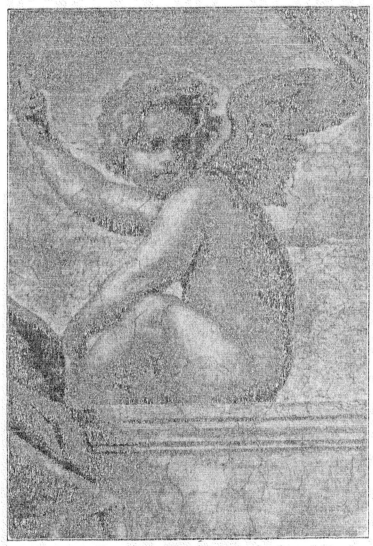

DETAIL FROM JURISPRUDENCE
By Raphael; in the Stanze

future Paul III., and another prelate, Antonio del
Monte.

The Stanza della Segnatura may be said to rep-
resent Raphael as does the Sistine Chapel Michel-
angelo. Both, perhaps, have individual greater
works to their credit. In the Madonna di San Sisto
Raphael reached a spiritual height unscaled in the
Camera. In the Moses, or the Medicean Marbles,
Michelangelo expressed the might and indomitable-
ness of his own soul perhaps even clearer than in
the ceiling of the Sistine. But in no other one work
is the entire man of each so fully displayed. For
clear, shining sanity, the Camera is unexcelled, while
the Sistine exerts power and impressiveness attained
by no other. In pure beauty and a unique perfection
of decorative and mural composition, the Camera
must take precedence. In the Sistine it is not beauty
so much as it is an overpowering grandeur of con-
ception that strikes one. The two cannot be com-
pared. They are as dissimilar as a deep inland
lake dazzling in its glorious shimmering blue and the
restless, whirling waves of the ocean itself.

The Stanza della Segnatura leads into the Stanza
dell' Incendio on one side and the Stanza d' Elio-
doro on the other. Not long after his completion
of the Segnatura, Julius ordered Raphael to com-
mence the second chamber of the Stanze. Before
he had finished the Eliodoro, Julius had died and

Leo X. was Pope. Whatever difference the new reign made politically or ecclesiastically, it was unchanged in its attitude toward Raphael. His work was prized as ever, and the one change seen in the Camera was that now the features of Leo appeared where before would have come those of Julius.

In the ceiling of the Stanza d' Eliodoro, Raphael's hand alone is felt. By the time the wall frescoes are reached, it begins to be apparent that the tremendous amount of work demanded from him, and which he, like artists everywhere, could not refuse, necessitated his giving more and more of the work to his assistants and pupils. Compared with the Segnatura, the Stanza is very simply adorned. Unfortunately, and the why is not thoroughly understood, the ceiling has suffered terribly from a loss and corrosion of colour.

The custom of draping the cold stone palaces with tapestry had come to Italy from the colder north. The Pope apparently had instructed Peruzzi, who was at work before Raphael took his place, to make a design on the ceiling imitating tapestry stretched across it in divisions. Raphael kept to this original intention, and the four principal ceiling compositions look as if they were woven or painted on cloth stretched and tacked to the curved sections between the heavily ornamented ribs that come from the central medallion to the outside border of the

ceiling. This centre design has the Pope's escutcheon framed in a round of oak leaves. The borders over the windows have the name and arms of Julius II. twice repeated, supported by angels. Between these are bas-reliefs, in painting, of Roman skirmishes and examples of Friendship, Chastity, Wantonness, Baptism, Prayer, Law, Labour, Force, Childhood, Play, and Study. It is a curious medley of Christian and heathen mythology. Hercules represents strength, for instance; Moses with the tablets, law.

The four ceiling pictures are God's Promise to Noah, Abraham's Sacrifice, Jacob's Dream, and the Burning Bush. Each of these four is directly over one of the four big wall frescoes, and each, by way of analogy, is connected with it. Half obliterated, with the colours almost ruined, these groups, nevertheless, show the highwater mark of Raphael's genius. It has been often said that when the young painter designed them, he had already had a sight of the ceiling of the Sistine. And indeed there can be little question about it, for Michelangelo had uncovered half of it to public view at about the time of the composition of the Camera della Segnatura. The power and vigour and sweep of the figures certainly do suggest the great sculptor-painter, who, influencing others, himself changed only by his own inner thoughts.

In the appearance of God before Noah there is
little in that majestic form to remind one of the
archaic type in the Disputa. Supported by three
angels, he floats through the air a few feet above
ground, with his arms held out over Noah, who,
kneeling, guards within his arms the clinging Ham.
At the doorway beyond and behind Noah is his wife,
carrying Japhet over her left shoulder, and turning
to encourage Shem, who is proudly holding a turkey
and looking up at his mother. The grace of the
children contrasts charmingly with the rugged frame
of Noah and the majesty and might of the Eternal.

The Sacrifice of Abraham fills its space less
perfectly than is usual in Raphael's compositions.
The sacrifice fire on the left of Abraham does not
adequately balance the angel floating down with
the lamp and the dropped clothes of Isaac on the
ground on the other side. Yet Abraham's figure, as
he stands with the knife uplifted over the altar where
Isaac is bound, is splendidly poised, and has the
realism of nature combined with the lines of the
Greeks. His lifted arm is stayed by an angel who
sweeps across the sky, and below, on the right, is
the second angel carrying the lamb.

The massing of Jacob's Dream is much more beau-
tiful. Jacob, dreaming on a pillow of stones, which
he tries to soften for his head by resting his arms
between, is a finely imagined figure, as he stretches

out considerably beyond the half of the picture. From the midst of clouds springs the dream-ladder, going upwards to the left, till it is met by the figure of the Lord, who, seen only to his waist, is enveloped in the billowing clouds. Michelangelo is again suggested in this Jehovah, whose head is much like the Zeus of antiquity. But the most exquisite part of the whole picture is the line of ascending and descending angels. Nothing lovelier than the lowest one can be imagined. With her head thrown up in profile, her hands clasped over her breast, and her beautiful wings spread behind her, she has the grace and holiness of one of Fra Angelico's creations.

The swirl of flames in the Burning Bush has not the dramatic, decorative lines that a modern Vedder would have given. None the less do they portray the mystery and blinding light that make Moses cover his eyes from the sight beyond mortals' ken. The difference between the shepherd, sylvan character of Moses, and the power and dignity of God, surrounded thus with flames and flying cherubs, is remarkably shown. Modern taste, as Crowe and Cavalcaselle rightly observe, which has slighted these four really wonderful compositions, has undoubtedly been influenced to its unjust decision by the state of the frescoes. The original colours have been retouched, the background entirely repainted by Carlo Maratta. The rawness of the edges and

the discrepancy between the new and old make the actual sight of these gems almost less valuable and less just than the photographic reproductions of them.

Heliodorus Driven from the Temple, the fresco which gives its name to the room, is a composition, every part of which conforms to the crescent-shaped space on which it is painted. The groups are distributed so that in the centre of the half-circle are the empty steps leading to the temple. The centre of interest, therefore, instead of being the central part of the picture, is here divided evenly between both sides. The balance is exactly maintained, and the result is a composition as unusual in its distribution as it is in its action. Within and between the pillars of the temple that border the central aisle of the edifice, is the altar at which kneels the High Priest Onias. About him are the priests of Aaron, the light from the row of tapers in front of Onias dimly illuming their faces and robes. At the left, on the pavement and steps leading to the Presbytery, is a striking group of worshippers, mostly women and children, who are staring with excited wonder and exclamatory gestures at the rout across the temple. Here, a gold-armoured avenger seated on a rearing horse has thrown to the ground Heliodorus, who vainly tries to protect himself from the plunging fore-feet of the excited animal. He has dropped

to the ground the jar full of the stolen treasures, and
the golden pieces are spilling all over the pavement.
By the side of the dancing horse, gliding over the
ground their feet do not actually touch, are the
angelic messengers, who, with the scourges in their
hands, threaten the two companions of the prostrate
chamberlain. The scene in the other half of the
picture is very different. Borne on a chair carried
by two figures, recognised as portraits of Marcan-
tonio and Giulio Romano, is Julius II., a living type
of the victory of the Church.

The state of this fresco is bad, dark, and dull,
especially in the right-hand groups. Heliodorus is
much injured. A flue of a chimney ran up behind
the wall, and caused numberless bad cracks. Though
the wall was clamped to prevent damage, many
parts of it have been repainted to its exceeding detri-
ment, while other parts have turned muddy and gray
and dark. It is supposed that the chief harm was
done in 1527, during the Spanish occupation of the
palace. It is evident that both Giovanni da Udine
and Giulio Romano largely assisted Raphael in this
composition.

In effect the Heliodorus is rather dark in tone.
Opposite it Raphael placed the glowing Attila, just
as on the walls with the windows he balanced the
high key of the Mass of Bolsena with the shadows
of St. Peter's Prison. The Attila, originally ordered

by Julius II., was completed under Leo X., and in
the representation of the Pope of the middle ages
Raphael immortalised his new patron. The fresco
shows the horde of Huns filling more than half
the crescent. In the middle, mounted on his war-
horse, richly robed and crowned, is Attila himself,
gazing terror-struck at the vision in the flaming
sky. In his consternation he has flung his arms to
the left, and both his horse and the white charger,
shown in the right foreground, are as frightened as
their riders. They pause and rear and snort, giving
splendid lines and positions for the master's brush.
The white steed, in the present state of the fresco,
where so much is unduly blackened, comes out
rather too strongly for the perfect harmony of the
composition, but in itself is a wonderful example of
a wildly excited, nobly proportioned animal, magnif-
icently seated by the corsleted, helmeted figure. All
about are the hordes, some mounted, some on foot,
all evincing fearful fright. The daring poses of
beast and man add to the intense breathlessness of
the scenes. At the left of the centre are two warriors
facing each other, whose splendid forms, massive
muscles, and fine grouping are one of the best bits
in the whole picture. The extreme left is taken by
Leo on his famous white palfrey, his ringed hand
raised, as if calling upon Heaven's intervention.
Dignity, assurance, repose are the strongest char-

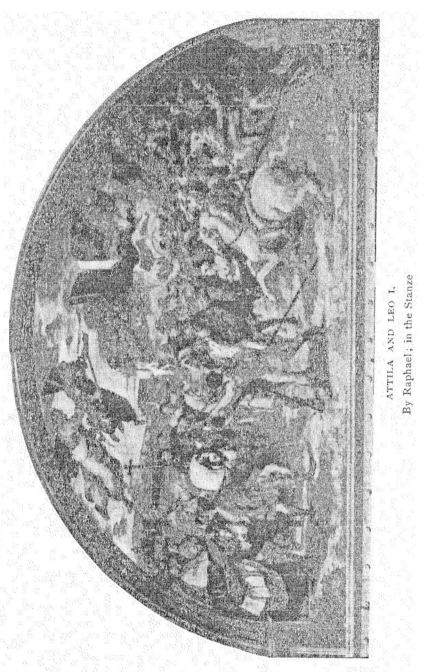

ATTILA AND LEO I.

By Raphael; in the Stanze

acteristics of this portrait face, with its puffy flesh, keen and protruding eye. Above, in the sky, are St. Peter and St. Paul, the vision called forth by the Pope, and which has resulted in the stampede of the enemy. Both hold swords, Peter carrying besides the keys. They are conceived with a grandeur of form and impressive appearance that, though not suggesting the actual shapes of Michelangelo, at least express the power his figures always conveyed. Beyond, in the left distance, against a glowing sky are the lines of the aqueduct and the Colosseum. The Pope is surrounded with his churchmen, and one of the cardinals is a duplicate of his own face. This was because the fresco was begun when Leo X. was still cardinal, and the Pope was intended to be a representation of Julius II. The riotous movement of the composition is admirably if somewhat arbitrarily balanced by the quiet, solemn group of the Church and the saints in the sky. Power, all through, — that is perhaps the strongest impression it conveys. It is not all by the hand of Raphael, this, as well as the Heliodorus, plainly showing the marks of his assistants. It has been retouched, also, to its great harm, and the ground is badly injured by corrosion of the plaster.

Over the window opposite the Mass of Bolsena is the Deliverance of Peter. It is as simple in its construction as the Heliodorus and Attila are com-

plex. There are even less figures than in the Bolsena. Of the four it is perhaps the one that most appeals to the modern spectator. The sentiment of it is wonderfully, beautifully, expressed. Directly over the window is the prison itself, clearly indicated by the barred door and the heavy framing pillars. Leading down from both sides of the window are the steps of the prison, where the guards are sleeping. Within the bars where Peter lies manacled and connected by chains to his two guards, is the angel bending over the prostrate saint. The glory that fills the gloom of the prison seems really of celestial origin. Its soft effulgence does not partake of the mundane. At the same time the original darkness of the dungeon is hinted at in the atmosphere that surrounds the light. Three of the guards on the steps at the left of the prison are roused from their sleep by a startled soldier, who points to the prison as he strides upward. In the sky the heavy clouds part about the crescent moon, answering the flaring torch that the soldier carries. On the other side, holding by the hand the dazed and wondering Peter, the angel, still with something of the glory that flooded the prison, is leading the released safely down by the two guards deep in the heaven-sent sleep. The angel here is supposed to be mostly untouched and to be wholly Raphael's work. The grace and curve of the figure, the benignity of the

face, the lightness of the poise, contrasted with the duller, heavier, half-realising Peter, all are wonderfully portrayed. The way also in which the light strikes different bits of the steel armours has a realistic incisiveness not often acquired. Technically, such a presentation of different moments of time in the one composition is a transgression of the laws of composition. Actually, in spite of a certain theatric quality, Raphael's success in thus presenting them proved his superiority to, and his right to disregard, what rules did not serve his immediate purpose. As an effect in chiaroscuro he has perhaps never surpassed it. The most injured parts are the figure of Peter, and the guards asleep on the right-hand steps. The angel in the cell is also badly corroded, and has been repainted in spots, and the landscape and sky on the left have been almost entirely modernised.

The Miracle of Bolsena was painted in remembrance of a legend of the thirteenth century of an unbelieving priest, who, while officiating, suddenly saw drops of blood issuing from the Host. In the fresco the features of Urban IV. are no longer his. Julius II. has taken his place. He kneels at one end of the altar, which is the centre of the picture, his elbows resting upon a cushioned stool. Opposite him is the priest lifting a wafer marked with the cross, and from which drops of blood are falling. Behind him,

on a level, are the acolytes with their lighted tapers.
This group is placed in front of a screen, dividing
them from the nave of a church whose receding
pillars are seen over their heads. Low down, behind
the Pope, are two cardinals and two prelates, and
still lower, on the ground, are the liveried bearers,
gazing up at the miracle. Their rich costumes give
a fine spot of colour to the foreground. In the other
half the congregation watch the amazing sight with
excited gestures or quiet interest, while leaning over
the screen behind the priest are two men, one point-
ing out the miracle to the other. This composition
is supposed to be almost entirely from Raphael's
own hand. The purity and transparence of the
colour, the exquisite finish of the modelling, along
with the subtile variety in each personage, are
unequalled by any other fresco in the room. Un-
equalled, one may say, by any other fresco in the
world. There is in this, too, no trace of the influence
of Michelangelo which is so often evident in many of
the other paintings. Rather, as Crowe and Caval-
caselle have noted, it carries one back to the portrait
work of Domenico Ghirlandajo, or to the breadth
of treatment and massive distribution of Masaccio.
Added, is a Venetian glow and depth of colour.
The scheme of colour, nevertheless, by which the
principals are thrown into light, higher tones against
the dark screen, is peculiarly Raphaelesque, as well

as is the manner in which the groups below are in
the darker tones, relieved by richness of garb rather
than by effect of light.

If the two larger wall paintings of the Stanza d'
Eliodoro had been as fully executed by the master's
brush as the two smaller, the room, it is safe to say,
would have been a greater monument to his genius,
even, than the Camera della Segnatura. As it is,
though in spots he rises in the Eliodoro to heights,
especially in technique, above the level of the other,
taken altogether the first room of the series still
ranks as a more perfect ensemble.

Among the other painters whom Raphael had dis-
placed in the Vatican was Perugino, his old master.
Perhaps out of respect, perhaps from lack of time
to create new, he left unchanged the ceiling decora-
tion of the latter in the Stanza dell' Incendio. It is
not important decoration, even for Perugino, and
there is an immeasurable distance between these
" tondi " and the ceiling of the Eliodoro. There is,
nevertheless, a certain charm about these frescoes
of saints and angels that recall some of the more
delicate and spiritual works of the Perugian.

Of the four wall paintings by far the best is the
one from which the room receives its name, — the
Incendio del Borgo. It was designed to commemo-
rate the fire that took place in the Saxon quarter
of Rome in the seventh century, and which Leo

IV. is said to have put out by making the sign of
the cross.

In the centre, at the back of the composition in
the Portico of St. Peter's, is the Pope, with the
features of Leo X. An excited crowd swarm below
him on the top of the wide steps, while below, on
each side, are the burning ruins. On the right the
people are carrying water in jars and pouring it
upon the flames, not yet conscious that the pontiff's
efforts are to still the raging fire. On the other
side they are beyond making any attempt at killing
the conflagration. Their whole efforts are directed
toward saving their lives. One is climbing down
the wall, another is dropping a child into arms
below, a son is carrying a father off on his shoulders.
In the foreground an hysterical mob of women and
children kneel and supplicate the Holy Father, dupli-
cated by another such crowd in the distance nearer
St. Peter's. This latter crowd, by the way, is one
of the best balanced and composed parts of the
whole fresco. Connecting the central foreground
group with the fire extinguishers on the right is a
woman who drives her naked children before her,
while she hurries along, carrying their clothes on
her arms. Taken as a whole, perhaps there is
more variety of position, more life and novelty of
grouping, than in almost any of the other frescoes.
The extraordinary amount of concentrated interest

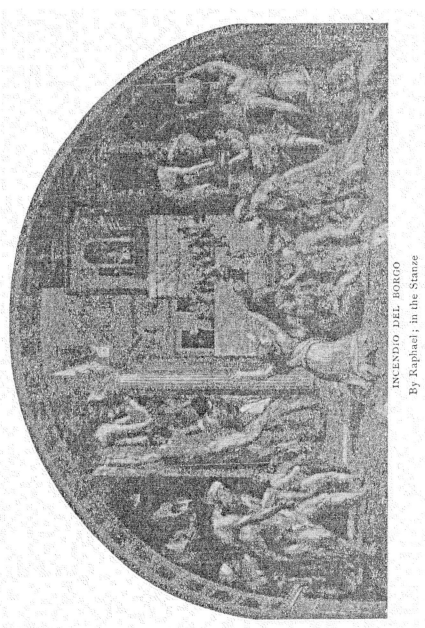

INCENDIO DEL BORGO

By Raphael; in the Stanze

in each part, however, has led to an accumulation of points of focus. Leo is too far in the background to be anything more than the literary centre. Of the other groups there is a different interest attaching to the two water-bearing damsels on the right than there is to the praying group in the centre, or the man scaling the wall on the left, or the one borne on his son's shoulders. Diverse as these groups are, they are of equal prominence in placing, and one's eye wanders over the wall without finding a central point of rest. There is no doubt but Raphael was here largely assisted by his pupils, and it is to them most of the exaggerations, the attitudinisings, the spreading of arms, and the coarse lines must be credited. Yet there is nevertheless a grand manner in it all, and Raphael's powerful conception is plainly felt, even under the most careless of assistants' brushes. The state of the fresco is bad. One fissure runs down obliquely through the centre, and the ground has been repainted in spots as well as the sky.

Raphael is not nearly so strongly felt in the other three frescoes of the room. Here he frankly turned over most of the labours to his aides, and satisfied himself with merely a cursory superintendence. It is not to be wondered at that they fall far below the standard of the great Urbinate.

Historically the Coronation of Charlemagne rep-

resents the presentation of the crown of the empire
to the King of the Franks by Leo III. In the fresco
Leo III. has become Leo X., and Charlemagne is
Francis I. Here, even the faces of the king and
pontiff show no sign of the master's hand. The
scene was depicted as taking place in St. Peter's,
as it was in its half-built state. Consequently there
are seen about many hangings and draperies, used
to cover the ruins and unfinished walls. Considering
the mixed-up setting, it is remarkable that Raphael
got, or constrained his pupils to get, the concord that
is shown here. In the middle distance, slightly at
the left, sits Leo, on his draped throne, holding with
both hands the crown he is about to place on the
head of the kneeling Charlemagne. All around are
gathered the cardinals, and it is in these, each
almost identically robed, and all close together, where
Raphael's own brush shows. Every individual head
is a personal study in its turn, line, and expression.
The extreme left of the foreground is occupied
by the bearers of the heavy silver gifts of Charle-
magne. Over their heads a part of a gallery shows
choir-boys watching the proceedings. The state
of the fresco is injured, both by repainting and by
abrasion. The heavy, opaque shadows are due to
the restorer's hand.

The Oath of Pope Leo, on the other window wall,
is also largely by Raphael's assistants, but still

showing the fine conception, the magnificent massing and space-filling, always characteristics of Raphael. In the centre over the window is the altar, Leo behind it, with his hand on the open book, gazing heavenward. At his right shoulder is the mitre-bearer, and beside him stands a cardinal, who is lifting Leo's embroidered mantle. The rest of the cardinals stand in a semicircle round the altar. At the back, raised, a clerk holds the crown of Charlemagne, while the king himself is upright, nearly back to, his head in profile, dressed like a Roman patrician, with a magnificent gold chain on his shoulders. He is pointing to the Pope. On each side of this scene steps lead to the ground, where are mace-bearers and some of the military following of the Pope. The fresco is faded and repainted so much that parts about the window are almost wholly gone.

On the remaining unbroken wall is the Battle of Ostia, representing Leo X. as Leo IV., after the so-called miraculous annihilation of the Saracen galleys, when, in 846, they threatened Ostia. The storm which arose, scattering and destroying their fleet, was supposed to be due wholly to the prayers of the Pope. The distance shows the ships of the Saracens, where the battle is still raging. Some of these battle-ships are in the bay, away from the shore, others are apparently alongside the landing

of a sort of tower-like octagonal building that con-
nects an open-arched portal with other walls and
buildings. Here, in front of the archway, a party of
the enemy is landed from a small boat. In the fore-
ground the prisoners are being hauled on shore and
led captive to the Pope, who sits at the left raised
on a block of marble. Behind him are the cardinals,
Giulio de' Medici and Bibbiena, and all about him are
members of his suite. With uplifted hands and
ecstatic face the Pope is blessing Heaven for this
victory to the Christians. Below, at his feet, his
captains are hauling the captive Saracens before him.
In the groupings of these struggling, suffering nude
figures, Raphael has marvellously displayed his com-
plete knowledge of the human form. They are being
stabbed, pierced, trampled upon, by their victors.
Out of the boat on the right, two of them, with their
hands bound behind, are being dragged to shore by
their hair. Everywhere torture, injury, frightful
hurt, — and it affects the Pope not at all. He
apparently regards all the agonies inflicted upon
the heathen prisoners as merely the just decree of
Heaven, — the Christians being only the instruments
of divine wrath. Raphael has made the Saracens
a fierce, barbarous looking race, evidently for dra-
matic emphasis of the differences between them and
their captors. The Pope's portrait is probably from
his own hand, as well as the two cardinals behind

.him. All three show Raphael at the very amplitude of his powers. The fresco is badly restored, blackened, and cracked. Several large fissures have made their appearance through the most important of the groups, and a number of the figures have been repainted many times. Even the faces of the Pope and the two cardinals and the crucifix-bearer have been hurt to a tremendous degree by retouching and patching. All the prisoners forced to their knees before the pontiff are in a lamentable condition.

The last of the three rooms which can really claim Raphael as creator, the Stanza dell' Incendio, is also the last of the three in point of achievement. The tendencies to exaggeration and unrestraint that are of occasional appearance in the Eliodoro are here almost an integral part of every fresco. Freedom and variety of movement have often degenerated into contortions and calculated posings, the " grand manner " has become dangerously like pomposity. Yet, as the American editors of Vasari say, " under and behind the exaggeration and the coldness is still the superb power of the Renaissance; we are yet close to the life-giving force of Raphael."

In the Hall of Constantino, the last of the Stanze that was to have even a word of direction from the great master, there is extremely little to show his part in the work. The Defeat of Maxentius con-

tains slight signs of the original studies by Raphael, the others almost none.

Two-thirds of this fresco are filled with the rush of the victor with his army through the ranks of his enemy, Maxentius lying head foremost and lifeless on the Tiber bank. Constantine, with his spear poised, has come safe through. Everywhere the steeds are galloping, struggling, kicking, or being stricken down. Men are fighting hand to hand, with here and there some one carrying off a dead friend. The emperor meanwhile presses on, trampling over his foes. Above the battle-ground angels are hovering, guarding Constantine, and assuring him victory.

The Vision of the Cross on the wall of egress shows Constantine upon a rostrum, in the middle of his camp. In the heavens above, surrounded by a golden glory, three angels bear a cross and advance toward a dragon-like monster who writhes in contortions, at their approach. A rush of soldiers and people before Constantine with battle standards flying and shields and spears flashing show that they, too, see the vision. Near the emperor stands his lieutenant, and at the extreme right a dwarf grins and prances as he tries on a helmet much too large. The landscape is full of the ruins of ancient Rome.

Giulio Romano, largely responsible for these last two, is probably also the author of the Baptism

of Constantine. The scene is laid in the Basilica of
San Giovanni Laterano. The principal figures are
grouped on a circular flight of steps. At their foot
Constantine is kneeling, nearly unrobed, while the
Pope Sylvester pours the water over him. The
pontiff has his left hand on the Gospels held up to
him by an acolyte. Near by, all kneeling, are a
servant with cloths, a deacon with a salver, and a
page with the emperor's breastplate, sword and
helmet. Behind are various other attendants and
prelates. At the left is a bearded man in sixteenth-
century dress, whom Vasari says is a portrait of
Nicolò Vespucci, the favourite of Clement VII. It
is possible that the sketch for this may have been
by Raphael.

Last of the four principal frescoes is the Cession
of Rome to the Papacy. The Pope, enthroned in
the old basilica of St. Peter, is receiving from the
kneeling Constantine a golden statuette. The usual
number of prelates, cardinals, and officials are
grouped about, while the Swiss Guard restrains the
crowd. On the high altar are relics of St. Peter
and St. Paul, and under the pillars on the right is
one whom tradition says is Giulio Romano, and on
the left Baldassare Castiglione. Kneeling or playing
on the foreground are women and children. This
is so poorly executed that only the arrangement and
distribution of figures is supposed to be by Giulio

Romano. It is thought that his assistant Raphael del Colle did almost all of it.

The Stanza di Constantino was hardly even planned when Raphael died. The only two figures completed were Justice and Comity. They were executed in oil, and were put in as experiments by Raphael. When Clement VII. came to Rome taste had returned to straight fresco. The two figures are both beautiful, showing many touches of Raphael's own hand. The scheme of the whole was to represent the frescoes as if they were painted upon tapestry that hung about the walls. This necessitated the rich borderings and the imitations of niches, with figures in relief, or of detached statues all about.

On the ceiling of the hall are various pictures by Tommaso Laureti and Antonio Scalvati, under the orders of Sixtus V. They are exceedingly ornate, but not of great artistic importance. Raphael dead, there was no one to take his place. His pupils could only imitate him, and never at his best. No more striking proof of the futility of their efforts could be found than to compare the Stanza di Constantino with any one of the other three. Michelangelo still lived, but the Renaissance was already dying.

CHAPTER VI.

RAPHAEL'S LOGGIE

AFTER Bramante's death, Raphael reconstructed one of the great architect's famous Vatican loggie, and built a third. It is with the one that, to save from becoming a premature ruin, he strengthened and supported, that the painter's name is most universally associated. For more than four hundred years this long, delicate corridor overlooking the Court of St. Damasus has been known best as Raphael's Bible. When one considers that the Bible scenes which have given it this name occupy a very small space in the midst of a decoration that covers the whole of the vaulting, the pilasters, and the walls of the loggie, one realises that it is what may be called the literary side of the painter's art which gives it fame to the world at large. Nevertheless it is the purely decorative portions of this wonderful whole that generations of less gifted decorators, designers and architects have found a mine inexhaustible in suggestion, fancy, and charm.

The gallery is divided into thirteen compartments,

so to speak, by twelve pillars and pilasters, the vault-
ing of each of these divisions being a square, domed
cupola. This roofing is entirely covered with an
ornamentation that encircles and separates four
rectangle or hexagonal spaces, placed one on each
side of the square that converges into the dome. It
is in these fifty-two small interspaces where are
painted the series of Biblical pictures. Bordering
them, filling the angles and curves of the dome, in
the walling between the pilasters, on the faces of
pillar and pilaster, around the entrances, on the
embrasures of the windows, everywhere, leaving not
an uncovered inch, are stucco-work and mono-
chromes imitating reliefs, grotesques, wreaths of
fruit and flowers, birds, children, landscapes, fishes,
musical instruments, beasts, all kinds of conven-
tionalised animals, reptiles, fanciful arabesques, and
scrolls, — all painted in the brightest and gayest
of colours. So bright that even to-day, in spite of
weather and time, and in spite of the fact that flakes
of the plaster are continually sifting down, — with
an ultimate and sure ruin as consequence, — even to-
day the gay freshness of the tones is a marvel and
delight. The designs themselves, in their sponta-
neous fertility of invention, their fantastical orig-
inality, their exuberance of colour, and a very
abandon of richness and floridity, yet are so com-
bined and made into such a perfect ensemble that

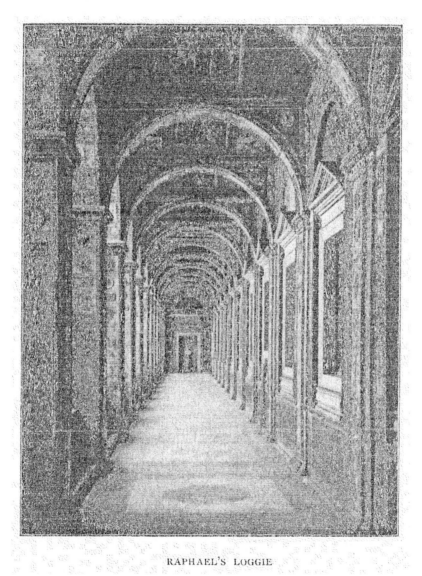

RAPHAEL'S LOGGIE

there is not a hint of useless or overdone exaggeration in part or whole. To attempt any adequate description of this ornamentation would require many volumes. Volpato and Ottaviani during the eighteenth century started to make them well known through engravings, but stopped long before they had completed the work.

The stimulus for decoration of this character was doubtless found in the excavations of ancient Rome, especially in the baths of the emperors, where wall paintings were full of quaint grotesques of all kinds. But these loggie of Raphael surpass not only all Roman excavations, but they conform more perfectly and yet more originally to the spirit of ancient art than do even the best of the long-after discovered walls of Pompeii.

Up to the beginning of the nineteenth century the whole corridor was open to wind and weather. At that time it was concluded worth while to take some ordinary precautions for the preservation of this priceless heritage, and forthwith the open arcades were furnished with windows.

Although these loggie are always given Raphael's name, as a matter of fact he himself painted not one stroke of them. It is even claimed that he did not so much as make the original drawing for any part. Vasari states that he gave the stucco-work and painting of the grotesques to Giovanni da Udine, that of

the figures to Giulio Romano, who, however, did
not do many of them. This last is probably a mis-
take. Giulio unquestionably had a very large share
in the work. With these two noted pupils of Ra-
phael were also associated Perino del Vaga, Penni,
Pellegrino da Modena, Vincenzo da San Gimignano,
Polidoro da Caravaggio, and Bologna. Yet, though
Raphael's hand is nowhere actually seen, his mind
and spirit everywhere are. At the time when the
loggie were painted, toward the close of 1517, Ra-
phael was surrounded with a corp of assistants who
were to him like so many extra hands. So well did
they understand his methods and ways of working
that, it has been conjectured, he needed only to indi-
cate hastily with a few determined strokes the main
points of a composition. The best of his co-workers
were then able to transfer it to wall or canvas, prac-
tically as the master had conceived it. Practically,
that is, so far as the distribution of mass, general
scheme of chiaroscuro, main dependence and inter-
dependence of figures, in groups or singly. Beyond
this, they could go only so far as their individual
talents would let them. The result of it all is a
magnitude of work passing under Raphael's name
with much of which his brush never came in contact.
In almost every case, however, it is saved from
mediocrity, and often is raised to highest artistic
value by the compelling power of the genius that

was the source of the inspiration behind the brush
work. Without question, the loggie would be more
beautiful if Raphael had painted them. There would
never have been the sometimes unpleasant brick reds
now in the figures, nor the heavy, often coarse, out-
lines, and certain crudities of colour and uncertain-
ties of expression would surely have been very differ-
ent under the harmonious and vivid touch of the
Urbinate's hand. But if Raphael had executed these
frescoes, the world in consequence would have lost
many other of the precious works better worthy of
his genius. And even as it now is, this composite
work of Raphael's aids ranks high among the great
wall decorations of the world. It is not too much
to say that hardly any other surpasses it in an
ingenuous gaiety, a fresh splendour, and, in the
scenes themselves, in a simple directness that is noble
in its simplicity, and wonderfully dramatic in its
pictorial treatment.

Of the fifty-two small frescoes in the thirteen bays,
in general it may be said that they almost literally
translate the Bible words they illustrate. Yet so
natural, unforced, inevitable are the compositions,
that they seem not at all constrained by the subject.
They appear to have been designed wholly with the
decorative point of view in mind. The simplicity
and straightforwardness in the telling of each story
is very unlike the way in which Michelangelo filled

his pictures with symbolical allusions and conceptions, which, full of spiritual significance as they may be, often cause confusion in the observer's mind. Raphael chose scenes specially adapted to pictorial representation, while Michelangelo, even when he took up his palette and brushes, could never free himself from the claims of sculpture. The surroundings of these scenes were so rich and varied that Raphael saw at once the paintings ought to be most marked for coherence, sobriety, and clarity. Like Ghiberti, he rendered each story with as few figures as possible, — making each thereby depend for its dramatic value upon the intensity of the moment described. So great a result with so few means has never been excelled. Of the most beautiful, perhaps, are Joseph Interpreting Pharaoh's Dream, Building of the Ark, The Angel's Visit to Abraham, Moses Striking the Rock, Interview of Isaac and Rebecca with Abimelech. In two of the frescoes it is easy to trace Raphael's indebtedness to other masters. Michelangelo's influence can be felt in the Creation, Masaccio's in Adam and Eve Driven from Paradise. In all the others, he relies not at all upon artistic tradition, but solely upon the text of the Bible. The subjects of the thirteen bays are as follows:

The first gives four views of the *Creation of the World:* God Divides Light from Darkness; He

Separates Land and Sea; Forms Sun and Moon, and Creates the Animals.

Second Bay — Story of Adam and Eve: Creation of Eve; The Fall; Exile from Eden; Labours of Adam and Eve.

Third Bay — Story of Noah: Building of the Ark; Deluge; Coming Forth from the Ark; Noah's Sacrifice.

Fourth Bay — Story of Abraham: Abraham and Melchizedek; Covenant of God with Abraham; Angel's Visit to Abraham; Flight of Lot.

Fifth Bay — Story of Isaac: God Appears to Isaac; Isaac Embracing Rebecca; Isaac Blessing Jacob; Esau Claiming the Blessing.

Sixth Bay — Story of Jacob: Jacob's Ladder; Jacob and Rachel; Jacob Asking for Rachel's Hand; Flight from Laban.

Seventh Bay — Story of Joseph: Joseph Telling His Dream to His Brothers; Joseph Sold into Egypt; Joseph and Potiphar's Wife; Joseph before Pharaoh.

Eighth Bay — Story of Moses: Finding of Moses; Burning Bush; Passage of Red Sea; Moses Striking the Rock.

Ninth Bay — Story of Moses, continued: Moses Receives the Tables of the Law; Worship of Golden Calf; Moses Breaks the Tables; Moses Before the Pillar of Cloud.

Tenth Bay — Story of Joshua: Israelites Cross
the Jordan; Fall of Jericho; Joshua Stays the
Course of the Sun; Division of the Promised Land.

Eleventh Bay — Story of David: David
Anointed King of Israel; David and Goliath;
Triumph of David; David and Bathsheba.

Twelfth Bay — Story of Solomon: Consecration
of Solomon; Judgment of Solomon; Queen of
Sheba; Building of the Temple.

Thirteenth Bay — Story of Christ: Adoration of
Shepherds; Adoration of Magi; Baptism of Christ;
Last Supper.

In the first compartment perhaps the best of the
four scenes is the Separation of Sea and Land. This
little fresco — and it is to be remembered that in all
these scenes the figures are only about a foot high —
is wonderfully fine, of pure Raphaelic character.
Hovering in the air over the globe, with flying,
splendidly massed draperies, is the Almighty, his
right hand pointing to the division of the land and
sea, his right forefinger resting upon a point of land
that projects into the water. A group of trees
partly hidden by the curve of the sphere gives the
finishing touch to a composition as simple as it is
dramatic and full of ·fire and imagination. The
colours are remarkably preserved, and almost it
seems good enough to be by Raphael himself.

The beautiful landscape in the Creation of Eve

STORY OF ADAM AND EVE
In Raphael's Loggie

has become sadly demoralised by abrasion. Here the Eternal is a man gray with age, wrapped in a heavy mantle. His left hand is upon Eve's shoulder, who, nude, stands in a beseeching attitude, her head inclined to Adam, who is sitting upon a bank and pointing to the place of his missing rib.

It is the expulsion from Eden that recalls Masaccio in Florence. The angel, sword in hand, descends a flight of steps, driving the two sinners before him. Adam, covering his face with his hands, is fairly pushed along by the angel's touch on his shoulder. Eve, whose too heavy shape is distinctive of Giulio, goes forward with lighter, more expectant tread. It is not difficult to fancy an excited interest in her countenance as she faces the unknown before her. The light strikes the front of the angel's robe, and lines the upper curve of his wing with fine effect. This effect is intensified by the shadow that glooms about the two in front, and is answered in the landscape, which behind and beyond them is bathed in light. Unfortunately, the angel's face is mostly sunk into oblivion, it is so badly abraded. The landscape, too, is discoloured.

In the third arcade, Noah, standing by the mighty framework of the ark, and the workmen whom he is superintending are forcibly contrasted. The builders are rough, burly workmen, Noah a figure of dignity,

and with a commanding bearing increased by the noble lines of his full drapery.

The story of Abraham is graphically told, especially where Melchizedek and his people bring bread and wine to the patriarch. In the foreground centre are the large and beautifully shaped wine-jugs. At the side of one stands Melchizedek, graciously presenting them. Abraham, in a Roman helmet and arms, with a lance over his shoulder, directs the movements of the slaves carrying the baskets of bread, at the same time acknowledging to Melchizedek the welcomeness of their arrival. The group is completed by attendants on each side offering and accepting the gifts. It is much damaged, and in many places has lost its colour. Yet it is distinctly Raphaelic in the grouping and balance, and the form of Melchizedek recalls St. Paul and the apostles in the cartoons.

Lot, Abandoning Sodom, strides along in the foreground, a hand in each of his daughters'. Slightly behind is his wife, just turning for the fatal backward look. Arrested as she is stepping forward, already the change from flesh to mineral has begun. She is painted as if she were of alabaster. The light strikes the group squarely in front, throwing shadows under their feet. The figures are spirited in movement, but somewhat heavy and clumsy in line.

In the bay devoted to Isaac, one of the frescoes shows the Almighty stretched upon a whirl of clouds, his figure and flying robes suggesting him of the Sistine. With his left arm reaching far out, he warns Isaac, who kneels in the foreground, not to undertake the journey into Egypt. At the left, under a tree, sits Rebecca. Isaac is modelled on the antique, his round cap rather like that of Mercury, but his limbs are too heavy for the fleet god.. There is a grand undulating landscape of trees and grass leading to the distance, where a castle on a hill and a chain of mountains break the sky-line.

Isaac Blessing Jacob shows the old father on his couch, the upper part of his figure nude. He is splendidly drawn, with a fine head whose white beard and hair give him the appearance of a Greek philosopher. At the foot kneel Jacob and Rebecca and three sons, while at the door enters Esau. In comparison with the patriarch, the others are poorly executed. The painting of this is assigned to Penni.

Jacob's Dream is differently conceived from the one in the Camera. The ladder is here directly in the centre, at the very top of which is the Lord, with arms wide outspread. Clouds effectually conceal the sides as well as the top and bottom of the ladder. Jacob lies on the ground, his head turned so that, if his eyes opened, he could see the double line of ascending and descending angels. The composi-

tion is possibly more graceful than the one in the Camera, but the figure of Jacob is better drawn and has more nobility in the latter. In this of the loggie, the chiaroscuro is extremely happy, particularly effective being the figure of the Almighty, relieved against a bright light that then merges into the darkness of the encircling clouds. The picture is well preserved.

In the Meeting of Rachel and Jacob at the Well, where a flock of sheep is drinking, Rachel, as well as the young girl beside her, has a grace and suppleness foreshadowing the later Italian art.

Two very good panels are in the division devoted to Joseph. Where he is telling his dream to his brothers, he is shown in the midst of an Oriental landscape, a flock of sheep on the extreme right, his brothers sitting and standing about him. Against the sky above are two disks upon which the dreams are painted. Joseph is delicately, even effeminately, formed, his charming grace in vivid contrast to the ruggedness of the others. The groups of these are skilfully balanced, and well indicate their surprise, indignation, and envy as they listen. The three standing with locked arms, nearly back to, are especially noteworthy for distribution of light and shade.

Again the subject is a dream. This time Joseph is interpreting for Pharaoh. Within a room whose two arcade openings look on to a pastoral scene,

Joseph, with the courtiers grouped behind him, stands before the king. Pharaoh, sunken in thought, sits in profile at the left, his hand feeling his beard. The dreams are again painted upon the conventional disks above the arcades. There is a certain looseness of massing here, at variance with Raphael's manner. The best part, perhaps, is the group of courtiers.

The Finding of Moses is at the moment when a couple of maids of Pharaoh's daughter have just drawn the cradle to the shore. Two of them are bending over it, while the baby reaches out his arms in delight. A number of maidens behind are looking on with great surprise, while the princess stands with her hands outspread, much kindliness in face and manner. Beyond, the sun is setting behind the low hills that slope to the water's edge, lighting with its reflection this well-composed group. Vasari claims it to be wholly Giulio's composition.

The Passage of the Red Sea shows the last of the fleeing Israelites crawling on to the land. At the extreme end of all, Moses, with his wand, is directly in front of the pillar of fire. The chariots and horses of the Egyptians have fallen victims to the waves. Parts of this composition have the dignity and impressiveness of scenes from the Sistine. But the less compact build of the whole, and the more literal transference of studies from the antique, show that Raphael's hand was needed here to give it that vivi-

fying touch with which he could bring untoward elements into glorious unity. It has, however, great movement.

The positions of the many heads of the kneeling or dancing Israelites about the Golden Calf are perhaps the most skilful parts of this picture. There is great diversity, not alone in the way the heads are turned or bent, but also in their features and expressions.

Moses Showing the Tablets of Law to the Children of Israel is a finely conceived picture, with a dramatic arrangement of light and shade. Standing before his prostrate people, Moses holds the tablets in front of him, three of his elders by his side. The power and grandeur of his face are striking. The light that splashes over the backs of his attending priests, and leaves the rest of their bodies in shadow, is duplicated by equally strongly marked effects in the crowd in front. One of the most vigorously drawn is the youth kneeling in the foreground, his hands resting upon his staff.

It is the moment just before the cavalcade leaves the dry land that is illustrated in the scene called the Transfer of the Ark through the Jordan. The precious Tabernacle, a wooden construction of about the shape of the toy arks of nursery days, is carried by priests and escorted by the band of Israelites extending in a curving line beyond. A man in feath-

STORY OF JOSHUA
In Raphael's Loggie

ered helmet, with rather exaggerated proportions, turns to direct them. At the other side is a seated river god of antique lines, indicating the miraculous opening for the passage. Joshua, in the middle of the foot columns on a white horse, raises his joined hands to heaven in prayer. The colours of this scene are harmonious, in a light key. The painting is undoubtedly by Perino del Vaga.

There are reminiscences of the Battle of Ostia in the one called Joshua Commanding the Sun to Stand Still, without, however, the splendid control of the thing as a whole. It is, nevertheless, an exciting scene of carnage, done with sufficient abandon fully to show the onslaught of the victorious and the agony of the defeated. Joshua, on his white charger, rides with far-flung arms, demanding the sun on one side and the moon on the other to obey his behests. Youth and force are expressed in his alert face and impetuous movement. Perino del Vaga is again assigned as author.

One of the very best of the frescoes attributed to this painter is the Triumph of David. David, in his chariot, follows his captive prisoners, one, a captain, with his hands bound behind him at the chariot's wheel. Back of them are the Israelites, headed by a plumed leader. David carries his harp with him, and his mien is that of a serious, deeply thoughtful sage, rather than that of a victorious warrior. The

two horses of the chariot, which largely fill the foreground, are drawn with much spirit and fire.

Of the Solomon arcade, the Reception of the Queen of Sheba is perhaps the most satisfactory. The character and build of several of the figures are more suggestive of Giulio Romano than of Perino del Vaga. Solomon, stepping from his throne, meets with welcoming hands the queen, who is already flying up the steps, while behind her are her slaves, heavily laden with presents. The movement is somewhat forced and theatric. The unqueenlike rush and flying draperies of her of Sheba are amusingly naïve. Yet the figures are well done, the king at the right of the throne, standing back to, and the kneeling slave emptying a basin of coins upon the floor being particularly felicitous. There is, too, more cohesion in the grouping than is usual with Perino del Vaga.

In the last arcade, the Nativity and the Adoration of the Magi are the best. The composition of the latter is much like that in the second series of the tapestries, but has, possibly, a better unity of feeling. The kneeling Madonna under the oblong window, through which angels are throwing flowers and blessings on those below, has a Tuscan charm that is emphasised by the bright if now disappearing colours. The Epiphany is more solid, constructive, and perhaps more Raphaelic in treatment. In fact,

however, the whole of the last three arcades, compared with the others, show much less coherence of design, charm of feeling, and knowledge of technique.

CHAPTER VII.

THE Galleria degli Arazzi is one division of one
of the long galleries built by Bramante to connect
the Vatican proper with the Belvedere. Here, on
both sides of the badly lighted corridor, hang, among
others, the ten tapestries called the Acts of the
Apostles, the cartoons for which rank among the
greatest of Raphael's works.

While the young painter from Urbino was dec-
orating the Stanze, Leo X. issued a new order. At
this time St. Peter's was still in such an unfinished,
unroofed condition that during inclement weather
it could not be used. On such occasions the cere-
monies took place in the Sistine Chapel, that being
by far the largest sanctuary in the Vatican. Paris
de Grassis, who was in charge on such occasions,
was continually forced to invent new decorations for
celebrating mass at the death of a cardinal, or for
a reception of deputations and foreign envoys. It
occurred to him that a set of tapestries to hang
below the wall frescoes on each side of the chapel

would make a more beautiful and more appropriate ornamentation than any he could devise. Up to this time Raphael had had no hand in the adornment of this, the principal chapel in the very heart of Latin Christendom. Possibly the knowledge of Bramante's earlier desire to have his young friend there represented may have influenced the Pope in his choice of painter for the work. At all events, about 1514, Raphael began the cartoons, which were finished by 1516. He was paid one hundred ducats apiece. As fast as each cartoon was completed, it was despatched from the master's atelier to the weavers in Brussels. Thus neither Vasari nor the Roman public in general ever really saw the original drawings. Strictly speaking, these cartoons, seven of which are now in the South Kensington Museum in London, are drawings rather than paintings. The colour is only lightly and slightly indicated. In spite of the grandeur given by brilliant tones with the interwoven gold and silver threads, it is the cartoons instead of the tapestries that rank higher in the art of the world. For in not a single one of the weavings did the Flemish painters in thread succeed in reproducing the delicate shades of expression and subtile indications of type and character that are such potent factors for beauty in all the cartoons. It is estimated that the weaving took about three or four years. In December, 1519, seven

of them were put on the chapel walls, and the whole
series was hung in 1520. This was an extraordinary
feat, and is evidence of some sharp pressure put
upon the Brussels workmen. Under Louis XIV.,
at the Gobelins, they required more than ten years
to weave a set of about equal labour, — the History
of the King, still to be seen at the Garde Meuble
National in Paris.

The tapestries have passed through many strange
vicissitudes. At the death of Leo X. they were
pawned for five thousand ducats. During the sack
of Rome in 1527, they were treated to all kinds of
indignities, the Punishment of Elymas still showing
where it was cut in two to sell more easily. Two
went as far as Constantinople, and all were sold by
the soldiers of De Bourbon. In 1545 the Vatican
managed again to get possession of them. In 1798
the French sold them to a company of dealers, and
they were exhibited in Paris. Once more Pius VII.
purchased them, and in 1808 they were returned to
Rome, and ever since have hung in the palace of
the Popes.

As has been often said, Raphael violated every
law of tapestry decoration in his designs for these
magnificent specimens of " arazzi." But, as usual,
his genius, riding over every conventional restriction,
succeeded in producing a series of stupendous, monu-
mental, historical compositions. As our American

editors of Vasari have excellently said, " In spite of
sprawling fingers, writhing toes, and rolling eyes,
and in spite, too, of a lack of subtile characterisation
which makes many of these figures academic, their
movements are grand." Of the cartoons, they remark
that they "are, as compositions, almost perfect.
Although the pantomime is exaggerated, the story
is told clearly and simply . . . with a directness
and force unrivalled since Giotto, with the new
science of the great epoch, and with a freedom from
mysticism which made them especially comprehen-
sible."

Vasari states that when the tapestries arrived,
they "awakened astonishment in all who beheld
them." But it was the depth and richness of the
colouring and their decorative qualities more than
their higher artistic worth that appealed to those
early observers. And, as Grimm remarks, their
moral and spiritual significance seems never to
have been noted. To-day, it is quite impossible
to judge of them from the sixteenth century stand-
point. Here and there the gold threads gleam out,
in a few detached spots the softness of the flesh-
tones or the richness of drapery and landscape still
faintly hint of what the whole must have been nearly
four hundred years ago. But mostly, time has dealt
as heavily with these treasures of the weavers' loom
as with the paintings of Leonardo. No longer glow-

ingly rich, exquisite in gradations of tone and colour,
they are almost monochromatic in their weak, dull
grays. Only the grouping, harmony of arrange-
ment, balance, and general effects of drawing and
composition remain. In such ways alone they must
be considered, and so considered their inferiority to
the cartoons is far more apparent than it could have
been in their days of gorgeous brilliancy.

As stated, the ten pieces are known under the title
of the Acts of the Apostles. More strictly, they could
be called scenes from the lives of Peter and Paul.
The first of the series is the Miraculous Draught of
Fishes, or, according to Grimm, the First Call to
Peter. Two very small boats, hardly large enough
to hold one, let alone the three passengers that are
in each, are near the shore. In the first, at the bow,
Christ is shown sitting in profile, with his right hand
raised as if acknowledging from where comes his
power. In the middle kneels Peter, his hands
clasped, adoring the Master. Andrew, stepping
down from the stern, seems about to follow Peter's
example. All around are the fish, of which indeed
the boat is full. In the other craft are two young
men, both tugging with might and main to bring in
the heavy haul that drags the net deep into the sea.
They are half naked, and the pull on their arms is
shown in their rigid muscles thrown out like cords.
The old man steering is modelled on the lines of

an ancient river god. So far as one can see stretch
the waters of Gennesareth unbroken to the horizon
line. At the left, people are busy on the shore near
the city walls, behind which lofty buildings tower.
In the foreground, among the grasses, are cranes
eagerly waiting for their share of the catch.

Raphael, of course, was quite incapable of drawing
such inadequate boats from the lack of knowledge
that they were inadequate. Rather, he used them
as the Greeks used symbols, — as mere suggestions.
Doubtless when the hanging came fresh from the
looms, the colour prevented their diminutiveness
from appearing so strongly. Now, when the shades
are so faded, when the lights and shadows no longer
have their balance of proportion, to modern eyes
the insufficiency of these tiny boats sometimes threat-
ens to obliterate the real dignity and nobility of
Christ, the fine feeling in the expressions and pose of
the disciples.

The borders of the tapestry are very lovely, as
indeed are all of the series. At the top of this are
the arms of the Medici, at the bottom Leo appears
riding with his suite of cardinals at the gates of
Rome. On the left is the figure of a woman standing
behind an allegorical impersonation of the Arno. On
the right, a captain, in classic military dress, wel-
comes the pontiff. Rome is indicated by the Tiber
lying at his feet, his left elbow on a wolf, and a

cornucopia in his hand. The side borders are ara-
besques, impersonations of the seasons, festoons, gro-
tesques, birds, and animals all woven into one
harmonious decorative design.

In the Charge to Peter, Christ stands at the left,
pointing to a flock of sheep behind him, while with
the other hand he emphasises his words to the kneel-
ing Peter, who holds the big key in his arms. Peter
is in front of the other disciples, thus connecting
and at the same time separating Jesus from the
group that is admirable in an arrangement which
brings each member clearly into view. The varying
attitudes and expressions are given with portrait-like
fidelity, the two foremost ones of the number, An-
drew and John, being strikingly beautiful. The
intent seriousness of Peter is no less plainly shown.
In the Redeemer's own figure is an added spiritual
dignity and an ideal beauty of face.

So far as is known, no cartoon exists of the third
of the series, — the Stoning of St. Stephen. Stephen
kneels a little to the left of the centre in deacon's
dress, his arms outstretched. He is calling upon
God, who, with Christ and Angels, appears before
his vision in the skies. Saul sits in the right hand
corner of the picture, and directs five or six big,
burly ruffians. They are bending, picking up stones
or already flinging them at the martyr. The action
and grouping of these revilers are extraordinarily

spirited, showing, too, some wonderful foreshortening in their positions. This last is especially marked in the man with bared shoulders stooping over in the foreground. The landscape, the really lovely part of the picture, reminds one of the palace-crowned hills about Rome.

The Flemish weavers must have found in the Healing of the Lame Man a subject more congenial and natural for their looms. Here there is no lack of gorgeous ornament, fine dresses, florid architecture. It is a scene much more suitable for reproduction in tapestry than any of the others. Between the twisted pillars, said to have been copied from those brought from Jerusalem to Rome, stand St. Peter and St. John, intent upon their deeds of mercy. Peter is holding the right hand of a fearfully deformed beggar, while with his other he exorcises the evil spirit. The strain in Peter's own hand is evident, and in the uplifted face of the beggar shines his consciousness of the beginning of the cure. On the other side, looking down with compassion, is John, and beyond, between two pillars, another crippled beggar leans on his staff, gazing with neck far forward, skepticism and hope struggling in his ugly face. At the extreme sides of the picture, charming young Roman mothers with their babies are passing along, while a sturdy sprite of a naked boy at one end gives vivacity to the whole.

The Death of Ananias, next in the series, is built somewhat upon the lines of the School of Athens. The apostles are upon a platform, Ananias and his companion on the tesselated pavement below. At the left, beyond, a flight of stairs is seen, on the right, an open window gives a glimpse of a peaceful country landscape. The rough wooden platform with draped background suggests the hasty improvised church of the early Christians. St. Peter, the centre of the apostles, stands with hand extended, his face expressing sternest judgment as he calls down upon the offending perjurer the punishment of Heaven. As if at the command of that pointing finger, Ananias has fallen to the ground in a writhing agony that is already turning to the paralysis of death. The frightened spectators press forward, hardly believing the sight of their eyes. On the platform next to Peter is another apostle, pointing upward, and others at right and left show by their faces their grief and anger at the unhappy man's sin. All the attitudes are vivid to an extreme degree.

The Martyrdom of St. Stephen and the Conversion of St. Paul are not equal to the others, and it is reasonably sure that Raphael's pupils had a large share in their production. The telescopic lines of the composition of the latter are particularly un-Raphaelesque.

Seventh in order is the Punishment of Elymas.

This so absolutely explains in line the Biblical
words it illustrates, that, as Müntz observes, nothing
describes it better than the verse itself: "And . . .
they found a certain sorcerer, a false prophet, a Jew,
whose name was Bar-Jesus; which was with the dep-
uty of the country, Sergius Paulus, a prudent man;
who called for Barnabas and Saul, and desired to
hear the word of God. But Elymas the sorcerer (for
so is his name by interpretation) withstood them,
seeking to turn away the deputy from the faith.
Then Saul (who is also called Paul), filled with
the Holy Ghost, set his eyes on him, and said, O
full of all subtilty and all mischief, thou child of
the devil, thou enemy of all righteousness, wilt thou
not cease to pervert the right ways of the Lord?
And now, behold, the hand of the Lord is upon thee,
and thou shalt be blind, not seeing the sun for a
season. And immediately there fell on him a mist
and a darkness; and he went about seeking some one
to lead him by the hand. Then the deputy, when he
saw what was done, believed, being astounded at the
doctrine of the Lord." Grimm says that generally
one feels, in comparing Raphael's sketches with the
finished compositions, a lack in the latter of the
splendid breadth and robustness so strongly shown
in the original studies. Here, however, he finds this
same vigour of treatment. He says that it seems as
if he had "brought his models straight on to the

cartoon." Indeed, he goes on to note, "A look
of common reality lies over the whole which reminds
us of photographs. The hand gestures are speaking
. . .; most of all Elymas, who is trying to inter-
rupt Paul's discourse, and terrified by the darkness
creeping over him, stretches out his arms like huge
feelers, which grope tremblingly about in the empty
air." As remarkable as any part of the composition
is the management of the crowd of spectators, where
are infinite variety and movement with no lessening
of homogeneity.

Illustrating the verses in the fourteenth chapter
of Acts, where Paul heals the cripple, is the tapestry
called Paul and Barnabas at Lystra. The moment
described is when the people have become convinced
that the two are the very gods come to earth, in
consequence of which belief they bring oxen and gar-
lands to make sacrifice to them. "Which when the
apostles, Barnabas and Paul, heard of, they rent their
clothes, and ran in among the people, crying out, and
saying, Sirs, why do ye these things?" Here again
the full scene is depicted. And no one, it is to be
believed, but of Raphael's own genius could have
brought all these many incidents and elements into
a successfully fused whole. He has succeeded beyond
even his own standard. In no other one of all his
marvellous compositions has he attained more per-
fect expression, more abundant life and power, or

more absolute coherency. In the forum a crowd is
gathered. On one side are the mere spectators,
gazing with utmost, astonished devotion at the two
apostles who are descending the temple steps. Their
own faces show horror and pity, and Paul tears his
robe as he turns away from the scene in front, where,
led by the sacrificial priests, are the oxen and rams.
An executioner lifts his club high over the head of
the big ox held by the kneeling captors. By the
altar are two entrancing little boys, one blowing the
pipes, another bearing the censer. At the moment,
a young man, apparently seeing and interpreting
the expression in the apostles' faces, springs forward
to arrest the intended sacrifice. Among the crowd,
the paralytic, the cause of all this excitement, has
flung away his crutches and is throwing himself
bodily toward his healer, his face full of an incredible
joy that is very nearly glee. An old man near him
lifts his short garment and examines with astonish-
ment the suddenly straightened legs. Here is another
composition by Raphael where vigour and grace,
strength and charm, compact lines and masses, along
with tremendous variety of form, expression, and
position, all mingle and make that wonderful har-
mony which was the perfection of his art.

In the Preaching at Athens, simple as is the
idea, Raphael has, with much less action, given as
dramatic and lifelike a scene as in the " Lystra."

Paul is telling the Corinthians that their altar to the Unknown God is the only altar at which they should worship. "And when they heard of the resurrection of the dead, some mocked: and others said, We will hear again of this matter. So Paul departed from among them. Howbeit certain men clave unto him, and believed; among the which was Dionysius the Areopagite, and a woman named Damaris, and others with them." As Paul stands on the steps preaching, he is a simply lined, noble figure. The crowd before him express well the surprise, the skepticism, the doubt, the contemplation of its different members. Every face tells its own story, and every figure helps to balance the consummate scheme of the picture. To give the scene its full significance, Raphael shows Damaris and Dionysius in rapt absorption at the end of the steps.

Paul in Prison, also called The Earthquake, is of much the same order as the St. Stephen and Conversion of St. Paul. Owing to the large part entrusted to his pupils, it is a comparative failure. The tapestry is injured. Paul is behind a grating similar to that of the "Deliverance" in the chamber of Heliodorus. At the corner of the foreground are two men, the foremost of whom is being forced upward by the convulsive movements of the personified Earthquake, — a huge giant who is lifting the earth till he has formed about him a sort of vast cavern.

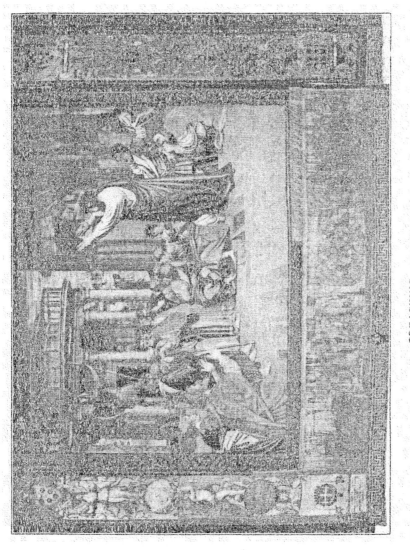

PREACHING AT ATHENS

From drawing by Raphael ; in the Galleria degli Arazzi

The borders of all these tapestries are sumptuous
beyond telling in imagery, in dramatic interest, in
decorative effect. Many of them, so fine are the
groupings and so vivid the scenes they depict, have
been assigned to Raphael's own hand. He was one
of the first artists to discard the inevitable fruit and
flower borders for a sort of running story. Some
of these framings are in imitation relief, in mono-
chrome; some, painted in brightest tones, are alle-
gories of the seasons, of the virtues, of life in all sorts
of phases, interspersed with geometrical, floral, and
grotesque designs where, as in the loggie, birds and
reptiles, animals and flowers, are mixed in an exuber-
ance that is never beyond the limits of the decorative.
To-day, when the colours of the weavings are so
changed, it sometimes seems as if these framing
designs were the most beautiful parts of all.

Of the rest of the tapestries in the gallery, nothing
much in the way of praise can be given. The won-
derful success of the Sistine series decided Leo X.
to ask Raphael for another set, descriptive of the
Life and Death of Christ. The subjects were The
Nativity, Adoration of the Magi, Massacre of the
Innocents (in three pieces), Descent into Hell,
Resurrection, "Noli Me Tangere," The Supper at
Emmaus, the Ascension, the Descent of the Holy
Ghost. All except the Descent into Hell still exist
in the Vatican. With them is a hanging which

was once behind the pontifical throne in the Sistine. So far below the first set are these, so forced the action of the figures, so coarse and common the drawing, so vulgar and heavy the accessories, it is only by diligent study that here and there a bit is found suggesting the master who is said to have designed them. They were undertaken in the last years of his life, and it is doubtful if he made a full study for any one. After his death, his assistants gathered the scattered, separate heads and figures, and built from them the result which is so far below the worst their first projector could have imagined. It was bad enough when pupils less favoured than Giulio Romano undertook so to interpret the master. It was much worse, as Müntz points out, when men "like Tomaso Vincidor da Bologna, or some Fleming who was perfectly strange to the principles of the Renaissance, attempted to continue the work of Raphael."

CHAPTER VIII.

THE SCULPTURE GALLERIES

THE old summer-house of Innocent VIII. is now the centre of the sculpture gallery of the Vatican. During the pontificate of Julius II. and Leo X., their small collection of antique marbles, as has been said, was arranged by Bramante in the gardens of the Belvedere. Under Clement XIV. and Pius . VI. they grew to such numbers that some other and better protected housing had to be devised for them. The Pio-Clementine Museum was the result, that followed by the Chiaramonti and the Braccio Nuovo, and then, with Gregory XVI. came the Etruscan and Egyptian rooms. For many years the sculptures of the Vatican were universally regarded as being the most wonderful and perfect specimens of Greek art extant. The later explorations of Greece and the searching investigations of modern critics have torn them from their towering pedestal of fame. Most of the very best specimens have been proved to be merely admirable copies of celebrated works, and the majority of the rest are

not even considered first-rate replicas. Such has
been the rebound in opinion as to their value. But
after all, these copies of antique works of art are
in a way more valuable than the undoubted originals
that occasionally reward the explorers' excavations.
Furtwängler has truly said that even the most
mediocre of the marbles in our museums are proof
in themselves of the value and celebrity of the origi-
nals. The more beautiful and famed a work the
more numerous would be its duplicates. There is
little question that the greatest marbles of Greek
art are lost for ever. It is only by the replicas, bad
copies as they may be, that one can learn the charm
and value of the rarest of the antique sculptures.
And nowhere are copies more abundant, or, on the
whole, more excellent than in the enormous collec-
tion of the Museum of the Vatican.

Whatever the critical estimate of the actual value
of the collection itself, there can be no two opinions
as to its extent or arrangement. Nowhere are gal-
leries more splendidly designed for their purpose or
more artistically decorated, or antiquities more intel-
ligently and beautifully arranged, than in the palace
of the Popes. Of the sixteen rooms stretching from
each end of the Braccio Nuovo, bounding all sides
of the Giardino della Pigna, and squaring the Cor-
tile di Belvedere, each is paved, walled, arched, and
lighted with unusual taste, and with a continuity of

design and purpose not often seen in public museums.
The prevailing colour of the walls is an old rose,
a most effective setting for the creams and grays of
the statues.

The Museo Pio-Clementino is made up of eleven
different compartments. Of these the most beautiful
in construction and ornamentation are the Sala a
Croce Greca, built by Simonetti under Pius VI.,
and, as its name suggests, in the shape of a Greek
cross, with its floor paved with fine mosaics, some of
them found in the Villa Ruffinella, near Frascati;
the Sala della Biga, a circular hall with a cupola;
the Galleria dei Candelabri, a very long corridor
with ceiling paintings and a handsome modern
marble pavement; here are some lovely vases in
marbles of unusual and striking colours; the Sala
Rotunda, also erected by Simonetti, and with a fine
mosaic flooring found in the Thermæ at Otricoli;
Sala delle Muse, a magnificent room, of octagon
form, domed, and ornamented with sixteen columns
of Carrara marble; Galleria delle Statue, the
summer-house proper of Innocent VIII., still with
traces in the lunettes of paintings by Pinturicchio;
Gabinetto delle Maschere, so called from the ancient
mosaic in the centre of the floor, which was found
in Hadrian's villa; the Cortile del Belvedere, part
of the original summer-house, has an inner arcade
and corner cabinets where are some of the chief gems

of the collection; finally, the Museo Chiaramonti, chiefly remarkable for its great length. In this corridor alone there are fully three hundred marbles. Of all the Vatican's many hundreds of statues, it will, of course, be possible to speak of only a few.

Dilettanti, amateurs, connoisseurs, archeologists, have exhausted themselves and their language in description, appreciation, adulation, and criticism of the Apollo Belvedere. For long it was supposed to be an original dating from the fourth century B. C., an example, therefore, of the greatest era in Grecian art. Now it is pretty conclusively proved to be no original at all, and most probably a copy of a work of the Hellenistic period. This statue, according to Helbig, was not found at Antium, as has been generally claimed, but in an estate belonging to Cardinal Giuliano della Rovere near Grotta Ferrata. It is said that Giuliano bought it the very day it was discovered. The top of the quiver, the left hand, the right arm almost from the shoulder, and various small parts of drapery and legs were all restored by Montorsoli. It is stated also that he has not put the right arm quite as far forward as it should be, and the open hand he has given it is universally condemned.

Poised so lightly that he seems to be moving through the air rather than on solid earth, the god is shown with his weight somewhat thrown upon

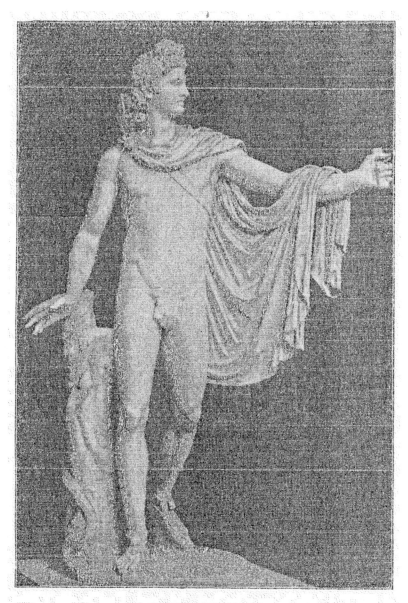

APOLLO BELVEDERE
In the Cortile del Belvedere

his left foot, his right slightly behind and with the
toes only touching the ground, as if he were advanc-
ing rapidly but noiselessly. The twist of the figure .
is marvellous, slight, yet full of a rhythmic har-
mony. From the waist he turns toward the right,
while his head is thrown sharply to the other side.
The left arm is held far out and is partly draped
by the chlamys which hangs from the neck and over
the back and left shoulder, mostly covering the
quiver slung over his back. His right arm is also
away from the body, and the restorer has placed
upon it a foolishly open forceless hand. There
have been reams written discussing the nature of
the object he is supposed to have carried in his left
hand. Furtwängler says positively that the one
time prevalent notion that it was an ægis is wholly
incorrect. He, as well as several modern archæolo-
gists, claim that in that hand he held a bow, and in
the right a bunch of laurel with knotted woollen
bands, the traces of which are found in the bit of
laurel carved on the tree-stump at his side. He
was thus shown in his double capacity of the " far-
darter " and the healer. Whatever he was originally
meant to represent, there is a subtilty of swing and
expression that makes the statue something far
removed from a mere type. It is a vivid presenta-
tion of an intense personality, at a suddenly intense
moment. One feels in the superb poise a very rush

of noiseless movement as if he had sped away from
concealing clouds. His face is no less expressive.
The slight scornful lift of the proud lips, the brows
just hinting at a contraction, and the quivering
nostrils all seem to suggest some definite, hasty
demand upon the god, rousing his wrath and call-
ing for his assistance. The calm forehead, how-
ever, is unruffled. It is as if the scorn and indig-
nation of the rest of the face were held in check by
his consciousness of his infinite mind. And yet,
in spite of the boldness, the surety, the sweep of
the poise, the nobility of brow, and the godlike charm
of the whole creation, there are other things besides
that prevent unalloyed or deepest admiration. The
overelaborate hair, the careful, precise, though beau-
tiful, folds of the chlamys, ill according with the
swift onrush of the wearer, the almost too exquisite
curve of outline, a sort of dainty grace and an in-
dubitable if slight theatricalness about the whole
figure, all are foreign to the grand simplicity and
noble directness of the greatest art creations. It
has been called the " prince of a fairy tale," a not
inapt title. Yet, granting all its severest detractors
have alleged against it, the Apollo remains what its
first lovers called it, — a thing of joy for ever. His
" noble limbs are moulded with the ease and freedom
which are the result of perfect mastery, and the proud
and beautiful face from which the Muses drew their

inspiration gleams with expression as he moves along in graceful majesty, bathed in the purple light of eternal youth."

In its own "Gabinetto" in the Cortile is the Laocoön, the group famous not only in art but literature. The subject of a wonderful essay on the limitations of different arts by Lessing, it has been discussed in all its relations by Winckelmann, Goethe, Heine, and others, and is still under constant examination among archæologists. It was discovered in January, 1506, near the Thermæ of Titus, and when Michelangelo and San Gallo were sent to inspect the wonderful find they declared it was the group described by Pliny as having stood in the palace of Titus. Lübke is of the opinion that there is no reason for the supposition fostered by Pliny's remarks that it was originally made for the palace. At least it is proved by actual measurement that the niche in which it was said to have stood is too small to hold it. The right arm of Laocoön is a restoration of the early eighteenth century, and indeed the right arms of both of the sons are modern, and incorrectly placed at that. Laocoön was a priest of Apollo, and because he blasphemed against the god two snakes were sent to destroy him and his two boys, as he was about to offer sacrifice at the altar to Neptune. The altar is behind the priest in the group, and the two boys are on each side.

Making a connected group of the three otherwise
detached figures, are the huge pythons. They have
wound their folds about them in a terrible struggle
in which one son is already expiring, while the
father is in the midst of the most awful death-
dealing agonies. The other son as yet is unbitten.
The folds, however, are about him, but as he turns
to gaze horror-struck at his father, the spectator
feels that he at least may have a chance of escape.
It is the only point of perspective, so to speak, the
only outlet, in the whole composition. The uncer-
tainty as to his fate is just enough to give one
a breathing space from the accumulated horror of
certainty as to the end of all the rest. It adds
greatly, therefore, to the dramatic intensity of the
group. The shape of the composition is pyramidal.
Though the father has half-sunken to the altar in
his agony, he is still above the two sons, both of
whom are under size. This pyramidal form is in-
creased by his wrongly restored right arm, now
thrust through the serpent coils up into the air far
above his head. It would be more compact and
better massed if the hand was where it undoubtedly
originally was, resting on or near the head.

To Lessing, the horrible convulsions of the three
victims meant a tremendously heroic struggle with
destiny. It was the mental significance that lay
behind the tortured limbs and anguished face of

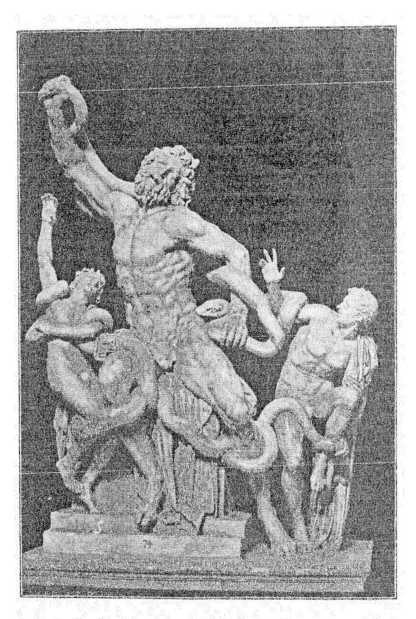

LAOCOÖN

In the Cortile del Belvedere

the father that made it seem to him so wondrous
a work. If one could thus translate the struggle to
the realms of real tragedy unquestionably the gran-
deur of the group would be immeasurably increased.
But to most observers to-day there is little to be seen
or felt but mere physical agony. This is carried
to its extreme in a marvellously effective manner.
Of all the creations of plastic art no face, it is safe
to say, has ever succeeded in producing such an
intensity of suffering as that of the Laocoön. Homer
can go no further. Whether the representation of
such a state is a proper subject for the plastic arts
is another question. During the eighteenth and
early part of the nineteenth century the Laocoön was
the subject of the wildest sort of praise. Modern
criticism has to a certain extent robbed it of the
supremacy then undisputed. Besides the question as
to its actual intrinsic artistic value, there has been and
even still is no less amount of conjecture as to the
date of its execution. It seems to be generally con-
ceded that it is an original, the only point of doubt
being whether it was a work of Rhodes of a later
date than the Pergamum frieze, or whether the
opinions of earlier archæologists, who assign it to
a period at least no later than the early part of the
second century B.C., can be sustained. Furtwängler
and others of equal prominence place it later. It is
claimed that its similarity, and at the same time its

inferiority, to parts of this same Pergamum frieze prove that its construction came at a later and less artistic date.

The Torso, the world-famous Torso of the Belvedere, has been subjected to equally scathing criticism. Even the old story of its discovery and placing in the Belvedere by Julius II. has been questioned, till now it is generally conceded that it was in the Colonna family down to the time of Clement VII., and by him was put among the Vatican collections. There is one indignity the Torso has escaped. It has never been defamed by the restorer's hand. In all its maimed glory, just as it was dug from the crumbling ruins, it rests to-day on its revolving pedestal in the Museo Pio-Clementino. It is indeed merely a torso, — no head, no neck, no arms, part of the left shoulder gone, the right leg broken off at the knee and the left but slightly below it, — no wonder the vandal restorer felt the task beyond even his powers. We may congratulate ourselves that there was so little undestroyed. Given a leg and arm or two more, and some one would have tried to match them. It is supposed to represent Hercules, partly from the lion skin that is spread upon the rock on which the god is sitting. He is bent sidewise to the right, and forward, and then is twisted to the left, giving chance for a fine play of muscles. The artist's name carved is Apollonios, son of Nestor.

The fact that names of sculptors were not usual in
the works of early artists is one reason why the first
century B. C. is ascribed as the date of this fragment.

It is thought that Apollonios may have been the
same sculptor who made the celebrated chrysele-
phantine statue of Jupiter for the new Capitoline
temple consecrated in 69 B. C. All sorts of ideas
have been advanced as to what the whole statue must
have been. One theory is that the god was sitting
playing a large cithara supported by the left thigh,
while he was singing over the success of his labours.
Again it has been ventured that he was only one of a
group. Whatever he was, that which is left of him
has been the admiration and the despair of artists
from the time of Michelangelo to Gérôme. The
great Italian said that all the excellencies of
antique sculpture were in it alone, and he called
himself its humble pupil, claiming that to it he
owed all his power for representing the human form.
And when he was an old man he used to run his
trembling fingers lovingly over its outlines. Com-
pared with the giants of the Pergamum frieze, mod-
ern criticism says that it has not their fresh freedom
of muscles or their exquisite rendering of skin and
veins. Indeed, even Winckelmann, who rhapsodised
over the extraordinary strength and beauty of the
torso, was impressed with the strange absence of
vein indications. To his mind, they were left out to

help to make clear the superhuman nature of the god! Antiquaries agreeing or no, Michelangelo's opinion of the rare beauty and power of this broken god, will for most seem the true appreciation. Massive, strong, full of grace, energy, and elasticity, there are few statues that better deserve the admiration of all times. The mere workmanship shows the sculptor to have been past master of his craft. The softened tooling has left no marks, the surface of the skin is of velvet smoothness, and through it all is a sensitive delicacy that makes the more tremendous the weighty strength that lies behind the big muscles.

Perhaps the Mercury, once wrongly called the Antinous of the Belvedere, has of all the noted works of the Vatican suffered the least under the fire of modern research. To be sure, since the discovery of the Olympus Hermes, it is usually regarded as being a copy, rather than an original. But, at least, if it is a copy, then the original, one is sure, must either have been of a transcendent beauty way beyond the god of Praxiteles, or else the copy is, to all intents and purposes, as satisfactory as the undoubted original would be. For it is only when direct comparison is made between this and the one on Olympus that any slightest lack is felt. It was found in 1543, in a garden near the castle of St. Angelo, and Paul III. put it into the Belvedere

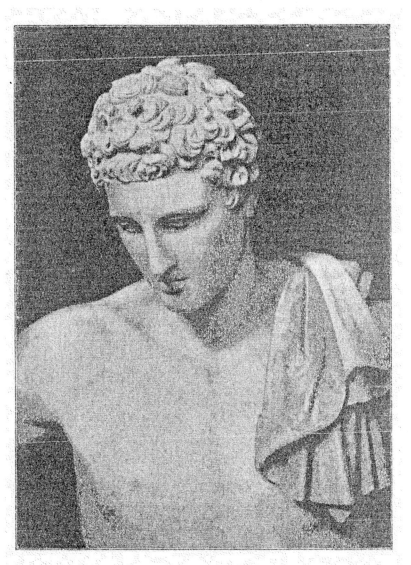

HEAD OF MERCURY
In the Cortile del Belvedere

garden. The legs were broken in two places when it was discovered, and the joining was incorrectly done, so that the ankle appears deformed.

The statue stands in the well-known Praxitelean attitude, the whole weight resting easily upon the right foot, the other leg bent slightly behind it, only the toes resting upon the ground. The right arm, which appears to have been more or less advanced from the shoulder, is gone, and the left wrist and hand are also wanting. One end of the chlamys is thrown over the left chest, and then it drops down the back, to be caught up and over the left forearm. The head is bent forward and slightly to one side, with the quiet, distantly pensive expression also clearly associated with Praxiteles. It has been generally considered that this must be a copy of a statue by that sculptor, though certain critics have ascribed it to a slightly later period. The original was probably of bronze. The large free modelling, the beautiful planes of the chest and shoulders, the soft, yet never weak, masses of muscle, the grace and ease of the position, the proportion of the parts to each other, the overhuman individuality of the whole, mark this as one of the chief treasures of the Vatican. Possibly the head is a trifle small, and the expression of not quite the majestic sweetness and concentration of divine power felt in the Olympian statue; but it is a rarely lovely, thoughtful,

charming head none the less. Perhaps the two most
wonderful things about it are the subtile, beautiful
swing of its poise and the intense feeling of flesh
in its marble planes. Almost one can see the pulsing
veins beneath, almost one is sure it would yield to
the pressure of the finger-tips. Only, one thinks,
has Michelangelo in his David succeeded in achieving
such a semblance of living flesh. The gradations in
its modelling are as subtile as Titian produced with
his brush. To quote a well-known author, " It is
an exquisite image of blooming youth. For soft
and delicate beauty, — beauty which, like that of the
vernal rose, the sunset cloud, and the breaking wave,
is suggestive of brief continuance and early decay, —
this statue has no superior, hardly an equal. . . .
The softness of the limbs just stops short of languid
effeminacy. It is beauty, not like that of the Apollo,
in action, but in repose, filled to the brim with sweet
sensations; neither restless from desire nor cloyed
with enjoyment."

Very similar in pose is the Meleager of the Belve-
dere. In spite of this resemblance in attitude, the
difference in conception of character and impression
of the whole figure is remarkable. Standing like
the Mercury, with all his weight on the right leg, the
other slightly bent and resting somewhat behind
the left foot, just as in the Hermes, the line from
the hips down only differs in the somewhat more

extreme angle of the latter. The right hip of
Meleager is not thrown out quite so strongly. The
chlamys, which is probably a Roman addition, is but-
toned on his right shoulder and slightly covers his
chest before it slips down the back, and then, as
in the other, is wound once over the left arm. But
here is one of the noticeable points of difference.
There are no lazy, quiet folds here, expressing in
every line the pensive attitude of the Mercury. The
ends of the chlamys are flowing straight out, as if
a breeze had caught and held them. And undoubt-
edly it was a breeze. But it was made by the hero
himself. One can fairly see the whirl he must have
given the drapery as he flung it impatiently about
him and rushed along. In his right arm, which is
bent as Praxiteles often bent it, and resting on his
right hip behind him, there is, however, the feeling
of energy and action, very unlike the nonchalant
ease of Praxiteles. The head, instead of being bent
thoughtfully downward, is turned sharply to the
left, his eyes are gazing piercingly in the same direc-
tion. The beautiful half-open lips with their scornful
curves, the slightly inflated nostrils, all give a life, an
outward expression at variance with the type as we
know it, of Praxiteles. The modelling of the forms
is somewhat different also. There is less of softness
and grace, a hint of stronger lines and more decided
angles and planes. Altogether it seems probable,

according to modern criticism, to assign the original
of this to Scopas. It was found, on the authority of
Aldroandi, near the Porta Portese on the Janiculus.
Beside the statue, on his right, is a badly sculptured
dog looking up to him, and on his left is a boar's
head. This last indication, evidently, of the fight
in which Meleager came off victor — to his own
future harm. It is supposed that the boar's head is
of Græco-Roman manufacture. The elaboration of
it, when it is such a mere accessory, is very unlike
Grecian art. The statue is in perfect condition, ex-
cept for its left hand, and it is said that Michelangelo
did not dare restore that.

The Apoxyomenos in the Braccio Nuovo was
found in April, 1849, in the ruins of a private house
in the Vicolo delle Palme in Trastevere. The
restorations are all of a minor order. Tenerani
added the fingers of the right hand, the die, the
tip of the left thumb, parts of the strigil, and all
the toes.

After exercising at the Palæstra, the Greeks used
a metal scraper (the strigil) to remove the sand
which had accumulated on their oil-rubbed bodies.
This statue shows a youth in the act of cleaning the
lower side of his right arm, which is held out for
the purpose. Lysippus, who is supposed to be the
sculptor of the bronze original, was a contemporary
of Scopas and Praxiteles, and was as famous in the

Peloponnesus as were they in Attica. Certain characteristics for which this master was noted among the ancients are strongly marked in this figure. Very tall and slender, the proportions of the whole figure, with the much smaller head, longer legs, slighter wrists and ankles, all show the innovations introduced by Lysippus. They were marked innovations, even when compared with the Parthenon figures or the Doryphoros of Polycleitus. The mobility of this Apoxyomenos is such that every change of each movement of his arm is almost visible. His weight is still partly on his right leg, and its momentary, sidewise stretch is wonderfully indicated. The expression of the face is much more individual and has more intellectuality than the statues of an earlier date. The play of the muscles is faithfully shown and the skin is admirably indicated as being a covering for the flesh beneath. It is an idealistic treatment of a realistic subject and is peculiarly that of the type attributed to Lysippus. Like him, too, is the care bestowed on details, such as the rendering of the hair in separate locks. The face is naturalistic to a degree that it almost becomes portraiture. Again what one would expect from the chisel of the man who was always chosen by Alexander the Great for his numerous portrait busts and statues.

There are in the Sala della Biga two statues of Discobolus, the disk thrower. One represents the

athlete in repose, the other at the moment of action.
The one in repose has been variously ascribed to
Naucydes, a pupil of Polycleitus, to Alcamenes, a
contemporary of Phidias and Myron. Brunn gives
it to the latter, backing up his belief by showing the
points of similarity between this and better known
types of Myron.

The statue was found by Gavin Hamilton in 1792
in the ruins of an ancient villa on the Via Appia,
and it was acquired for the Vatican by Pius VI. It
is only slightly restored in minor parts. The athlete
is shown at the moment when he has just grasped the
discus in his left hand, which still hangs easily at his
side. With his right hand bent at the elbow and
forefingers held out, as if he were measuring the
space to cover, he seems to be studying the direction
and distance that he must throw. The figure is
firmly but elastically poised, and there is a well
executed intentness and preparation for movement
in the whole body. The face, too, though not carried
to the extreme expressiveness of a late day, clearly
indicates the keen interest and speculation of the
moment.

Myron, who is universally acknowledged to be
the author of the bronze original from which the
other Discobolus must have been copied, was cele-
brated in antiquity, both for his statues of athletes
and for his representations of animals. His was the

bronze cow about which so many epigrams were
written. Goethe summarised these bon mots, —
a few of which were, that, so real was she, " a lion
sprang upon her to tear her to pieces; the shepherd
threw his halter about her neck to lead her to pasture;
some pelted her with stones; others whistled to her;
the farmer brought his plough to yoke her in for
work; the gadfly settled on her hide; and even
Myron himself was at a loss to distinguish her
from the rest of his herd." It was this same ability
to portray life, life, too, at an intense moment, that
made his athletes so famous. Lucian in speaking of
one of these noted figures so exactly describes several
existing statues, that there is no doubt they were
copies after the bronze original. In the Vatican
is one of them, though it is not so good an example
as one owned by Prince Lancelotti of Rome. With
his whole weight upon his right foot, which rests
squarely upon the ground, the athlete has grasped
the discus with all the strength of his right arm,
and flung it up and back as far as it will go. His
whole shoulder and torso follow the violent move-
ment of the arm. This gives a twist to the body
that brings into play admirably worked muscles,
and makes a movement that at once suggests the
inevitable return in the opposite direction. His
head is here improperly placed. It should follow the
motion of the right arm. The face itself is still

somewhat of the archaic type, where the most violent
movements of the body left unaltered its perpetual
smile of sweet intelligence. That, too, is typical of
Myron, for even the critics of his own day objected
to his expressionless faces. But this seizing of a
passing moment at the very height of one action,
just before it merges into the next, and so spiritedly
that at once one's mind and eye leap to that
next — in this lies Myron's great genius. As Lübke
says, there is "in it the most acute observation of
life, the most just conception of bold, rapid move-
ment, and the greatest freedom in the expression of
the action." It was found by Count Fede in 1791 in
Hadrian's Tiburtine Villa, and Pius VI. bought it.

Of almost modern feeling and treatment is the
lovely crouching Venus in the Gabinetto delle
Maschere. It was discovered about 1760 in the
Tenuta Salone, situated on the Via Prænestina, and
got by Pius VI. from the painter La Piccola. The
entire back of the head, the upper part of the left
ear, and all the hair except that lying upon the neck,
are restored. The fingers are modern, as well,
probably, as the whole of the right hand and wrist.
Modern, too, are the front of the right foot, two
toes on the left, most of the vase, with its waves,
and various fragments of the body. The face also
has been slightly retouched by the restorer.

As the name indicates, the goddess is represented

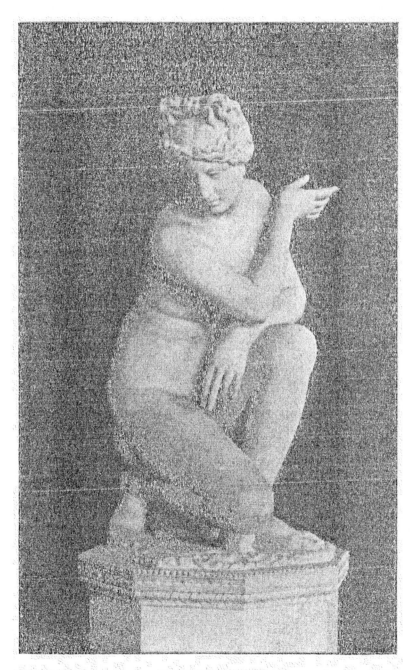

CROUCHING VENUS
In the Gabinetto delle Maschere

in a crouching position, as if she were just under the spray of a shower bath. The attitude is extremely charming in the way the limbs cross and partly conceal each other, and the modelling of the whole body is delicate and sensitive to a degree. According to Pliny, the temple of Jupiter, within the Portico of Octavia in Rome, had a marble statue by Dædalos, of Venus seated in the bath. It is reasoned that this and similar statues are reproductions of this ancient one. Dædalos is supposed to have been a Bithynian of the period of the Diadochi. This is especially regarded as true, as it is not likely such a statue was designed before the Cnidian Aphrodite. The "accentuation of the sensuous element and the realistic treatment of the nude" presuppose a period after rather than before Alexander the Great.

In the Sala a Croce Greca is the Vatican copy of the most famous Venus ever sculptured. With the exception of the Zeus of Phidias, no statue in the ancient world received such unbounded praise as did the Aphrodite of Cnidus. As Pliny tells the story, Praxiteles made two Venuses, — one clothed, the other nude. He offered them for sale at the same time, and the people of Cos, perhaps for moral and religious reasons, selected the one that was draped. The Cnidians therefore took the other, and to the fame of the statue was due all the future pros-

perity of that place. In showing how it was valued,
Pliny goes on to say that the Cnidian national debt
was very large, and Nicomedes, King of Bithynia,
offered to pay the whole of it in exchange for the
statue. But the Cnidians preferred to remain in
debt rather than relinquish this work of art. Up to
Praxiteles's time a nude goddess of love had scarcely
been thought possible. That he succeeded in present-
ing her undraped, and yet kept her the goddess to
be worshipped, proved how great a triumph he
achieved. The statue was of Parian marble and
stood in the centre of a small temple in a grove of
myrtle and other trees. Here the art of the period
as well as the art of Praxiteles reached its culmina-
tion. It expressed probably as no other statue the
spirit of the new Attic school, — and it could have
been created neither in the preceding nor following
period of Hellenic art.

The copy in the Vatican is not a first-class work,
though it has very many beauties. The head, un-
fortunately, is turned in the wrong direction. She
should be looking more toward the left shoulder,
with the head slightly bent backward. Owing to
certain moral scruples at that time rampant in Vat-
ican authorities, it was deemed expedient to drape
the statue. A metal covering was therefore made,
and now hangs from below the hips. As may be
easily imagined, it does not add to the beauty of

the figure. She stands, as now represented, resting
upon the right foot, her left hand holding the super-
imposed drapery in front, her right arm dropping
the real drapery on to a vase at her side. The large,
free modelling of the shoulders and arms, the sub-
tileness of the poise of the torso, recall the hand of
the great master, but there is a trace of heaviness
and sensuousness that can hardly be pure Praxitel-
ean. And the face, though with a calmer and less
abashed expression than some of the other copies,
has certainly not the entrancing loveliness imputed
to it by the ancients. Moreover, unquestionably
antique as it is, it could not have belonged origi-
nally to the present body, for the two are of different
marble and differently executed.

According to the testimony of ancient documents,
the Eros of Praxiteles was only less beautiful than
his Aphrodite. The story goes that Phryne wished
to secure for herself the work most esteemed by the
sculptor. She, therefore, had an alarm of fire
sounded, and the artist, thinking his studio was in
flames, exclaimed: " If my Eros or Satyr is burned,
I am undone." So she chose the Cupid, and sent
it to the temple in her native town of Thespiai,
where it was worshipped till Caligula stole it. Clau-
dius, however, returned it to Thespiai, and there it
stayed till Nero took it and put it in the Portico
of Octavia in Rome. During the reign of Titus it

and the portico were destroyed by fire. Pausanias saw only a copy of it at Thespiai by an Athenian, made to take the place of the great original. No one knows now whether any copy still exists, though the " genius of the Vatican " and its many replicas may hold faint traces of it. At least it is evident that Praxiteles represented him in the early years of youth, pensive and dreamy, and persuasive, rather than as the mischievous child. It was made of Pentelic marble and winged, and in his lowered right hand he held his bow, while from his eyes, as an epigram says, came shooting the arrows of love. The one in the Galleria delle Statue was found in a group of ruins known as Centocelli, on Via Labia-cana, and acquired for the Vatican by Clement XIV. The point of the nose and fragments of hair are fortunately the only restorations. No attempt has been made to add legs to this torso or even to piece on the arms, which are both broken above the elbow. There are holes in the back, showing where wings, perhaps of gilded bronze, were once added. Poorly executed as this is, in comparison with what is known of the work of Praxiteles, it has a grace and sweet-ness, a dreamy tenderness of expression, and a soft suppleness of modelling that make it a very lovely fragment.

Another and less doubtful copy of a statue by Praxiteles is the Resting Faun or Satyr in Braccio

Nuovo. It is the exactness of description of this
work that has come down to us, rather than its
own excellencies, that makes this certain. In itself
it is not a particularly good work and shows few
touches that distinguish the labours of one who
grasps both technically and mentally the whole idea
of the work before him. Praxiteles conceived this
quiet, restful figure, probably, in his intermediate
period. It does not show all the freedom from tradi-
tion found in the Hermes of Olympia, but it is at
least a new type. The rollicking, sensual nature of
the satyr is the phase the sculptors before him always
presented. Here he is almost like a young Apollo.
There is, to be sure, a delicate smile on the lips that
hints of untold mischief behind, and in the languor-
ous eye is something of a voluptuous glance. But as
a whole the graceful figure has little resemblance to
the accepted faun type. He stands mostly upon his
left foot, somewhat assisted by his right arm, which
leans at the elbow upon the tree-stump beside him.
His right leg is bent, the toes pressed directly behind
the heel of the other foot. Over his right shoulder
and crossing his back and chest is a tiger skin which
his left hand, resting on his hip, pushes to one side.
Grace and charm and lazy enjoyment are the chief
characteristics of this statue. The original undoubt-
edly gave him a flute in his right hand, and one
could imagine that the dreamy, amused expression

of his face came from his trying to catch the last
notes of the sweet strain. In the Vatican copy, for
no apparent reason, instead of the flute he holds a
pedum. The nose, right forearm, and pedum, two
fingers on the left hand, various parts of the panther
skin, the left foot, a great toe of right foot, and
the upper part of the stem are restorations.

There is another satyr in rosso antico (red
marble) in the Gabinetto delle Maschere, which is
very unlike the one by Praxiteles. It was found by
Count Fede in the Tiburtine Villa of Hadrian, and
obtained for the Vatican by Pius VI. The glass-
paste eyes, probably entire right arm, and various
other less important parts are restored. The bestial
element is here the most noticeable trait. Standing
with his left foot slightly advanced, his head is lifted
as he gazes up to the bunch of grapes held high in
his right hand. The greedy light in the glass eyes
is well represented, and the colour of the marble
suggests vividly the sunburned skin of this forest
denizen. The whole appearance of the figure, espe-
cially perhaps the goat-like appendages on the throat,
places it in the Hellenistic period of art. There are
other indications, however, that relegate the work
to the Græco-Roman days.

Far different from the Apollo Belvedere is the
slighter, more youthful figure of the god in the Gal-
leria delle Statue called the Apollo Sauroctonos —

a term given it by Pliny, and meaning the Lizard
Slayer. Critics agree in assigning the original to
Praxiteles, and Furtwängler places it at a date some-
what earlier than the Hermes of Olympia. It is
at least very unlike that majestic work in either form
or expression. The slight, delicate build suggests
rather the satyr style than that of the athlete. He
rests on the right leg and leans slightly forward,
with the left leg bent sharply at knee, the toes of foot
directly at back of the heel of the other foot. With
his outstretched left hand he steadies himself by
the tree-stump beside him, while with his right he
is about to strike the lizard crawling on the tree.
The ancients gave great praise to the statue, extolling
first of all the unusual and graceful attitude. And
even in this copy the body, so lightly is it poised,
could surely swing straight around the tree. The
head is of the Venus type, with gently broadening
forehead, hair nearly identical with the Cnidos
goddess of love. Here, to be sure, there is little
of the ideal beauty ascribed to the face, but the
attitude, as has been said, must be nearer the original.
It is full of a soft, sweeping grace, with the broadly
and tenderly modelled forms that are not without
traces of the severer simplicity of the Phidian days.
The contrast in the muscles of the left side, a little
strained by the sharp uplifting of the left arm, and
the more compressed ones of the right, gives charm

to the pose and a symmetrical balance. It was found in 1777 in the Villa Magnani on the Palatine. A large part of the top of the head, entire left side of face, including eye, nose, mouth, and chin, the right forearm, three fingers of the left hand, the right leg from the middle of the thigh, and the left leg from knee downwards, part of the tree-trunk, with the upper part of the lizard and the plinth, all are restorations.

Among the earliest antique statues found and placed in the Belvedere was the Sleeping Ariadne, now in the Galleria delle Statue. Even in the pontificate of Julius II., she already adorned a fountain in the Vatican garden. For a long time she was called Cleopatra, probably because of a bracelet in the form of a little serpent which is on the upper part of the left arm. The nose and lips are restored, as are also the right hand, the third and fourth fingers of left hand, the rock on which she reclines, the end of her robe which hangs down over the rocks below the left elbow, and the horizontal section of this garment between the rocky projection and the vertical fold hanging from her thigh.

Stretched out upon the boulder, she is supposed to be sunk in the sleep in which Theseus left her, just before, presumably, Dionysius found her. It has been conjectured that the original, for this, too, is unquestionably a copy, was taken from a painting,

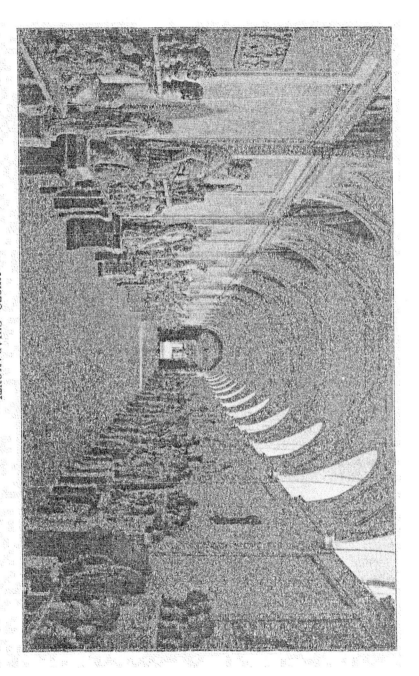

MUSEO CHIARAMONTI

perhaps the one Pausanias describes as being in the
Temple of Dionysius at Athens. The faults in the
drapery, with the slight indistinctness of parts, have
been laid to the copyist. But perhaps these are the
mistakes of the painter rather than the sculptor. The
attitude is dignified and the forms noble. The posi-
tion of the head, bent upon its left arm, may slightly
recall the Medicean statue of Michelangelo. There
is, with the other arm also thrown over the head,
a certain complexity not usual in the best art
periods of Greece. It is more like the floridity
of Roman art. The two sides of the face, also,
as Winckelmann pointed out, are not even, and one
feels pretty sure that the restorer did not accom-
plish all he might with the mouth. The tumbled
drapery has suggested to many that it is indicative
of the unhappy, uneasy dreams of the deserted
Ariadne.

Very much more beautiful is the drapery of a
headless, neckless, and armless girl in the Museo
Chiaramonti. Indeed, this so-called Daughter of
Niobe is one of the most beautiful draped statues
in Rome or anywhere else. It was found near Tivoli,
and was formerly in the garden of the Quirinal. It
is unspoiled by the restorer, and so perfect is it in
all it suggests, that the missing forms are scarcely
needed. Nothing, one feels, could add to the charm
of the motion, or to the expressiveness of the figure

as it flies over the ground. She is, according to
Furtwängler, not so much a copy as she is an
Hellenistic adaptation of an earlier statue from the
famous group. Every fold of the exquisite drapery
expresses the fleeing rush of the frightened girl.
The chiton, that covers the figure without hiding the
shape beneath, clings closely over the legs, emphasis-
ing with every line the pressure of the wind against
it. The garment above, with its wider, freer, looser
folds, tells even more unerringly of the impetuous
dash of the wearer.

There are several statues of Amazons in the
Vatican, all of them far removed in artistic value
from what has been written concerning the ancient
originals. The story goes that three artists, Phid-
ias, Polycleitus, and Kresilas, in a certain com-
petition, all made statues of Amazons. In spite
of the great fame of Phidias, it was Polycleitus who
won, and it was his Amazon that received the great-
est admiration of after generations. It is generally
supposed that both the Polycleitan and Phidian
types are represented in the Vatican, though so
badly that any just estimate of the originals is
about impossible. The Mattei Amazon in the Gal-
leria delle Statue is the one usually assigned to
Phidias. The weight of the body is mostly on
the right leg, the left bent, her left arm hanging
down, and her right lifted over her head. A short

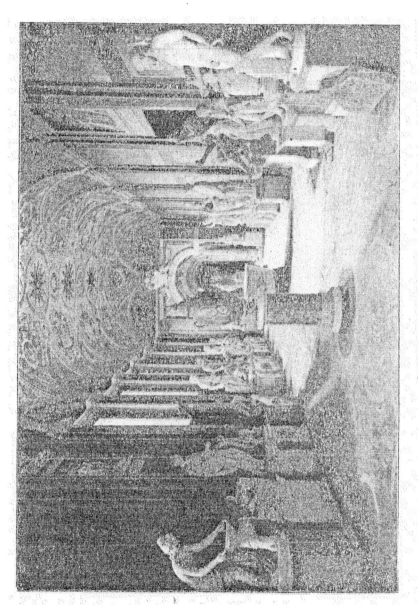

GALLERIA DELLE STATUE

tunic reaches not quite to her knees, leaving her breast uncovered. Purchased by Clement XIV., it has been largely restored. The neck, both arms, top half of quiver, right leg from knee to ankle, upper half of tree-trunk with shield and axe upon it, and crest of helmet are all modern. The head, which is united to the body by a modern throat, is antique, but belongs to another statue. No replica of this type has retained its head. It is softer and slenderer than the Polycleitan type, but ought not, authorities seem to urge, to be placed later than the close of the fifth century B. C.

In the Braccio Nuovo is the one ascribed to Polycleitus. It was found in Frascati, and was formerly in the Camuccini collection. The nose, both arms, quiver, right leg, left leg from knee downwards, support, and plinth are modern. Here she is distinctly represented as being wounded. The right hand is held above the head, and originally the thumb at least must have been touching it, while the left arm was resting on a plinth. There is an expression of suffering upon the face explained by the wound near her right breast, although the face is after the conventional and earlier method. The breadth in the forehead and cheek-bones, with the narrowness in cheek and chin, the projecting eyelids and finely cut lips, denoting its bronze original, all

mark it as characteristic of the work of Polycleitus, who still adhered to the strict and impassive style.

One of the best known statues of Leochares, generally considered to have been a pupil of Scopas, was his Rape of Ganymede. There is a late copy of this work in the Galleria dei Candelabri, largely restored, but, with the exception of the left arm, probably correctly. The boy, with his shepherd's crook, pipe, and dog, has evidently been resting on a wooded summit, shown by the shape of the plinth and the tree behind him. Zeus's messenger, the eagle, has swooped down upon him, and with wings outspread is carrying him up to the height where dwells the king of the gods. The hound, left below, howls after him with upraised head. In Roman times this subject was used for monuments of children who died young, and most likely this was such a funeral stone. Of course one cannot see here the real worth of Leochares's work. But much of the idea and scheme of composition is plain, and the artist has succeeded in freeing the marble from its heaviness and ponderosity without violating the laws of his material. The flight upward is very cleverly indicated, and the original had a bold inventiveness that places Leochares high in the artistic ranks. Even in this marble the justness of Pliny's observation can be seen, that the eagle's claws, fastened just above the youth's waist and through the

slight drapery, were holding the delicate flesh as reluctantly as if the bird himself feared to give pain.

The Zeus Otricoli, the massive bust in the Rotunda, is regarded by many as a fair copy at least of the most famous of all the antique statues, the Jupiter of Phidias that stood at Olympia till 500 A. D. But archæologists are now inclined to think this impossible. The very things that give this bust its grandeur and lifelike attributes are what really make it evident that it is not a copy of the ancient masterpiece. That gold and ivory god must have been a much quieter, less complicated conception, — one portraying more unbrokenly the calm majesty of the father of the gods. Here we feel the play of many different emotions. If it expresses most strongly a benignant thoughtfulness, it shows equally clearly the tremendous energy, the impressive power and wonderful sense of something mysterious and undefined. The deep shadows of the eyes; the mighty brows; the slightly open mouth with its sensuous curves partly concealed by the heavily cut moustache; the eyebrows, one much more curved than the other; the slightly expanded nostrils, — all combine to suggest a remarkable play of thought and emotion. The sculptor has amazingly indicated that all the powers and passions and thoughts of the universe could here find expression. All this play of intellectual life is characteristic of the second

Attic school rather than that of Phidias, when
emotion was much more restrained in its manifesta-
tion. It may possibly be taken from a Zeus by
Bryaxis or Leochares. The restorations include the
whole back and top of head, the left side of forehead,
tip of nose, ends of hair, and bust.

The statue of Apollo in the Gabinetto delle Mas-
chere has also been called Adonis. It was found in
Via Labiacana at Centocelle, and acquired under
Pius VI. He is placed beside a tree-stump, his right
leg decidedly advanced, left arm lightly lifted from
his side and extended, the right dropping down hold-
ing the restorer's javelin. His head is bent and
turned to the left. The nose, left side, and back of
head, left arm up to shoulder, right arm below biceps,
right leg, left foot, stem, and plinth are all modern.
It is probably a copy of a work by a master of the
fourth century, b. c., who adhered more or less
strictly to the older traditions of the Argive school.
The soft dreaminess of the face, and the whole
gentle, placid attitude suggest the Praxiteles Eros.

Still another Apollo is in Sala delle Muse, and
goes by the name of the Apollo Citharoedos. The
heavily draped figure has little of the masculine
about it. It might be one of the Muses rather than
Apollo the god. The left leg is in advance of the
right, and both feet are elaborately sandalled. The
drapery consists of a girdled robe coming fully

down to the elbows and ankles, and a heavy cloak
falling in voluminous folds from the shoulder. The
garlanded head is tipped slightly backward, listening
to the music of the cithara, which he holds in his
left hand and strikes with his right. The grace and
swing of the figure are charming, and would be more
so except for the superfluous, overdone drapery. It
has been claimed to be a copy of a work by Scopas.
If so the draperies were a late Roman addition.

Athena Giustiniani, sometimes called Minerva
Medica, was found near the Church of S. Maria
Sopra Minerva, and was purchased by Pius VII.
The statue represents Athena, fully robed, a helmet
on her head, standing in a placid, reposeful attitude,
her weight largely but not wholly thrown upon the
left leg. She holds a spear in her left hand, while
her right toys with the edge of her robe at her waist.
By her right side is coiled a serpent whose head
is lifted toward her. The face of the goddess is
extremely quiet, contemplative, the mouth slightly
drooping, expressing either dissatisfaction or melan-
choly. It is the intellectual side of the goddess
that is represented. Furtwängler considers it a good
copy of a statue by Euphranor of Corinth, who lived
about 375 - 330 B. C. But other critics have judged
it to be of an earlier date. It certainly suggests some
of the earlier, severer types, but the sophisticated
treatment of the drapery, the freedom of the masses

of hair and various details of the dress and helmet
seem to indicate that Furtwängler may be right in
his conjecture. At all events it is a charming if
slightly mannered statue, with exquisite feeling
about the face and neck, and with a dignified, godlike
pose that vividly portrays the character of the god-
dess. It is in the Braccio Nuovo.

The so-called Venus Anadyomene, in the Gabi-
netto delle Maschere, is doubtless a copy of a later
edition of Praxiteles's celebrated Venus, possibly
from the draped one that went to the city of Cos.
She stands somewhat as does the Venus of Milos,
with her head, however, bent down, while with both
hands she arranges her unbound hair. The lines
and masses are sweetly pleasing, but there is little
of the majestic beauty of the goddess of love to be
seen in this adaptation.

A copy of an adaptation is what the Hercules
holding Telephos, in the Museo Chiaramonti, may
be called. The original was presumably a group by
Praxiteles. But most of the simple beauty of Prax-
iteles has been obscured. Even the lion's skin is
more theatric. The attitude, too, is changed, and
the child is awkwardly placed on the left arm. The
Hercules in Villa Albani is a better copy of a better
adaptation. In the head of the one in the Chiara-
monti, however, the main points of the Praxitelean
Hercules are faithfully preserved. Even the gen-

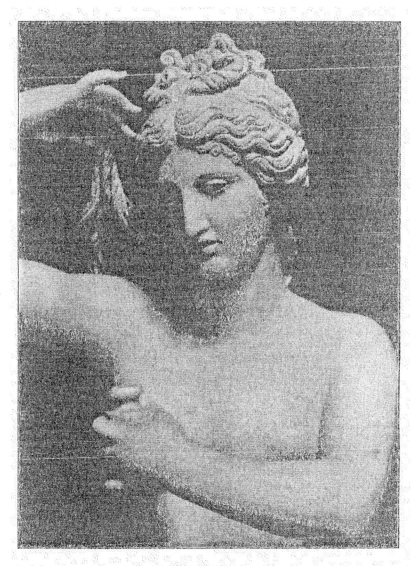

VENUS ANADYOMENE
In the Gabinetto delle Maschere

eral plan of the forms corresponds with the Hermes
of Olympia. The modelling of the forehead is simi-
lar, though more powerful, and eyes, lids, sockets,
nose, and profile correspond exactly. Only in details
like the hair and lower eyelid occur the differences
of treatment always found in a copyist's work. It
is undoubtedly the most beautiful head of the hero
except the beardless Scopasian type. In it, too, one
finds resemblance to another noted type, — Zeus of
Otricoli. Not because they are the work of one
master, but because of " one development and one
age." This head is probably a copy of the second
Attic school.

In a similar group is Silenus with the infant
Bacchus in his arms. On one of the pedestals in
the Braccio Nuovo, it is not a first-class copy of
what, to judge by the numerous replicas, must have
been a famous group of antiquity. Silenus stands
with his left leg sharply advanced, leaning with his
left elbow on a tree-stump twined with grape leaves.
His head is bent protectingly over the little Bacchus
whom he holds in his arms. This baby was hardly
more than a torso when found, but it is perhaps in
the main correctly restored. Silenus's beautiful
hands, with the tender pressure upon the little body
so charmingly indicated, are after all much too
modern in treatment to go with the rest of the body
in its simpler lines. The god-guardian is a graceful,

almost noble figure. His animal nature is scarcely hinted at. Only the pointed ears show connection with the usual presentations of this nurse of the god of wine. Such soft idealisation, as well as the easy quiet of his attitude, recalls the Praxitelean manner. The more naturalistic treatment of the two bodies, however, indicates that probably it is a copy of a work of days as late as Lysippus. Another variant of this same group is the one where Silenus leans completely on the tree at his side, with his legs crossed.

There are innumerable statues of Dionysius, one of the better known being in the Museo Chiaramonti, where he is grouped with a satyr. It was found at Frascati, and has been restored only in minor parts. Attempts have been made to connect this, too, with the time of Praxiteles. But the slight archaic traces discernible, such as the lack of fuller modelling of chest and abdomen, proclaim it a copy of an earlier work. Over his grape-crowned head, with its soft, dreamy expression, Dionysius has flung his right arm. His left, holding a wine-cup, is about the satyr's neck, who, with his arm behind Dionysius, seems, as he looks up at him questioningly, to be urging the god forward. There is more of the lower order of being shown in the satyr than in the Dionysius.

The colossal statue of Hercules in gilded bronze,

in the Rotunda, was found in 1864, in digging the
foundations for a house in the Piazza Biscione. It
was actually buried in a kind of coffin of solid
masonry veneered with marble, and was purchased
by Pius IV. for ten thousand dollars. The Theatre
of Pompey used to be on about this spot, and the
statue, it is guessed, was one of the works of art
used for its adornment. It had apparently some
time fallen upon its head, and an extremely flat-
tened appearance is the consequence. It represents
the young hero as an immensely heavy, powerful
figure, with both feet firmly planted on the ground,
the weight a little more upon the right leg. His
right hand rests upon his club, and the lion skin
covers the left forearm. In his right hand he holds
the apples of Hesperides. These apples, left foot,
and most of the club have been restored. The lost
piece of the back of the head has never been replaced.
This seems to be an adaptation if not a copy of
the Hercules of the Scopas order. It bears a good
deal of resemblance to the Hercules of the Lans-
downe House, which is generally regarded as a good
copy of that work of the Attic master.

During the pontificate of Leo X., the two enor-
mous mythologic groups of the Nile and the Tiber
were found near the Church of S. Maria Sopra
Minerva. They were apparently part of the decora-
tion of the Temple of Isis that stood near here. The

Tiber was not returned by the French after Napoleon's defeat and still rests in the Louvre. The Nile is now in the Braccio Nuovo. Clement XIV. had it restored by Gaspare Sibilla. The restorations include, besides unimportant patchings, the fingers of the god's right hand, and the ears of corn within them, the toes, nearly all the upper parts of the children, and sometimes even more. The work probably dates from the time of the Ptolemies at Alexandria. The large figure of the god is half reclining, half sitting, his left elbow resting upon a statue of the sphinx. His right hand holds a bunch of ears of corn, while his left hand grasps a twining cornucopia, which is filled with grapes, corn, and fruits, with a small boy crowning the apex of the contents. The mild, benevolent head of the god is turned toward this laughing baby, but his eyes are not upon him. He is rather gazing out and beyond, as if viewing the immense territory his river must nourish. All about him in extremely well-chosen attitudes and groups are sixteen *putti*, who, in their chubbiness and interested actions, somehow suggest Rubens's little gods of love. They are clambering up his arms and legs, playing with a crocodile at the foot of the god and with an ichneumon at his side. Their number indicates the sixteen cubits which was the maximum rise of the Nile, and was

needed to render the whole country sufficiently fertile.

Another statue in which a river god figures is that of the group of the City Goddess Tyche and the River God Orontes in the Galleria dei Candelabri. It is thought to be a far copy of a work by Eutychides of Sikyon, a pupil of Lysippus. He is said to have worked in marble as well as bronze and also to have been a painter. There are echoes of this Tyche on Antioch coins and in this marble statuette. The goddess rests carelessly on a rock, a graceful, gentle figure, very different from the stately goddesses of olden days. The river is a vigorous youth, apparently swimming out from under her feet, bearing the goddess of the city on his back through the waves. Such a composition can scarcely be beautiful as a whole. In spite of the outreaching arms of the boy, the base is not large enough for the massive figure above. The drapery is simple, with large, free folds, but without the exquisite study and inevitableness of the Phidian frieze. There is an added significance to this statue, inasmuch as the creator of the magnificent Winged Victory in the Louvre has been said to be the author of the original of this. Some slight indications seem to connect the two, as well as the mannerisms that place them at about the same date, — the third century before Christ.

Among the many portrait busts and statues in the Vatican, perhaps the Demosthenes, the Menander and Poseidippus, the Alkibiades, and the Augustus are the most worthy of notice.

The head of the Demosthenes statue is well known from many duplicates, and is supposed to be a copy of the bronze original by Polycleitus, placed in Athens in 280 B. C. This stood with folded hands, the gesture used all through antiquity to express perplexity and often affliction. At a late date either this very bronze or a copy was seen in Constantinople. The statue in Rome has the lean arms, bared, bony chest, and scant drapery of the Athens group, but it carries a roll, instead of having the hands folded. Michaelis thinks this attitude was chosen because the statue was made when Demosthenes was admired more as the great author than as the afflicted patriot.

The two seated statues of the comic poets Menander and Poseidippus in the Galleria delle Statue are most excellent examples of the portrait work of perhaps the Hellenistic period. They rank nearly with the celebrated Sophocles in the Lateran Museum. Poseidippus, the Athenian dramatist of the "new comedy," flourished in the early part of the third century B. C. The preservation of the statue is extraordinary. There is nothing modern about it except the thumb of the left hand. It produces strongly the impression of being an original

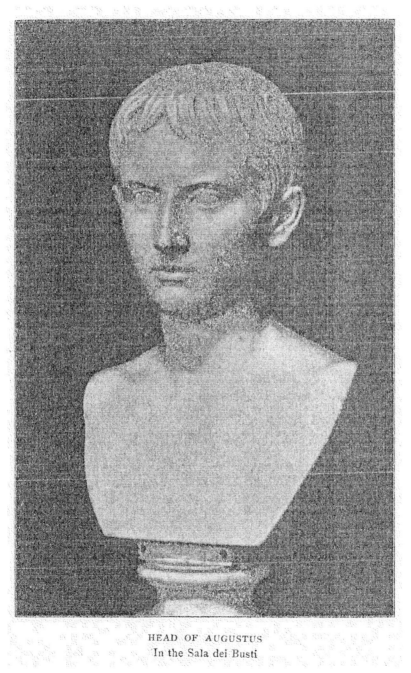

HEAD OF AUGUSTUS
In the Sala dei Busti

work, and also of being a speaking likeness. It may have been modelled in the actual presence of the subject, but in that case the name on the front of the plinth was doubtless inscribed later, when the figure was removed from its pedestal and taken to Rome. He is shown clean shaven, according to the fashion of the time of Alexander. The companion statue, Menander, is of equal merit. The two men are strongly contrasted in features, expression, and bodily carriage. Both show, as do many others of the same period, that no idea of the actual appearance of the Greeks can be gained from the purely ideal creations of Greek sculpture.

Alkibiades in the Sala della Biga is, according to Furtwängler, badly restored. The whole of the right leg, the left leg from the knee, right arm from shoulder, and left arm from above elbow, — all are added, and all, claims the archæologist, wrongly. He stands with his foot on his helmet, he himself resting upon a tree-stump, his right hand placed on the upper part of his bent right leg, with his left arm held out from his body and slightly back. Furtwängler puts the whole figure on a run — with the right arm held forward and the left somewhat back, both hands loosely closed. He also claims that there is not a work in all the fifth century art with which this statue is more closely connected than with the creations known to be by Kresilas, — he who com-

petéd with Phidias and Polycleitus for the Amazon.
Furtwängler goes on to say that he considers it a
portrait statue of a winner of noted races. The
original was of course in bronze and executed
probably about 440.

One of the most beautiful of the statues of Roman
times that have come down to us is that of Augustus,
found in 1863, in Livia's Villa on the Via Flaminia,
near Prima Porta, and now in the Braccio Nuovo.
It was without much doubt done soon after the
emperor's triumphant return from the north. The
statue was broken when discovered, but only a
finger, a bit of one ear, and its sceptre were lost.
There are signs, however, that even in antiquity it
had been restored in the right arm and left leg.
Originally it was painted with purple, red, crimson,
and blue, though now the colours are only faintly
discernible. They touched up the finger rings, gar-
ments, hair, etc. He is standing with outstretched
left arm, the right bending the paludamentum and
the sceptre. The attitude is lordly, calmly majestic,
and at the same time benevolent. His cuirass, with its
exquisite reliefs, seems like the actual piece of metal.
His hair is rather indicated than fully worked out,
and the pupils are cut into the ball. The mantle is
fine in the general arrangement, but has the sharpness
in the finish of the breaks of the folds characteristic
of this Græco-Roman time. At his foot on a

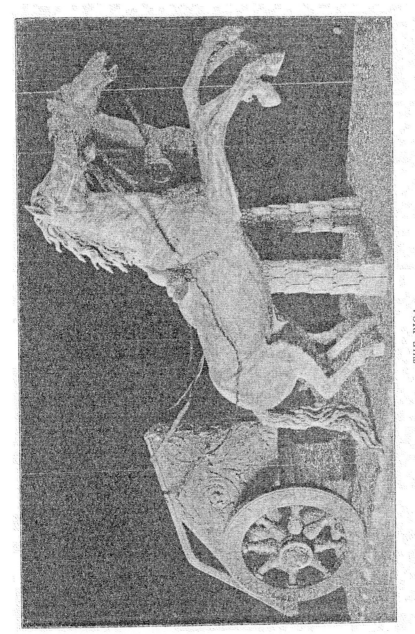

THE BIGA

In the Sala della Biga

dolphin rides a Cupid. Perhaps that was meant to indicate the emperor's descent from Venus, but it was needed, technically, for a support for the marble. It is much inferior in workmanship to the statue itself.

The Sala della Biga is so named from the Biga or two-wheeled chariot which stands there on a base of verde antique. The chariot is marvellously beautiful, of a marble most richly ornamented in reliefs. It is supposed to have stood in a temple dedicated to the Sun God. The bronze reins, the wheels, left horse, and portions of the right are restorations made by Frangoni under the orders of Pius VI., and the effect of the whole with the spirited animals and the rich trappings is gorgeously impressive. The chariot was for a long time used for an episcopal chair in the choir of St. Mark's.

While the treasures of the Vatican were reposing in the Louvre, Canova was called upon both to restore many broken marbles that were being unearthed and to create new works. It was to him that was largely due the reviving of the love for the classic. Three of his most noted sculptures are in the Cortile in the Gabinetto di Canova. Sincere, earnest, with a strongly marked idealistic temperament, he could love the antique, but to produce any such masterpieces was far beyond his powers. The futility of the modern attempt is never more glar-

ingly shown than here among the great examples of
the old days. Even the poorest stage of Greek art
never descended to such theatric effects as are seen
in his Perseus or the two boxers, who with their
softly modelled muscles and overdone movements
are far removed from the mighty athletes of the
Greeks.

Perseus stands with his left foot far in advance of
the right, his head turned in the same direction, while
his left hand holds out the Gorgon's head. His
right grasps the blade that has done the deadly
work. Somehow, in spite of an undoubted faultless-
ness of line and proportion in this dainty, almost
effeminate hero, there is little more than a picture of
a drawing-room page. The age of Bernini is too
apparent in this as in the Boxers, Kreugas and
Damoxenos. The story of these pugilists is that
Damoxenos won in a final contest between them by
an unlawful, cowardly attack, striking Kreugas in
the peritoneum with the extended fingers of his right
hand, and so tearing out his entrails. Canova has
markedly shown the animal nature of Damoxenos,
not only in his face but in his whole build and posi-
tion. Neither head, however, betrays much but a
bulldog determination. Unfortunately, the big round
muscles of the two fighters have a soft flabbiness
entirely at variance with their profession.

'A word at least should be said of the Galleria

degli Animali. It contains a unique collection of
domestic and wild animals, the work of ancient
Greek and Roman sculptors. They are made of all
kinds of coloured stones and marbles, — oriental ala-
baster, rosso and verde antico, breccia, Egyptian
granite, porphyry, and paonozzo. " Their connec-
tion with older religions surrounds them with a
certain traditional dignity, and these enigmas of
creation, in which the propensities of superstition
discovered a mystic language intelligible only to
the initiate, become objects almost of wondering
curiosity as handed to us, through centuries, thus
immortalised and beautified by art."

CHAPTER IX.

THE PINACOTECA

UNTIL after the peace of Tolentino there was no real picture-gallery in the Vatican. When the treasures Napoleon had filched during his years of triumph were once more returned to the papal states, Pius VII. retained in Rome many of the paintings that before their pilgrimage to France had belonged to various churches and monasteries in Italy. The collection, compared with most of the picture-galleries of Europe, is small, and with a very few exceptions of minor importance.

Among the exceptions, however, are some masterpieces of the Italian Renaissance, one of them the work that for generations has been called the greatest picture in the world. Raphael's Transfiguration occupies, with his Madonna di Foligno and the St. Jerome of Domenichino, one of the four rooms of the Pinacoteca. The very last work achieved by the genius of Urbino, there is still doubt as to whether the Transfiguration was actually finished when Raphael died. Vasari states decidedly that it was,

and that it was placed at the head of the painter's bier. At all events it is absolutely sure that Giulio Romano is responsible for parts of the picture. It is known that Raphael intended to paint this composition without any assistance. If he adhered to his determination, then Giulio merely finished what his master left incomplete. It is probable, however, that even in this case the young Urbinate found himself so pressed for time that he was obliged to fall back on his right-hand man, as Giulio had long since become.

The subject of the picture was given to Raphael by the Cardinal de' Medici, for whom it was painted. Critics who have found fault with its double perspective, its two halves, etc., have apparently forgotten this fact. He was obliged to illustrate two distinct incidents happening at the same time but far removed in space. The parents of a lunatic boy carry him to the disciples to be cured. At the moment of their arrival, on a distant mountain the Transfiguration takes place before Peter, James, and John. The painter, therefore, had to combine these two occurrences, and it is a carping critic who fails to admit the masterliness with which Raphael has accomplished it.

The mount rises somewhat above the centre of the picture. There, lying on the ground, awakened by the blinding rays, the three disciples half raise

themselves and shade their faces from the overpower-
ing brilliancy. Slightly above their heads, the Christ,
with wide-reaching arms, rises into the heavens. On
either side of him are Moses and Elias. Below,
partly in the shadow of the mount, are the remaining
disciples, a kneeling woman, and the crazed boy, who
with starting eyeballs and open mouth is in a
frenzy. He is held by his father and mother, whose
grief-stricken faces tell how much they had counted
upon the assistance of the vanished Saviour. The
connection between the two divisions is made by
the significant gestures of the apostles as they point
to the mount. It is claimed that to Giulio Romano is
due the concourse of people at the base of the moun-
tain. The figures, however, were undoubtedly
designed and grouped by his master. And in spite
of some disagreeable colour and theatric massing
of light and shade, many of them are wonderfully
expressive. The woman kneeling in the immediate
foreground is a noticeable example. It is only
Raphael's genius that has saved her from the
commonplace. She is not distinguished in face or
form. Yet the poise of the figure, the twist of the
torso, are so full of verve and movement that she
stays in one's memory with a keenness like that pro-
duced by life itself. The apostles on the left, two
pointing to the mount, others looking at the demented
boy, and the man in the foreground, lifting his head

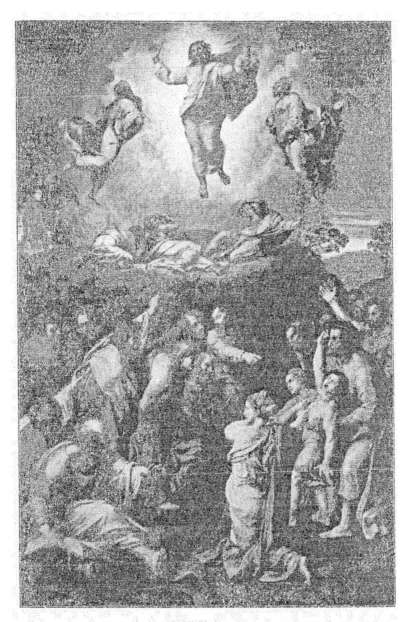

TRANSFIGURATION
By Raphael; in the Pinacoteca

from poring over his volume, are combined with a charm and skill equal to the kneeling votaries in the Disputa. The arrangement of light and shade, too, is wonderfully effective. Above, on the mount, it unquestionably is true that the figures are over large for the perspective of the picture. By painting all this part in a much higher key, Raphael evidently attempted to give it a sort of fictitious distance that would save the necessity of otherwise making the figures so small as to be insignificant. And for centuries the world has agreed that it is in just this upper half of the picture where Raphael's art is seen at its greatest. The transparency and purity of the colours, the amazing effulgence of the light that radiates from the Saviour and lingers over the ground where he had been praying, the nobility of his figure, the wonderful fall of the draperies that float about him as if caught by a celestial ether, and finally the sublimity of the expression of a face beyond words beautiful; — all this and more has been claimed for it with an utter abandonment to adjective and rhapsody. Even one who feels very differently must, after such an avalanche of adoration, hesitate to express opposing views. Nevertheless, a few critics have of late years ventured to suggest that, though of undoubtedly beautiful parts, as a whole the Transfiguration is neither the most perfect picture that was ever painted, nor is it

Raphael's own masterpiece. Certainly from a technical point of view it cannot be compared with the Sistine Madonna; and as certainly, it would seem, is it below that in its spiritual expressiveness. In spite of the nobility of Christ, the outflung arms with the flat open palms do recall, as Taine said, the gestures of a swimmer. And tender, benign, and soulful as is his face, it lacks the mysterious inner strength, the hidden, yet ever penetrating spirit that sees and knows and feels and has power to subdue, — the spirit that is a very part of both the Mary and the Babe of the Sistine.

The second of the three treasures of this chamber was painted more than ten years before the Transfiguration. Sigismondo Conti, chamberlain for Julius II., ordered the Madonna di Foligno about the time when Raphael was working in the Camera dell' Eliodoro. Conti wished to commemorate his escape from a meteor during the siege of Foligno, an escape he credited to the intervention of Heaven itself. The picture shows him in his red mantle and cape with fur linings, kneeling in the foreground of a landscape while the bolt is whirling across the sky. The mantle allows the full play of his arms, which are sleeved in brown. His face, thin, worn, is lifted in profile to the heavens, while Jerome, accompanied by his lion, rests his hand on the chamberlain's head. Jerome's gesture, as he calls the atten-

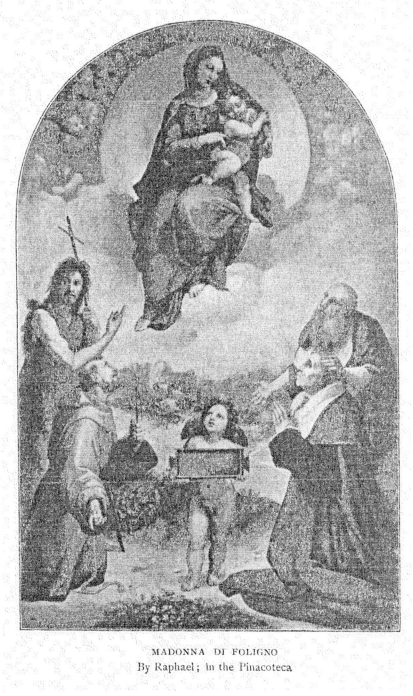

MADONNA DI FOLIGNO
By Raphael; in the Pinacoteca

tion of Heaven to his charge, is full of dignity and a concentration that finds its strongest expression in his deep-set, piercing eyes. The vision above, to which they are both appealing, is that of Mary seated on the clouds in the centre of a circle of golden light. All about her swarm cherubs and angels, who seem partly to uphold her throne of clouds. Upon her right knee stands Jesus, whom his mother steadies by one hand on his shoulder, while with the other she grasps the muslin about his waist. He bends one arm across his breast, and with the other clutches with all ten fingers his mother's robe, his head at the same time turning toward the suppliants on the earth below. Perhaps the most exquisite bit of painting in the whole picture is that of the winged boy who stands holding a tablet near the kneeling Conti. His attitude is that of perfect repose, as graceful as it is natural. He it is that makes the connecting link between the group in the sky with the churchman on the one side and St. Francis on his knees on the other, with the Baptist beyond him, erect in his tunic of skins. He has the grandeur of head, the full, perfect modelling of limbs, the brilliant rendering of flesh, the subtile play of light and shade, characteristic of Raphael in his best moments. The treatment of the landscape and the figures of the Baptist and the Friar indicate that here he was perhaps assisted by Dossi. At any rate, they have

not the breadth, the power, the full command of
his highest powers that mark the rest of the picture.

Popular opinion has placed Domenichino's Last
Communion of St. Jerome second to the Trans-
figuration alone in the Vatican collection. At the
foot of the altar at the right is the emaciated and
almost nude figure of the saint. He is supported
by a young man, and is so near death that it is only
with great difficulty that he can take the bread from
the Pope, who, himself an old man, is bending far
down toward him. On the left of the Pope kneels
a young deacon with a green stola crossing from
shoulders to hips. His head is turned in profile,
and is mostly in deep shadow, only his white robe
coming out sharply into the light. Behind him is
another, a man in a gold-flowered red dalmatia, hold-
ing out in his right hand the chalice. Other figures
are near the saint, one an old man weeping, while an
old woman leans forward to kiss his withered arm.
In the left-hand corner is the lion, his head upon
his paws, apparently as full of grief as the human
beings about him. Above in the air four little
angels are flying, and through the arch behind the
altar a landscape of trees, river, and houses is seen.
The individual heads here are wonderfully finely dis-
criminated. The colour is rich and deep, the dra-
peries well studied, the massing firm and restrained.
The saint is a finely characterised nude, and the

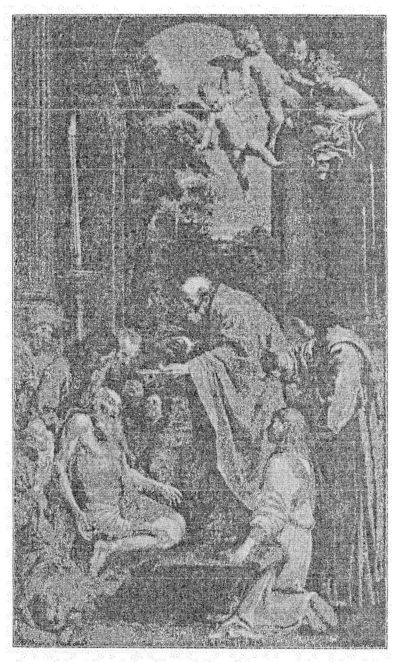

LAST COMMUNION OF ST. JEROME
By Domenichino; in the Pinacoteca

young fair-haired deacon a beautiful, graceful figure.
Altogether it is a work much ahead of most of those
of the days of the decadence, and brings back fleeting
memories of the halcyon times of Raphael.

Less popular but of far greater beauty than the
St. Jerome is the Madonna of San Niccolò de'
Frari by Titian. The lack of appreciation of this
glorious picture was early shown by a most aston-
ishing act of vandalism committed against it. Origi-
nally it was an arched panel. This arched part has
been entirely cut off, and the dove which was shed-
ding its rays upon the head of Mary is gone. Below
this height, but still in the clouds, sits the Madonna,
holding the Child in her lap. He is lifting a wreath
while he looks down, as if he were about to drop it
into the company below. Two charming little angels
on each side of Mother and Babe are also holding
wreaths. Below, within a curving, roofless temple
are six saints. On the right St. Sebastian, his hands
bound behind him and his body stuck all over with
the arrows that do not change his serene expression.
At the extreme left is St. Catherine Martyr, and next
to her St. Nicholas in a magnificent golden robe
with book and crozier. Between these are St. Peter
carrying the keys and St. Francis and St. Anthony
of Padua.

Here is all the Florentines ever got, and infinite
else besides. No more admirable presentation of

the nude human body than that of St. Sebastian can
be imagined. As Vasari rather grudgingly remarks,
it does not seem to be paint, but actual flesh itself.
If there is no attempt made at a careful specialisation
of type, if there is no great refinement in bodily
forms, at least one has every reason to believe it was
exactly what the Venetian tried to produce, — living,
pulsing flesh. And even to-day, begrimed and var-
nished and retouched as it most unfortunately is, the
marvel of those delicate tones melting imperceptibly
into one another, the glow and texture of the velvety
surface still show what it must have been in its
best estate. As wonderful in its own way is the
golden brocade of St. Nicholas. The very woof
and web, the uneven roughness, the shine of the
under golden threads, all is such a presentation of
texture as can only be felt in the very cloth itself.
Not less consummate are the expressions of the dif-
ferent faces, the attitudes of the individuals, the
grouping of the whole and the scheme of chiaroscuro.
And finally, when the dove was there to keep the
upper part in its right relation, the balance of the
whole as a composition must have been perfect.

In the group above there is such a wealth of
beauties that it seems as if no side of the painters'
art but was presented in all its power. Colour, —
brilliant, tender, subtile; drawing, — graceful, every
line full of life and movement, showing absolute com-

mand over every curve and joining; spacing and massing, — full of rhythmic charm and superb balance; and last, a sentiment of tenderness as penetrating as a lily's perfume. The glow of the child's flesh, the modelling of the softly rounded planes, the golden tone over all, has never been surpassed by Correggio, and here besides there is less the feeling of evident attempt. The Mother, bending over him, and looking below, is largely in shadow, the light striking her in a subdued glimmer on brow and nose. If she has not the depth of grandeur of the Madonna di San Sisto, she is far removed from the merely sweetly gentle faces that even Raphael was content to give most of his girl-mothers. There is a nobility of brow, a tender thoughtfulness in the shadowed eyes, a pensive strength in the curving lips, and a calm grace in the whole figure that properly place her where she is, above the world with the Holy Child within her arms. The scheme of colour below is, as it could not help being under Titian's brush, a symphony whose richness never degenerates to riotousness. The glowing flesh of St. Sebastian is answered by the brown frocks of the Franciscans, those in turn illuminated by the golden tones of St. Nicholas's brocade. The gloom of the shadowed niche is further relieved by the yellow robe of Peter and the crimson dress of Catherine. If the Roman public did not wholly realise the rare worth of this

picture, the painter himself had a great fondness for it; he even drew a copy of it on wood with his own hands. St. Nicholas is supposed to be inspired by the Laocoön, a cast of a copy of which by Sansovino Titian always kept in his studio.

Besides the two already spoken of, there are in the Vatican several other pictures by Raphael. The Resurrection of Christ dates from his student days with Perugino, and indeed it is supposed to be a joint production of the two. To Perugino is given the credit of the general composition, to Raphael most of the execution. The two angels above on each side of the Lord are in Perugino's well-known style. They have apparently just flown to the positions they occupy, and, standing on one foot with the other extended, have their hands clasped and heads bent. Christ is rising out of the tomb within a rainbow-toned ellipse. The sleeping soldier is thought to be a portrait of Raphael, and the one running away is called Perugino. Altogether the picture has the defects of Perugino, a " want of ponderation and too great distance between the figures, though the fullness of the forms and the grace to be seen in persons is characteristic of Raphael."

The Coronation of the Virgin was executed probably in 1503. The scene is built in two parts, the lower consisting of the apostles gathered about the

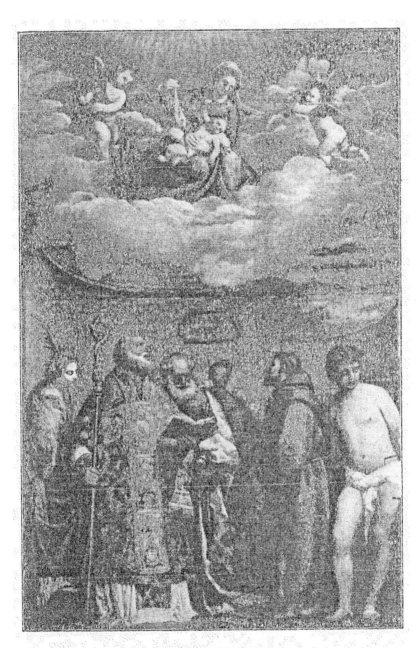

MADONNA DI FRARI
By Titian ; in the Pinacoteca

empty tomb of Christ, within which flowers are springing. In the upper portion, Christ, seated on clouds, a glory of angels about him, is placing a crown upon his mother's head. Some of the apostles below apparently see this group in the heavens. Their searching gaze is all that serves to connect the two parts. It would have been impossible for a young man in Perugino's workshop to be able fully to express twelve varying emotions on as many faces of different ages. Some of the disciples, therefore, show but slightly the astonishment they are supposed to feel. Their position and grouping, too, are somewhat perfunctory, with less ease and harmony than the later Raphael would have given them. Nevertheless, there are very beautiful faces and individuals, and the figures of Mary and Christ are remarkable for their pure and rounded beauty. The angels about the throne are lovely enough for Botticelli himself. The one beneath Christ, his head lifted with a certain indefinable melancholy, is much like one in the Sistine Madonna.

The predella which was once under this picture represents the Annunciation, the Adoration of the Magi, and the Presentation in the Temple. Already, though painted when Raphael was a mere lad, the art of the boy was strongly apparent. The Annunciation shows Mary sitting on one side of a portico supported by Corinthian columns. She has her head

bent, and is sweet and thoughtful in expression. On the other side the angel comes toward her so swiftly and eagerly as scarcely to touch the floor. In the sky, seen through the arch, is God the Father sending down his messenger.

In the Adoration of the Magi, behind the monarchs, are the shepherds with a lamb. Thus he combined in one scene the subjects always before made into two pictures.

In the Presentation in the Temple there is an architectural background of the Ionic order. Simeon takes the child most tenderly from Mary, but the baby is afraid, and turns to his mother, holding out his hands appealingly, and giving a touch of nature that was seldom attempted before.

Perugino, the man under whose direction it is supposed that these works were accomplished, has several pictures of his own in the Pinacoteca.

His Three Saints is only a small part of a large painting that originally was over the high altar in a church in Perugia. There were pictures of five other saints, and the central part of the painting was an Assumption now in the Museum at Lyons. The lunette is in the Museum of St. Germain d'Auxerrois. It was painted in 1495, and it is reported that he received five hundred ducats in gold for it. Vasari calls it the best painting Perugino ever did in Perugia. It was already divided into pieces before

the seizure by the French, and the Pope left the
Ascension in Lyons as a memento of his gratitude
for the devotion shown him by that city.

The Three Saints now in the Pinacoteca are St.
Benedict looking down, while St. Flavia and St.
Placida with hands joined in prayer gaze heaven-
wards. There is in all of these much of the delicate
sweetness and pure line of Perugino, but they are
far from his highest achievement.

His Madonna Enthroned shows a very sweet and
lovely maiden, seated on a heavy throne with a
curving canopy under an archway. The Child stands
on her knee, one hand tucked into the folds of her
bodice. On each side stand two patron saints
of Perugia: St. Lawrence, St. Ludovick of Tolosa,
St. Herculanus, and St. Constantius. There is much
expression in the saints' faces, and the picture is
noted for its transparency of colour. It was painted
for the chapel of the Palazzo Communale in Perugia,
and went to Paris in 1797.

Lo Spagna, as Giovanni di Pietro is called, was
the most noted of Perugino's scholars after Raphael.
He kept pretty closely to the Peruginesque ideals,
although in places he approaches Raphael's manner.
His Adoration of the Magi in the Vatican is one
of his early pictures, and has been variously assigned
to Pinturicchio, Perugino, and even to Raphael. It
is full of the Peruginesque delicacy and sweetness of

expression, and has a sort of superearthly grace. On the ground in front lies the Holy Babe on a piece of cloth rolled up under his head like a pillow. At the right kneels Mary, at the left behind his head, Joseph, and with them are three angels. These five figures are really exquisite. Mary's tender homage that yet carries the mother-ownership, is very beautiful, and the gauzy, transparent veiling falling about her head emphasises her own flower-like beauty. St. Joseph has a fine head, too, full of thought and showing the years of work behind him. Each of the three angels in their varying attitudes is a charming picture of celestial grace. Above their heads in the sky are three others holding the scroll bearing the good tidings to man. Raphael has hardly done lovelier angelic beings. Advancing toward the Holy Family, still in the middle distance, is the company of the Magi. A corner of the shed showing the cow and ass is on one side between them and the mother. The colour is fresh and clear and transparent, the feeling throughout the whole is one of idyllic tenderness.

The Virgin Enthroned with Two Saints, by Fra Angelico, has some of the characteristic and lovely attributes of this painter. The Virgin sits holding the Child on her arm, with a white rose in her other hand. The Child's little body is a trifle archaic and woodeny in construction, but it has the naïve grace

and innocence always found in Fra Angelico. The Madonna herself is sweetly contemplative, while the Child caresses her cheek. Seraphim, with flames coming from their fair heads and robed in blue and rose-coloured tunics ornamented with gold, are hovering round them. At the foot of the throne are St. Dominic with the lily and St. Catherine. These are frankly out of proportion, being much too small for the prominent place they fill. The background is of gold.

The fresco by Melozzo da Forli, which once ornamented the library of Sixtus IV., was, to its great harm, transferred to canvas, and now hangs in a dark place between windows in the Pinacoteca. It is called Platina before Sixtus IV. On a stately chair at the right sits the Pope, in profile. In front kneels Platina, and here one feels that the keen face with its heavy hair, its firmly marked chin and nose, must have been an excellent portrait. By the side of the Pope are his nephew Giuliano, and Rafaello, son of Antonio Sansoni, and Violante Riario. Behind Platina are Giovanni della Rovere, Pope in 1475, and Girolamo Riario. The fine spacing of figures, careful drawing, graceful architecture, all make this a very excellent work.

Another Coronation of the Virgin is by Pinturicchio. In front of an ellipse of golden rays studded with gems, Christ is placing a crown on the head

of the kneeling Mary. On each side is a lovely angel
carrying a musical instrument, their robes blowing in
the wind. Below are twelve apostles, and St. Ber-
nardin, St. Francis, St. Anthony of Padua, St. Louis
of Tolosa, and St. Bonaventura. The figures of this
composition are full of interest, and are youthful in
shape, but have lost their transparent colouring, and
have been sadly hurt by bad varnish. Here and
there on the mountains of the landscape-background
are groups of sportsmen. The upper part is a fine
example of Pinturicchio. The lower is said not to
be his work.

The Madonna of the Monteluce is by Raphael's
two noted pupils, Giulio Romano and Francesco
Penni. In the upper part is Christ crowning Mary,
and in the lower are the disciples grouped round her
tomb, now filled with flowers. This was done after
Raphael's death, but perhaps somewhat after his
designs. It was a picture he had promised the nuns
of Monteluce. The Madonna is Raphaelesque, and
the figures below, though their heads are in certain
ways like Perugino, show such violent action,
especially with their open hands, that it is easy to see
how these two pupils of the Urbinate were influenced
by Michelangelo, — greatly to their own harm. The
upper part is considered to be by Romano, the lower
by Penni.

Cesare da Sesto, who died about 1524, was late

in his life a friend of Raphael. He was an eclectic painter, sometimes imitating Raphael and sometimes Leonardo, some of his work having been ascribed to the latter painter. The Madonna of the Belt in the Vatican was credited to Da Sesto, but critics now call it merely a poor picture of the late Lombard-Milanese school. It is a circular panel, the Madonna seated, with heavy clouds rising behind her like a huge chair back. The infant Christ upon her lap is unfolding the belt before St. Augustine. To the right is St. John the Evangelist, with a scroll in his hand. The faces are small, pointed, insignificant, with no beauty of arrangement in pose or grouping.

Far inferior to the Madonna dei Frari is Titian's Doge Giovanni Mocenigo. The bust is life-size, turned in profile to the left, on a reddish gray ground, now spoiled by retouching. With its enormous pointed nose and very inadequate chin, the face is too marked not to have been an excellent portrait. The eyes are small, sunken behind many wrinkles, the lower lip projects heavily, as if to make up for the retreating chin below. It came from the Aldo-brandi collection in Bologna. The face, right hand, and background have been all repainted. Yet even in its present state there are hints of the warm colours of the master. An elaborate brocaded cloak covers his fleshy figure.

Francesco Francia's Virgin, with Child on her

lap and St. Joseph at one side, is not one of his best known works, but has the sweet piety of his Madonnas with some of his pearly flesh tones. It is said that Raphael declared that Francia's Madonnas were the most devoutly beautiful he knew. Her large dark eyes and perfect brows in this panel are very lovely and fine in line.

There are a number of pictures by Guercino, whose name was Giovanni Francesco Barbieri, surnamed Guercino da Cento. He was noted for his grace, as well as a decided power and depth of expression, with a charming knowledge and use of chiaroscuro. Later in life his works became more sentimental and thinner. His Incredulity of St. Thomas in the Vatican is one of his more important works. Christ stands with his robe pulled off his left shoulder and chest, showing the wound, while his left hand grasps a pole from which the ends of a white flag float about his head. St. Thomas, his head thrown into a deep shadow, except where the light strikes him sharply on the neck and ear, leans forward, putting his finger into the wound in Christ's side. Other disciples are behind. The management of the light and shade is masterly, the chiaroscuro all through most effective. The Saviour's face, as he stands in profile, is full of beauty, not without strength. Infinite pity shines from his eyes as he looks upon the intense, questioning face

of the bearded Thomas, rugged in its simplicity and honesty. This was one of the few pictures already in the Vatican before it was taken to Paris.

St. Margaret of Cortona is also by Guercino. She is in the dress of a Franciscan nun, and kneels on the altar steps, a halo about her head, her eyes turned upwards, her hands clasped. Above her head two angels are flying, pointing still higher. The picture is not good, and perhaps not wholly by him. Equally poor is the Bust of St. John, in his later style.

A very strong picture is Poussin's Martyrdom of St. Erasmus. The saint is spread out nude upon a log of wood. While one executioner is disembowelling him, another is winding the intestines about a mill as a rope. Beside the half-dead martyr is a pagan priest, pointing at the statue of Hercules. Behind him is an armed captain on horseback, showing some horrified spectators the deed taking place in front. St. Erasmus's mitre and robes are on the ground near the block of torture. Above are seen two angels with the crown and palm of victory. The light is thrown sidewise upon the white-robed priest, and shines upon the chest and falling arms of the saint. All the rest is in shadow or half-shadow, lighted only in the outlines. Here are big, broad massing, magnificent drawing, freedom of action and movement. The colour is somewhat

thin, but the skilful chiaroscuro helped to neutralise that fault. The saint, drawn down on the torture rack with his head bent far back, is a very wonderful accomplishment.

Murillo is very poorly represented, though his Marriage of St. Catherine has some fresh, charming colour suggesting the Venetian school. It was given to Pius IX. by Queen Christine of Spain in 1855. The Adoration of the Shepherds, though attributed to him, is at best only a smaller copy of one in the Museum of Seville. Mary half kneels by the cradle, from which she partly lifts the baby, while she draws away the light covering. The shepherds kneel about, the light that is focussed upon the holy pair reflecting on to the one in front. Mary is sweet and lovely, but the whole composition borders on the commonplace.

Two very attractive canvases are by Federigo Barocci, though neither of them represents him at his very best. One shows St. Michelina standing on the Mount of Calvary, her arms thrown forward in ecstasy. Her pilgrim's hat and staff are on the ground, her mantle is blown about by the wind. It was executed for the Church of S. Francesco, in Pesaro, where it remained till 1797, when it was taken by the French. Barocci had a tenderness, an idyllic sweetness of manner without any very great depth of meaning. His colour, though pleasing and

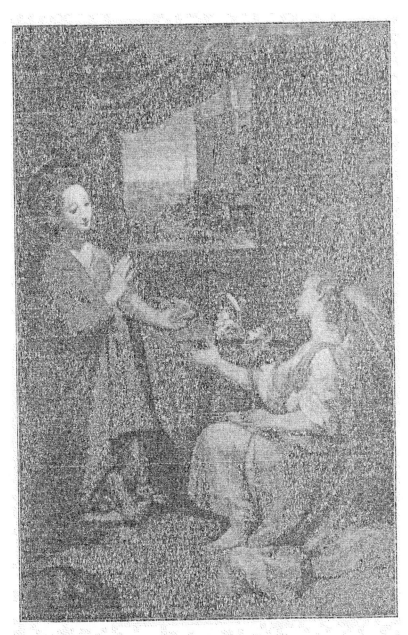

ANNUNCIATION
By Baroccio; in the Pinacoteca

sometimes extremely soft and harmonious, is too red in the "carnations." His positions, too, are apt to be affected, and his sentiment degenerate into sentimentality.

Escaping this last fault, yet not rising to his very highest achievement, is his delightful Annunciation, not far from the St. Michelina. Mary, who is a dainty, youthful figure rather heavily draped, kneels at the left of an open window, through which castle walls and lines of a city can be seen. In front of her, on one knee, is the angel with the branch of lilies. There is a soft luminosity to the colour of Mary's face that is perhaps a trifle overemphasised by the pink of her cheeks. Very tender, however, are the high forehead and delicate eyebrows, with a faint suggestion of Orientalism about them. The angel, though not impeccable in drawing, is a radiant being with a wonderfully lovely head and neck, and golden curls that lie tenderly against the soft modelling of temple and neck.

Bonifazio II. has a Holy Family which has been repainted, but still carries many characteristics of the Venetian who at his best nearly equalled Palma Vecchio. Mary, seated in the middle of the picture, is a matronly figure of the rather florid Venetian type, with a sweet, not too expressive face. The child on her knees has been repainted so much that there is little left of the original. At Mary's side

is St. Elizabeth, from whose basket she takes some
roses. The little St. John is at the extreme left,
seated upon a lamb, and at the right St. Joseph and
Zacharias are conversing. St. Elizabeth is almost
as young, and has a more interesting face than Mary.
The two old men are splendidly done, their heads,
though almost identical in beard and hair, possess-
ing an individuality as fine as is the modelling.

An Entombment by Amerighi da Caravaggio is
one of his best works. The figures are magnificently
drawn, in striking, original grouping, with a colour
as glowing in the light as it is deeply mysterious in
the voluminous shadow which is over most of the
picture. The draperies are beautifully indicated,
and if heavy have a fall of line and mass almost
unexcelled. Christ, supported by Nicodemus and
John, is being laid into the tomb, while behind stand
the three Marys. It has been said to resemble a
picture of the burial of a gipsy chief rather than
that of the Christ. Yet power, great dramatic feel-
ing, and splendid technique it has in abundance.
The figure of Mary, who has wept herself tearless,
has seldom been surpassed in its expression of heart-
wringing sorrow.

Not even by a second-rate picture is Correggio
represented. The Christ upon a Rainbow, called his
in the catalogues, has been credited by Morelli to a
weak disciple of the Bolognese school of the last

"decadenza." The only part of the canvas distinctly recalling Correggio are the four little angels at Christ's feet. With their soft, luminous eyes and waving, golden curls they have something of the exquisite modelling and colour of the great painter. The figure of Jesus, on the contrary, is almost fuzzy in its overmodelling.

Much more satisfactory is the Martyrdom of St. Lawrence by Ribera. The saint is naked and on his knees before his executioners. Like all of Ribera's works, there is here the dramatic intensity in the forced contrasts of highest light and deepest shade. The figure of the saint is vigorously drawn and modelled, the arm that is grasped by one of the executioners being marvellously real in its straining muscle, with the white flesh gleaming against the red fingers of the torturer's heavy hand.

Veronese's St. Elena is a graceful, attractive panel, with the warm, soft colours and rich accessories of the Venetian school. Really enchanting is the little winged nude boy, who stands nearly back to in the right corner, bearing the cross of St. Elena's dream. The soft modulations in the curves of his tender little body are almost equal to Correggio.

THE END.

Bibliography

BAEDEKER: Central Italy.

B. BERENSON: Florentine Painters of the Renaissance. Central Italian Painters of the Renaissance. Venetian Painters of the Renaissance.

BLASHFIELD: Raphael in Rome.

BLASHFIELD, BLASHFIELD, AND HOPKINS: Vasari's Lives.

ALCIDE BONNEAU: In Revue Encyclopedique — L'Appartiment Borgia au Vatican.

BRYCE: Holy Roman Empire.

BRUNN: Griechische Künstler.

J. CARTWRIGHT: Raphael in Rome.

CARTIER: Life of Fra Angelico.

C. CLEMENT: Michelangelo, Leonardo da Vinci, and Raphael.

L. M. DE CORMENIN: Histoire des Papes.

MARION CRAWFORD: Ave Roma Immortalis.

CROWE AND CAVALCASELLE: Life of Raphael and His Works. History of Painting in Italy.

M. J. DE CROZALS: Beato Angelico.

L. DOUGLAS: Fra Angelico.

J. DENNIE: Rome of To-day and Yesterday.

F. H. DYER: History of the City of Rome.

F. EHRLE AND E. STEVENSON: Gli Affreschi del Pinturicchio nell' Appartamento Borgia.

FURTWÄNGLER: Masterpieces of Greek Art.

S. R. FORBES: Rambles in Rome.

LA GOURNERIE: Christian Rome.

GEBHART: Le Palais Pontifical.

GOYAU, PÉRATÉ, AND FABRE: Le Vatican, Les Papes et La Civilisation.

GREGOROVIUS: Rome in the Middle Ages.

H. GRIMM: Life of Michelangelo. Life of Raphael.

A. J. C. HARE: Walks in Rome.

C. I. HEMANS: Historic and Monumental Rome.

WOLFGANG HELBIG: Guide to the Public Collections of Classical Antiquities in Rome.

KUGLER: Italian Painting.

LANDON: Vie de Raphael.

LAROUSSE: Dictionaire Universel du XIX. Siècle.

L. C. LOOMIS: Index Guide to Travel and Art Study in Europe.

LÜBKE: History of Art.

H. J. MASSI: Compendius Description of the Museums of Ancient Sculpture in the Vatican. Cursory Notes in Illustration of the Paintings in the Vatican.

MATZ: Antike Bildwerke in Rome.

L. M. MITCHELL: History of Ancient Sculpture.

MUELLER: Ancient Art and Its Remains.

E. MÜNTZ: Raphael. Les Arts à la Cour des Papes.

MURRAY'S Rome.

A. S. MURRAY: History of Greek Sculpture.

L. PASTOR: History of the Popes.

PERKINS: Historical Handbook of Italian Sculpture.

W. C. PERRY: Greek and Roman Sculpture.

K. M. PHILLIMORE: Fra Angelico.

E. MARCH PHILLIPS: Pintoricchio.

COUNT PLUNKETT: Botticelli and His School.

G. B. ROSE: Renaissance Masters.

SCRIBNER'S Encyclopædia of Works of Architecture in Italy, Greece, and the Levant.

SPRINGER: Raphael.

J. A. SYMONDS: Life of Michelangelo Buonarroti. Renaissance in Italy — The Fine Arts.

TARBELL: History of Greek Art.

TUKER AND MALLESON: Handbook of Christian and Ecclesiastical Rome.

VIARDOT : Les Merveilles de la Sculpture.

VENTURI : The Vatican Gallery.

C. H. WILSON : Life and Works of Michelangelo.

WOLTMANN AND WOERMANN : The Painting of the Renaissance.

ZOLA : Rome.

Index

341

Printed in the United States
28396LVS00001B/21